ESTELLE McDONIEL

One Girl...
Two Countries

a Biography

First Edition • Published in the United States of America

Website: thefamilybookstore.com • E-Mail: emcdinaz@aol.com

ISBN: 978-1-73294-642-2 Print
ISBN: 978-1-73294-643-9 eBook

CONTENTS

Chapter One: Ohio Before Venezuela .. 1

Chapter Two: A Surprise Announcement 7

Chapter Three: Preparing and Traveling to Venezuela 19

Chapter Four: Observations of Puerto Ordaz 31

Chapter Five: High School and College In Ohio 61

Chapter Six: Summers in Venezuela .. 69

Chapter Seven: Teaching in Puerto Ordaz 95

Chapter Eight: A Secret Marriage .. 117

Chapter Nine: Colorful and Challenging Florida 127

Chapter Ten: Returning to Venezuela 145

Chapter Eleven: Florida…Anguish to Contentment 173

Chapter Twelve: Retirement and Personal Reflections 191

Acknowledgements

Thanks to Terry Curran Croquer for sharing her story
of the Venezuela she knew and loved so many years ago and
the impact Venezuela had for the rest of her life.

Thanks to Derry Curran and Susie Stark Kuz for sharing
several of their stories, photos, and remembrances regarding
the Venezuela they, too, knew and loved many years ago.

Introduction

As her day began, Terry, once again, thought about the Venezuela she knew and loved so many years ago. It was 1953, Terry was thirteen years old when she and her family moved from a city in Ohio to an undeveloped area of Venezuela, near the confluence of two large rivers and the jungle. The country of Venezuela was filled with freedom, freedom for everyone. There was beauty everywhere. Much of the beauty was in the warm welcoming spirit of the Venezuelan people. Years have passed, life has changed for Terry but her memories and love of the Venezuela she knew has remained with her forever. A personal decision caused her to leave Venezuela and to move forward with her life the best way she could. This is Terry's story. A story that blends two countries together creating long-lasting memories. Memories to be shared and cherished.

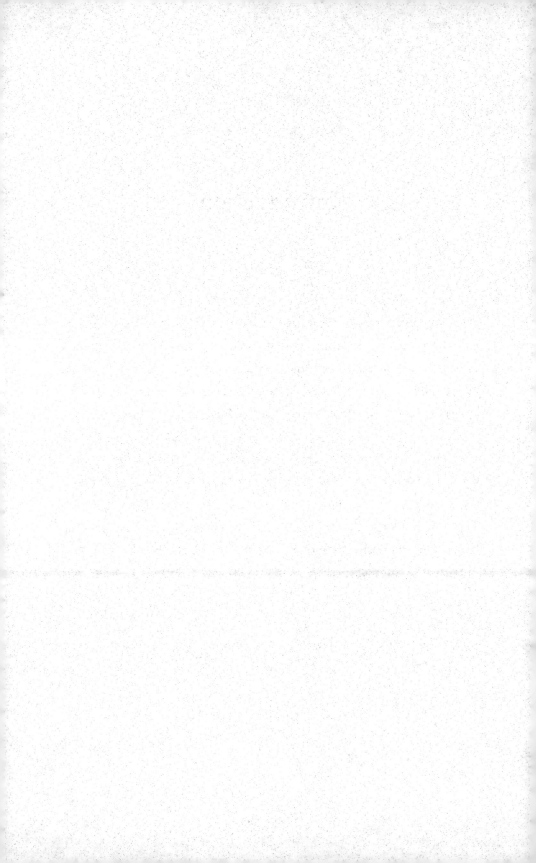

CHAPTER ONE:

Ohio Before Venezuela

The year was 1953, Dwight D. Eisenhower was the 34th President of the United States of America. Nikita Khrushchev was the leader of the Soviet Union. Those two men were the leaders of the political and economic hostility that continued between the United States and Russia for many years. The hostility was known as the Cold War. The two countries had different philosophies towards their citizens. The United States supported democracy and freedom for its people. The Soviet Union preferred a dictatorship with the government owning all property and allowing the government to decide which citizens would get paid for their work and how much they would be paid. The two countries, with the two different philosophies clashed; therefore, the Cold War continued for over forty years.

However, in Toledo, Ohio, Terry Curran, a young thirteen year old girl was happy and content in the world she knew. Her world was filled with family and friends and did not include the Cold War. Nonetheless, the Cold War and Venezuela would soon have an impact on Terry's life.

Teryle Lynn Curran was born in Toledo, Ohio on October 17th, 1939. She was the first child born to Jack and Genevieve Curran. Her brother, Derry, was born just over a year later. Like most families, at that time, Terry and her family knew their neighbors well. In addition, several family members lived close by. At that time in Toledo, it seemed that all men worked

outside the home and women did not work outside the home. The men, generally, worked for the same company for years and years. Rarely, did anyone move away from their hometown to take a job elsewhere. Like most families at that time, the family had one car for Terry's dad to use to drive back and forth to work. If Terry, her mother and brother wanted to go somewhere, they would walk or take the bus, which was what everyone seemed to do at that time. Actually, taking the bus downtown to shop was an enjoyable experience because shopping downtown usually meant shopping at one of the large department stores. The department stores often had six to nine floors of merchandise for customers to review and buy. The various counters in the department store always had an employee standing behind the counter, ready and willing to display merchandise to customers in hopes that the customer would find something she would be willing to buy.

Terry and her family lived the first ten years of her life in a house that was a duplex. It was a house her parents rented on Church Street in Toledo. Terry's family lived on one side of the duplex and another family lived on the other side. "My friend, Susie, lived on the other side of the duplex. When Susie and I wanted to have a secret conversation, we would each go to our upstairs bathroom and open the medicine cabinet. We could then chat with one another, through the medicine cabinets with no one else in our families able to hear our conversations and our giggles. That was always fun and we both enjoyed chatting together that way."

As Terry continued to grow, she enjoyed the freedom, as did most children, of walking to friends' houses or to her grandmother's house, which was only a few blocks away. Terry, to this day, vividly recalls the one day, when she was ten years old, walking to see her grandmother when something unusual happened right in front of her friend Karen's house. As Terry recalls, "I heard a voice in my head tell me that I would not live past the age of thirty-nine. I thought that was strange but I didn't worry about it. I just figured I would never get married and I would never have children; consequently, I just continued walking to my grandmother's house

2

and never told anyone what I had heard. As it turned out, that would not be the only time in my life that something unusual would happen to me."

Eventually, because Terry's parents had been renting the duplex and saving their money, they were able to have enough money to put a down payment on the house they wanted to buy on Randall Drive. Saving money was important to families and it was not unusual to see a number of envelopes in the house marked for such expenses as food, rent, house, church, and gasoline. Envelopes that the family would fill monthly with dollar bills to be spent wisely and carefully.

Moving to Randall Drive turned out to be a good move for Terry because she would no longer have to share a bedroom with her younger brother, Derry, who would frequently use his flashlight to make scary pictures on the bedroom wall or put rubber snakes or bugs in Terry's bed just to scare her at night. In the new house, Derry had the top floor of the house for his bedroom which included two twin beds. Terry had her own bedroom, on the main floor of the house, but her bed was a sofa sleeper. As Terry remembers, "Every night before I could go to bed, I had to turn the sofa into my bed. In the mornings, I had to put all the sheets, pillows and blankets back in the closet and turn my bed back into the sofa. I wondered why my parents thought a sofa bed was a good idea because I, certainly, didn't think so. Every morning, Mother would set the clothes out that she wanted me to wear that day. She did that everyday. I really wanted to select my own clothes to wear but I could't argue with my mother because I knew that, in our house, Derry and I were not to argue or ask questions. Mother was a very organized person who set many rules that Derry and I had to follow. One rule was that we could not get into the refrigerator and help ourselves to food or drinks. The refrigerator was off limits to us. Consequently, it surprised me when I would visit friends who would just freely go to the refrigerator and offer me a snack or a drink. On the other hand, once in awhile, Mother would wake Derry and me up in the middle of the night to announce that Dad was home with a fresh quart of ice cream for the family. I was always happy to see Dad because I knew he worked

long hours. Having him bring ice cream home made me even happier to see him. Truthfully, I was happy to eat ice cream any time of day or night."

Adjusting to the new house on Randall Drive, to the new neighborhood and to the new school was comfortable for Terry and Derry. Having made the move to the house on Randall Drive meant new schools for Terry and Derry. Terry and Derry both liked their neighborhood friends and their new classmates. Each school day, which was typical at that time, the children would walk to school, dash home for lunch, eat quickly and return to the school playground in time to play kickball, jump rope, or swing on the monkey bars before the bell rang for afternoon classes.

Like most families, Terry and her family enjoyed watching their favorite television shows. After dinner, the family could usually be found sitting together in the living-room watching such popular shows as "Ozzie and Harriet", "The Arthur Godfrey Show", "Candid Camera", or " The Lone Ranger". The television programs were great for family entertainment. A fresh bowl of popcorn made a favorite television program even better.

Terry's dad, like many dads, was part of a neighborhood softball team. Softball seemed to be the preferred sport and many men played the game. Watching high school football games was also an important activity. Attending a softball or a football game was generally a neighborhood and community event. Neighbors knew one another which not only made the game fun to watch but also provided neighbors the opportunity to talk and socialize with one another.

While many families tried to always go on a vacation, that was not something every family was able to do. That was true of Terry's family. Terry recalled only one vacation that the family ever had. That vacation was when the family spent a week living in a cottage on one of the lakes in Michigan. Terry loved the relaxing vacation so much that, as she recalled, she cried on the drive back home. She simply did not want the vacation to end. Terry also knew that returning home meant returning to all the family rules rather than just running freely and having fun.

Terry's dad enjoyed taking the family to The Toledo Express Airport where the family could sit in their car and watch the airplanes take off and land. Since Terry's mother was afraid of flying, Terry thought perhaps that was Dad's way of showing Mother that flying was safe, comfortable and fun.

"If someone had asked me on my thirteenth birthday what I was most excited about, I would have instantly said I was excited knowing I would soon be a freshman in high school. In fact, I would be a Freshman at Clay High School with all my friends. In high school there would be new teachers to meet, new subjects to learn, new clubs to attend, plus football and basketball games to watch. I was excited, anxious, and eager to start high school; however, something very unexpected happened which would completely change my life. I would be going from the known to the unknown.

CHAPTER TWO:

A Surprise Announcement

"However," recalled Terry, "as happy as I was in the summer of 1953 something very unusual happened to my family which greatly surprised me. I was sitting in the living-room and I could hear my parents, in their bedroom, talking very loudly to one another. It sounded like they were arguing but I had never heard my parents argue. They hardly ever raised their voices. Since my parents never argued over anything, I wondered what was happening. I sat very still and didn't make a sound. I questioned what was going on between my parents. What were they talking about? Soon, Mother and Dad walked out of the bedroom together, holding hands. My dad called Derry to come to the living-room. Dad said he had something very important to tell us. Without hesitation, Derry and I sat down together on the couch eager to hear and wondering what Dad was going to say. Immediately, my dad told us that he would no longer be working for C&O, the Chesapeake & Ohio Railway. What? He had worked there forever. That meant, Dad continued, he would no longer be working at the railroad yard near us in Walbridge, Ohio where he had worked forever! Dad told us that he had accepted a new job in Puerto Ordaz, Venezuela and that our family would soon be moving to Venezuela. What? Venezuela? Puerto Ordaz? Where is Venezuela? Where is Puerto Ordaz? We are moving there? How can we? I'm going to be a Freshman at Clay High School in

the fall, how could I move to Venezuela? I was looking forward to being in high school with my friends. Why did Dad want to move? Wasn't he happy in Toledo? What about our family and friends? Suddenly everything was confusing to me."

There were reasons why Jack Curran was willing to move his family to Puerto Ordaz, Venezuela. He had worked for many years at the large railroad yard in Ohio were men learned how to drive trains, care for trains, build train tracks and transfer cargo from trains to ships. There were Switchmen, Firemen, Conductors, and Engineers who worked together to care for and move the trains successfully, There was always a Yardmaster who had to monitor the trains coming and going. All the train cars had to be inspected daily and if a train car had a problem all the other train cars in front of and behind the problem car had to be moved out of the way so the problem car could be moved to the repair shop and fixed. The track gang built and took care of the train tracks. Terry knew her dad couldn't do everything. That would be too much work for him. She wondered why her dad could leave what he knew so well and go to Venezuela. He had worked in the C&O train yard forever. What was her dad going to do in Puerto Ordaz, Venezuela? She also wondered what she was going to do in Puerto Ordaz, Venezuela.

"My dad said that all the work the men did in the train yard in Ohio is, exactly, what the men would be doing in Puerto Ordaz, Venezuela and it was going to be his job to make certain the work would all be done correctly. Dad said this new opportunity was exciting to him. It was an opportunity to live in an area that had very little. In fact, it had almost nothing. He called it a wilderness area. A wilderness area? Why would anyone want to go to a wilderness area? Dad said he would be working for the Orinoco Mining Company. He was going to help build the train yard plus the ninety miles of train tracks that would be used to carry iron ore down the mountain and onto the ships heading for the United States. Now, I was getting puzzled. What mountain? A mountain of iron ore. What's that? I had never

seen a mountain in Ohio. What is iron ore, I wondered. It was definitely time for me to learn more."

"Dad also said he thought leaving Ohio and starting a new job would be exciting for him and for our family. He, once again, told us that we would be moving to an area that had very little of anything. There were no paved roads, no telephones, no televisions, no department stores, and, there were only a few people living in Puerto Ordaz. Dad told us that Puerto Ordaz was near the confluence of two large rivers and next to the jungle. In fact, the Orinoco Mining Company was cutting down trees and other vegetation so they could build houses for the workers. Dad told us he would leave for Venezuela soon but the rest of our family had to wait until a house was built before we could move there. What? We were moving to an area that had no houses? We had to wait for a house to be built? This all sounded very strange to me. Dad told us that the Venezuelan people spoke Spanish. Spanish? I didn't know a word of Spanish. I thought to myself that this move to Venezuela could be a very interesting move or very puzzling move. I decided to simply think that our family would be going to Venezuela for a two year vacation and that's it. I had to think two years because Dad said everyone who was hired had to agree to work in Venezuela for, at least, two years. How did this project start, and why Venezuela, I wondered. Dad said there was a good feeling of cooperation between the United States and Venezuela which, I suppose, I was happy to hear."

Terry did learn that in 1945, a man by the name of Benjamin Fairless, who was president of the US Steel Company met with a man named Mack Lake who was a mining engineer. Mack Lake told Benjamin Fairless that he believed there was a mountain filled with iron ore in Venezuela. Mack Lake asked US Steel to finance his research so he could prove there really was iron ore in a certain area of Venezuela that no one else knew about. Eventually, after Mack Lake completed his research, US Steel learned that Mack Lake was absolutely correct. Indeed, there was a mountain filled with high grade iron ore in Venezuela, near an area called Puerto Ordaz. US Steel quickly moved forward with plans to mine the iron ore and bring

the iron ore to the United States. Iron ore was needed to make the steel products necessary to protect the United States against the Soviet Union during the Cold War. Should the two countries ever get into a physical battle against one another, steel would be necessary in order to defend the United States. Steel would be used to build military tanks, cars, trucks, trains, plus appliances for the home, medical equipment for hospitals and even small items like knives and forks. Recognizing the need to mine the iron ore, US Steel formed a new company, a subsidiary company of US Steel called the Orinoco Mining Company (OMC). The iron ore would be mined in Venezuela and shipped to the United States' steel mills where the iron ore would be processed and turned into valuable steel products.

Where was this mountain of iron ore? The mountain named Cerro Bolívar was near Puerto Ordaz, Venezuela. It was a mountain of iron ore; although, some people referred to it as a hill of iron ore; no matter, the hill or mountain of iron ore was nearly a mile wide. Some scientist said that the mountain, named Cerro Bolívar, had been known to hold the thickest concentration of iron ore on the face of the earth. The US Steel Company and the government of Venezuela agreed that the new company, Orinoco Mining Company would be responsible for mining the iron ore and transporting it to the United States and to other countries, when appropriate. This agreement was to last until the year 2000 but that didn't happen because on January 1st, 1975 the government of Venezuela nationalized many companies including the Orinoco Mining Company. Private companies were now government owned companies. Nonetheless, in 1952 cooperation was strong between the United States and Venezuela so the work began. The Orinoco Mining Company moved forward to mine the iron ore from the mountain, Cerro Bolívar.

The plan was to take the iron ore from the mountain using a method known as an open-cut method. Using this method, the miners would prepare the surface of the mountain in such a way that the workers were able to collect the rocks of iron ore from the mountain and load the iron ore onto the dump trucks. The iron ore would then be dumped from the trucks

into train cars. When all the train cars were filled with iron ore, the train would travel ninety miles down the mountain to the dock area. At the dock area, iron ore would, eventually, be transferred to the large ship docked at the base of the Orinoco River. The large ship would then navigate over a hundred and fifty miles to the Delta and then out to the Atlantic Ocean heading to the United States. However, before the plan could begin workers had to be hired, two communities had to be built with apartments and houses for the workers and their families, a commissary for families to by able to buy food, and, eventually, a church, a hospital, a social club, a school and other amenities appropriate for the workers and their families which would take several years to complete.

Jack Curran was to be responsible for building the ninety mile railroad track, hiring experienced railroad men to work in Puerto Ordaz, creating a working railroad yard, and overseeing the jobs necessary to get the iron ore down from the mountain and onto the ships. Jack was excited about the challenge and he hoped moving to Puerto Ordaz would be an exciting adventure for him and his family. Jack's challenge and responsibility would be more than the work he had in Ohio.

"I knew I wasn't as excited as my dad about moving to Venezuela; however, he kept saying that our family would enjoy new experiences and we might grow to love Venezuela. I think his enthusiasm helped me decide the move might not be too bad. I did ask my Dad if I could have a lion in Venezuela. My dad told me there are no lions in Venezuela. I don't know why I thought about a lion but years later, looking back on that request, perhaps it made sense that I had I asked for a lion. Derry was eager to learn about Venezuela. He spent a great deal of time at the library searching for maps and books to study and read. Derry learned there was a large modern city in Venezuela, called Caracas. He also learned that Puerto Ordaz was over 300 miles away from that modern city of Caracas. Puerto Ordaz wasn't even a city, or a town, or a village. It was simply an area close to where the Orinoco River and the Caroní Rivers met. Realistically, Puerto

Ordaz was a settlement near the jungle and Dad thought that was great. Indeed, Dad was an adventurer!"

"Dad told us, once again, that Puerto Ordaz had no paved roads, no telephones, no televisions, no department stores, and, there were not many people living there. Interesting, I thought, not many people living in Puerto Ordaz and we are leaving Toledo where nearly half million people lived and where we had department stores, telephones, televisions, paved roads and Dad thinks moving to Venezuela will be exciting. All in all, thinking about this moved to Venezuela was somewhat baffling to me. Why would I like it? Dad said the Orinoco Mining Company had workers in Puerto Ordaz who were busy trying to transform the wilderness into a community. I must admit that I was pretty happy living in Toledo. I had girlfriends that I'd had for years. I always felt safe and comfortable walking around our neighborhoods, day or night, because I knew all our neighbors. Would I have good friends and neighbors in Puerto Ordaz, I wondered."

Feeling comfortable, in the neighborhood where a family lived, was true of most young people living in Toledo at that time. Terry would walk her friend Carol halfway home as the girls continued talking. At the halfway point the two girls would continue walking together until they had finished all their talking for the day. At that point, each girl would return to her own home. Young people and families were comfortable with one another and with their neighborhoods. There was no doubt about it, parents, teenagers and children all felt safe in their homes, their neighborhoods, and in the cities at that time.

"Yes, at this point in time," thought Terry, "I was a bit puzzled. We were moving somewhere and there was no house for us. Dad said there would be several housing areas designated as area A, B, or C. Hearing that, I immediately wondered if our house would be in area A, B, or C and what was the difference. When I asked Dad that question, he said that when he would first be working in Puerto Ordaz, he would have an office in the paper barracks and, maybe, live in a temporary apartment in the paper barracks. Paper barracks? That's something else that's new to me. What

are paper barracks? Dad explained that the paper barracks were similar to the barracks that soldiers often lived in during war times. The barracks were, usually, temporary and could be put up or taken down quickly. Dad thought the barracks would be made out of a heavy corrugated material or some kind of light wooden material. He said the barracks would be a short term solution until the office buildings and houses would be built. Apartments were being built for the workers but Dad wanted his family to wait until we could move into a house, not an apartment, so we waited. I think Derry and I were only excited about moving to Venezuela because Dad was so excited and his excitement seemed to just pour out of him and onto us."

After listening to her dad, Terry understood a bit more about houses in areas designated as A, B, or C. In each area, the houses were very much alike with all the houses being about the same size and having the same amount of space around the house which included the front and back yards. Apparently, the houses in the A area would be built for the workers who did much of the hard work and for their families. The B area houses might be a bit larger and would be for the employees who had more responsibility for the company; such as, supervisors. Area C was to have homes a just a bit larger than homes in the B area. Those homes would be for the superintendents and executives of the mining company plus accountants, doctors, and other professionals working for the mining company. Having areas designated in such a way allowed workers, families, and neighbors to have much in common with each other and to be comfortable socializing with one another. It was known, by many at US Steel, that the community being built in Venezuela for the Orinoco Mining Company would be one of the first, if not the first planned community in the world with the housing areas similar to housing developments in the United States. Being a planned community meant several rows of houses resembling one another and referred to as "cookie cutter" houses. The houses varied in size but were all similar in shape and floor plan. In both communities the houses were to be built after the trees, shrubs, bushes and other jungle vegetation

would be cut away or torn down to make room for the two new communities. Puerto Ordaz, being closer to the two rivers was the greener of the two communities. As the years would continue, paved roads and large office buildings would be added to the feeling of living in a city. All the planning, preparations, and actually building of the two communities would take several years but would, eventually, turn those two communities from undeveloped areas near the jungle to communities where the workers and families would enjoy living there and feeling part of a community. With thoughtful planning, an opportunity was presented for both American and Venezuelan workers to be part of something new, dramatic and different and that is what appealed to Jack Curran in 1953. Recognizing his enthusiasm, the rest of the family felt that, perhaps, going to Venezuela might be exciting and a remarkable adventure.

The Curran family knew it was important to tell family and friends they would soon be moving; therefore, Terry, her brother and their parents sat down with grandparents, aunts, uncles, cousins, and special friends to share the exciting news about moving to Venezuela. The response from family members was rather unexpected. Some family members wondered why anyone would want to go to an area that had so much unrest among its people. However, the unrest was more in the city of Caracas, not in Puerto Ordaz, according to Jack. Several family members expressed concern about the dangerous wild animals that lived and roamed freely in the jungle. Terry wondered how those family members even knew about dangerous wild animals and unrest when they knew very little about Venezuela. "Listening to the family's comments, I was beginning to wonder about this adventure to Venezuela. Obviously, I had no choice. I had to go. I think my mother, who was always the most fearful person in our family, was not overly excited about moving to Venezuela. Derry thought more like my dad so he was ready for the adventure. I knew Derry would do his best and make the most of it. I must admit that my dad's excitement about moving to Puerto Ordaz helped me to decide I might enjoy it. I decided I would try to learn, adjust and enjoy this adventure, no matter what. Derry and I asked

my dad a lot of questions; however, when Derry asked my dad how much money he would make in Venezuela, my dad never answered that question. Dad told Derry to never ask that question again. However, because of what we were able to do, as the years went by, Derry and I decided that Dad probably had a much larger salary in Puerto Ordaz than he ever had in Ohio. Dad did tell us that he would have more educational and managerial opportunities in Venezuela which he found exiting."

Before moving to Puerto Ordaz, Venezuela, Terry's dad had to go to Pittsburg, where the US Steel headquarters were located He had to attend a variety of meetings to learn the exact expectations for the job he would have in Venezuela. Jack understood his primary job was to focus on the railroad, the trains, and the tracks. He was hired to be the Superintendent of the Railroad Division in Puerto Ordaz. As the work progressed, Jack would eventually become the Superintendent of the Railroad Division and the Seaport Division.

"Moving to a country where the people speak a different language means one can either learn the language and participate with the locals or isolate oneself and only participate with the people who speak the same language you speak. Dad took many Spanish classes before leaving for Venezuela. He wanted to be able to speak intelligently with the Venezuelan workers he would hire and supervise in Puerto Ordaz. It was important for the workers to understand him in order to clear the area and lay the tracks, correctly. Dad worked hard learning and practicing Spanish. He understood the importance of being fluent and comfortable with the Venezuelan people he would meet and the people who would meet him."

Before any of the family could actually leave for Venezuela, the family's next step was to get all the shots necessary to travel to Venezuela, which included the small pox vaccine. Smallpox had not been eliminated from the world and was considered a very dangerous and deadly disease. Consequently, the family drove to Ann Arbor, Michigan where they could get the the necessary shots, including the small pox vaccine. Terry, after receiving a variety of shots finally received her last shot and,

promptly, passed out. Making a move to Venezuela did appear to have its ups and downs.

US Steel had a requirement for those individuals willing to work at Orinoco Mining Company. The requirement was that each individual hired to work for OMC would agree to work in Puerto Ordaz for, at least, two years. This agreement included the railroad men, the security people, the engineers, the accountants, the teachers, and any other employees hired to work in Puerto Ordaz. Perhaps because US Steel was starting this new iron ore project in Venezuela and recognizing they would be moving families to a new location and shipping all their belongs to Puerto Ordaz, the two year requirement seemed reasonable and fair. The final interview for applicants was held in Pittsburgh at the US Steel headquarters. Years later, although US Steel had created the Orinoco Mining Company, potential employees no longer needed to go to Pittsburgh for an interview. It was just no longer necessary or required because the mining company could do all the necessary hiring in Puerto Ordaz, themselves. There was one restriction for teachers that continued for many years. All teachers hired had to be single with, at least, two years of teaching experience. Married teachers could not to be hired.

Once the decisions were made, US Steel began making plans to turn a desolate land, near the jungle, into an area that would grow and eventually become home to the company's workers with modern homes. However, before all the work could be accomplished mining camps were set up to house those workers who would be doing the construction work. In February, 1952, the towns of Puerto Ordaz and Ciudad Piar were both established. Workers were hired to cut through the trees, through the dirt and dust in order to develop the area known as Puerto Ordaz which was near the sea port. At the same time, the second town, Ciudad Piar was to be built near the base of the mountain for the workers and their families. The two communities would work together to accomplish the goal of removing iron ore from the mountain and shipping it to the United States.

In September, as the school years started, both Terry and Derry started school in their familiar Ohio schools. Terry recalled that year. "I was to be a Freshman at Clay High School and I had been looking forward to going to high school. Since Mother, Derry, and I didn't didn't know exactly when we would be leaving for Venezuela, not going to school was not an option for us. I was happy to start high school with my friends."

"Dad sent Mother letters telling her everything he was doing and what he thought about living in Venezuela. His letters were sent via Air Mail and written on onion skin paper."

While the family stayed in Ohio, Jack Curran began working in Puerto Ordaz by first hiring several of the railroad men whom he had worked with in Ohio. He also hired men from other states and from other countries who were knowledgeable in their specific field of study. The men he hired would each be responsible for teaching his skills to the Venezuelan worker who would be hired to work and to learn from the North American worker. Several of the men who had worked with Jack in the Walbridge Train Yard agreed to accept a new position in Venezuela and to take their families with them. Not every Ohio person that Jack interviewed agreed to go to Venezuela for a variety of reasons. Many didn't want to take their families to an unknown area next to the jungle. Many did not what their families away from extended family members, friends, schools and the life-style they preferred.

However, several men made the decision to accept a job in Puerto Ordaz and move to Venezuela. In the railroad publication called "TRACKS, CHESAPEAKE & OHIO RAILWAY" the following was reported by William B. Swailes, Correspondent

WALBRIDGE-PRESQUE ISLE
A belated note on the loss of three former employees at
WalbridgeYard, namely, Jack Curran, Ralph Reeder and
Fred Harris. We wish them good fortune in their new venture.

Our loss is the gain of the Orinoco Mining Company of Venezuela, South America, a subsidiary of U.S. Steel. The three have supervisory positions in rail-road operations for that company.

The Curran family had to prepare to move to Puerto Ordaz, Venezuela but how soon would that happen and what would traveling to Venezuela be like for them, Terry wondered.

Preparing *and* Traveling *to* Venezuela

"It was October, 1953 when Dad told us that our house, in Puerto Ordaz, was finished and we could now fly to Venezuela. My mother, Derry and I were ready and anxious to go. Mother had received suggestions from the mining company regarding what she might want to take to Venezuela. She planned to take enough clothes for Derry and me for the entire year thinking we both were still growing and might outgrow some of our clothes or shoes during that first year in Puerto Ordaz. Interestingly, Mother also bought a case of canned black raspberries to take with us. That surprised me because we rarely ate black raspberries. Everything, including our clothes, household goods and furniture would be sent by ship to Puerto Ordaz."

"One of the exciting events that happened to me before leaving Ohio was when my girlfriends had a surprise going-away party for me. Uncle Howard suggested that I might need some pills that would prevent me from getting sick while flying in an airplane. He told me my 4-H leader, Mrs. Schoeder had some medicine that would help and we should go see her, which we did. When we arrived at her house, Uncle Howard said we would need to go to the basement to see her, which we did. However, much to my surprise and delight, when we walked down to the basement, which was, actually a rec room, my friends were there yelling 'Surprise!'. There were no pills, instead there were my friends who had secretly planned a

wonderful going-away party for me. I had never even had a birthday party and now my friends were giving me a going-away party. I knew I would miss those friends but I was getting more and more excited thinking about moving to Venezuela."

The Toledo Blade, the local newspaper, asked Terry's family if they could take a photograph of the families that would be leaving Toledo for Puerto Ordaz, Venezuela. The photo below is of Terry's mother, Terry and Derry, all sitting on chairs. The other individuals are Lucille Reeder, Tommy Reeder, and MaryKay Reeder. The Reeder family would be moving to Puerto Ordaz, Venezuela with the Curran family.

After telling family and friends good-bye, Terry, Derry and their mother left Toledo for Venezuela. The Reeder family traveled with the Curran family which helped make the trip more comfortable for everyone. Flying to Venezuela was a new experience for all. No one in the group had ever flown in an airplane before. Just getting onto the plane was exciting for Terry.

The first leg of the flight was from Toledo to New York City. The first night in New York was spent at The Lexington Hotel. Actually, much to Terry's surprise, as she and the Toledo group were walking through the lobby of the hotel a familiar figure was walking towards them. It was the man they had enjoyed watching on television. His name was Arthur Godfrey. However, the group wasn't pleased when Arthur Godfrey drew near to them and said to one of the young men, "out of my way, kid". Hearing that one comment, Terry changed her opinion of that well known man. Having dinner at the hotel was delightful and seemed like a fantastic experience to Terry.

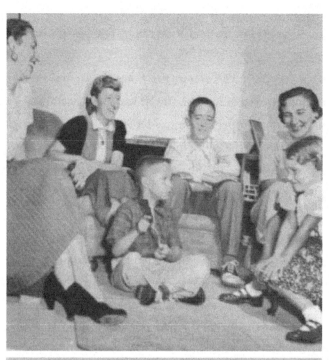

That dinner included the first shrimp cocktail she had ever eaten. To Terry, remembering that dinner and remembering the one vacation the family had ever had, the trip to Venezuela was becoming more and more delightful and appealing to her. It, actually, felt like the start of a super great vacation.

After a good night's sleep at the hotel, Terry and everyone in the Toledo group flew from New York to Caracas, Venezuela. The plane was a Venezuelan Airlines' propeller plane, a DC-3 which meant the noise from the spinning propellers was unending for that memorable thirteen hour flight. Terry commented, "the flight was long but the food was good. Even with the propeller noise, I had no trouble sleeping but it was, indeed, a very long flight."

Eventually, the plane landed in Maiquetía, the airport for Caracas, Venezuela. The airport was officially known as the Aeropuerto Internacional de Maiquetía or the Simón Bolívar Aeropuerto. That airport was opened in 1945 after the American aviator, Charles Lindbergh, suggested that particular location for the airport. During that time, the United States also helped pay for the construction of the airport. Maiquetía is a Venezuelan city near the waters of the Caribbean. The plane had to fly into Maiquetía because Caracas was in a valley surrounded by mountains which meant the plane did not fly directly into Caracas at that time. Jack Curran was at the airport anxious to welcome his family to Venezuela. Without a doubt, Terry and her family were happy and excited to be at the airport to embrace and greet Jack. There was another man with Jack, a man who was fluent in Spanish and English. He was there to guide Terry, her family, and their Toledo friends through Venezuelan Customs. The bilingual man was necessary because questions would be asked in Spanish and had to be answered in Spanish. The Orinoco Mining Company had an office in Caracas that, among other things, provided assistance to new employees who would be working in Puerto Ordaz but who did not speak Spanish. After answering the questions and successfully passing through Customs the next stop was Caracas. Caracas was a twenty mile drive from the airport. Terry recalls

that drive as being one of the most unusual and delightful drives she had ever had. The drive was nothing like a drive in Ohio. "I kept looking out the car window because everything was so different, so beautiful, so bright. I saw mountains, trees that didn't look familiar to me, colorful flowers, bushes, and even butterflies that were unique to Venezuela. I saw birds of different colors and birds sitting in cages on patios and birds flying freely everywhere. I had never seen palm trees in Toledo and the palm trees in Caracas were tall and beautiful. It was all breath taking to me. I was, also, surprised to see so many men in uniform walking around carrying guns. I had never seen that in Toledo. Caracas seemed to be a large modern city, nothing like the undeveloped area where we would be living, according to Dad."

That drive gave Terry a positive feeling about Venezuela. "I loved Venezuela, already. I was dazzled by the many new and different colors. Even the houses that I saw in Caracas were beautiful and colorful. Most of the houses were painted soft pastel colors. Houses were painted light pastel colors because dark colors would absorb the heat and make the house hot, which people didn't want. The feelings I had toward Venezuela were amazing. It was as if I had left Ohio in a black and white movie and entered Venezuela in a technicolor movie. I couldn't get over all the beautiful colors. Already, I was getting excited about living in Venezuela."

Terry and her family had dinner and spent the night in Caracas at the elegant Hotel Tamanaco.

I could hear people speaking but I had no idea what they were saying; however, I loved the sound of the Spanish language. After a good night of sleeping, the next morning the Toledo group rode back to Maiquetía to board the airplane that would carry everyone to Ciudad Bolívar, the next city where they would spend the night. That flight lasted several hours. After arriving in Ciudad Bolívar the family had dinner and spent the night at the hotel in Ciudad Bolívar. By this time, Terry was wondering if they were ever going to get to Puerto Ordaz. Terry and Derry had to share a room at the hotel which turned out to be beneficial since the unexpected

happened. When the two tired siblings turned off the bedroom lights to go to sleep they had an unexpected surprise which Terry remembers vividly, "When Derry and I turned the bedroom lights off, we were attacked by cucarachas (cockroaches) that were all over the room. They were everywhere, dashing here and there, in and out, zipping around as if the bedroom belonged to them. It was unbelievable and something Derry and I had never seen before. Derry and I decided to turn all the lights back on, which we did and that kept the cucarachas away from us because they went back into hiding. We slept with the lights on all night. I was not happy with that experience. That night, I really wasn't certain I was going to be happy living in Venezuela. I liked the colors that I had seen earlier in Caracas but I did not like the cockroaches that invaded our hotel room.

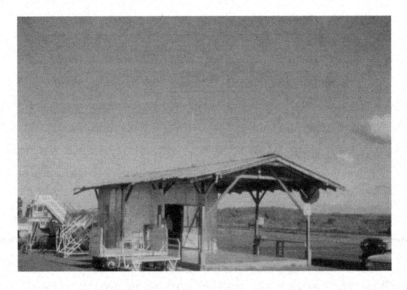

The next morning was the big day. In 1953, there was no airport in Puerto Ordaz. A year later, there would be a runway and a shack which would be the airport in Puerto Ordaz.

Because there was no airport, the family would drive to Puerto Ordaz. Terry and the family were up early because they were, finally, going to get to Puerto Ordaz. Driving a company car, which was a station wagon, over a very dirty, bumpy road kept everyone awake. The drive to Puerto Ordaz took over three hours and the road was definitely not a paved road.

As Terry recalled, "the road was like a dusty washboard, incredibly bumpy mile after mile after mile after mile. There were no paved roads, streets or highways to travel on from Cuidad Bolivar to Puerto Ordaz. At that time, I longed for a paved road as the ride was incredibly uncomfortable."

While driving to Puerto Ordaz, there were checkpoints (alcabalas) or controlled road blocks along the way, which required Terry's dad to stop the car. The checkpoints were manned by the Guardia Nacional (National Guard), military men dressed in uniforms carrying guns. To Terry, this was certainly a very different and unusual sight to see, something she had never seen before. Terry's dad had to show his identification card and explain to the guards that his family had just arrived in Venezuela and they were driving to Puerto Ordaz where they would be living. He told the military men that his family would get their identification cards in San Félix the next day. The Guardia Nacional allowed the family to proceed. As the three hour drive continued, Terry realized that this was not like the drive they had taken from the airport into Caracas. This area was filled with dust and dirt. There were no beautiful pastel colored houses. There was nothing. Nonetheless, Terry and Derry spent most of the drive looking out the car windows just in case they might see something exciting like a jungle animal. Terry and Derry had read about different animals in Venezuela; such as, the capybaras (giant rodents), ocelots (small wild cats), tapirs (a pig like animal), red howler monkeys, jaguars, sloths, armadillos, and others. The two siblings continually looked out the window anxious to see any of the animals they had read about, but they saw none on that long dusty bumpy ride to Puerto Ordaz.

Finally, the family made it. They were in Puerto Ordaz, Venezuela. "When I first saw the town of Puerto Ordaz, I didn't know what to think. Actually, I was extremely surprised. It was nothing like Caracas. It really wasn't a town or city at all. It was just an area near the jungle with two large rivers. There were no paved streets and in 1953, there were very few people even living in Puerto Ordaz. I know Dad had told us there was very little in Puerto Ordaz but I didn't think he meant this little. I couldn't believe we

were moving from Toledo to this small area in Venezuela that appeared to have nothing. Did Dad really think this was going to be a fun adventure? Although we were several hours, by plane, from the large city of Caracas, moving to Puerto Ordaz looked to me as if we were really moving to a wilderness area next to the jungle that really seemed to have very little and, yet, maybe I would learn to like everything that Puerto Ordaz did have. Maybe it wasn't quite as desolate as it seemed. Time would tell."

Actually, as the family continued to drive to their new home in Puerto Ordaz, Terry could see many houses, several office buildings and a hospital, all under construction. Arriving at their new home, Terry was anxious to look inside the family's home which looked much different from their Toledo home.

The house looked comfortable but the biggest thrill for Terry was to discover that she would have her own bedroom with a real bed, a real bed! Not a sofa sleeper bed that she had in Toledo. Having her own bedroom with a real bed made the home in Puerto Ordaz perfect for Terry. She knew she would adjust and learn but she would also love having her own bedroom, her own space. Plus, her mother had already agreed to let Terry choose the clothes she wanted to wear, everyday, while living in Puerto Ordaz. The mining company had provided temporary furniture in the house until the family's household goods and furniture would arrive. There was a washing machine in the house but no clothes dryer, which didn't seem to be a problem since it was apparent people hung clothes outside on clothes lines. "Since we were, finally, in our house, there was not much else to do that day but relax, unpack, and enjoy having the whole family together, again."

The next day, Terry's dad took the family to the neighboring town of San Félix to get their cédulas. The cédulas were the required identification cards that everyone had to carry with them at all times in Venezuela. Once again, the mining company had someone, who was bilingual, go with them to San Félix. To get to the small town of San Félix from Puerto Ordaz everyone had to cross the Caroní River in rickety looking ferry boats, the chalanas.

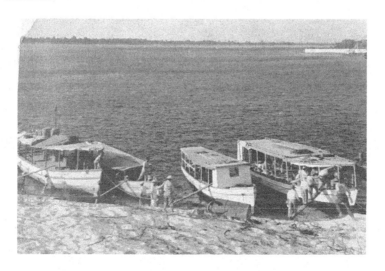

However, people had been crossing the river in the ferry boat for years. Actually, crossing the river in a boat was the only way to cross the river. There were no bridges across the river which meant there was no choice. It would be many years before a bridge would be built. The Orinoco Mining Company was hiring lots of workers and many workers lived with their families in San Félix. Although the company was rapidly building houses for workers in Puerto Ordaz and Ciudad Piar, there still wasn't enough houses in either community for all the workers. Construction continued but, meanwhile, the workers from San Félix continued to ride the ferry back and forth to go to work and to return home, every day.

After crossing the river in the chalanas, Terry and her family arrived in San Félix and went to the government building to get their identification cards. Everyone in Venezuela had to have an identification card, including children. "I must tell you that I didn't have the most positive feeling about San Félix. The buildings seemed pretty rickety to me. I was glad Dad was with us and the bilingual man from the mining company. In the government building, there were many pictures of Simón Bolívar on the wall which meant, I suppose, that many people liked him. Simón Bolívar was the man who had led the fight for Venezuelan's independence from Spain. While we were waiting our turn in the building, which was a pretty hot uncomfortable building, I decided to walk out the front door and look down the street. It was a very dirty street. There were ditches on both sides of the street with sewage in the ditches, very smelly sewage. I saw several wild dogs just roaming around in the street. When I asked about the dogs, I was told that people did not have dogs for pets in San Félix because people thought dogs were wild and did not belong in anyone's home. As I continued looking around, I saw a burro walking down the middle of the street. I called to Derry and, together, we decided to walk towards the burro to get a closer look at him.

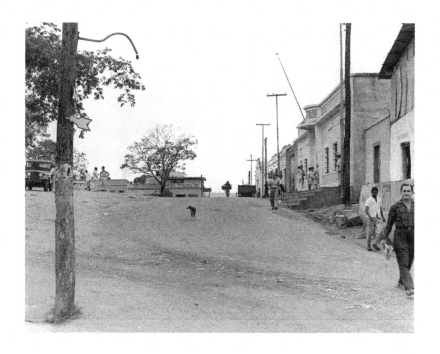

As we were walking, the burro started braying very loudly at us, again and again. Then, because of that one burro's loud braying there were suddenly many other burros running toward us, running and braying. I didn't even know where they came from. They just suddenly appeared. With that, Derry and I ran back into the government building happy to escape those noisy burros." It's likely the Venezuelan men, who were sitting outside and saw Terry and Derry being chased by burros, laughed with great pleasure at the North Americans running from the burros. Terry and Derry also laughed about what had just happened. One of their first experiences in Venezuela.

As the years passed, both San Félix and Puerto Ordaz would grow busier and larger; consequently, in 1961 both communities joined together to become part of the city of Ciudad Guayana. It is doubtful that in 1953, Terry would have predicted such growth for those two communities.

As the family returned to Puerto Ordaz and settled in, they would continue to make observations about about that they were seeing. What kind of observations would Terry make?

Observations *of* Puerto Ordaz

When Terry and family first arrived in Puerto Ordaz, in 1953, Terry said it was like moving to a barren land that had a massive jungle nearby filled with wild animals, rich multicolored birds, vibrant colored trees and flowers unique to Venezuela. "The soil was a reddish orange color. As Dad had said there were no streets or sidewalks. Orinoco Mining Company was, indeed, building a town from nothing. There was no doubt that Puerto Ordaz was very different from Toledo, Ohio. Toledo had a population of nearly half a million people while Puerto Ordaz might have had a few thousand people. I suppose it didn't really matter since I decided I would learn and adjust to my new situation and, hopefully, enjoy it."

Terry's family moved into a house in the B area that the company had filled with furniture, appliances, and most everything needed until their personal possessions arrived. The family lived there for several months while homes were being built in the C area. Once several houses were completed in the C area, Terry and family moved to a new house in the C area. That house would become the family's permanent home for nearly twenty years. The houses in both the B area and the C area were very nice houses with three bedrooms, two bathrooms, a living-room, kitchen, laundry-room and a patio. The bathrooms had showers but there were no bath tubs. Each house had a patio, something Terry's family had never

had before but which they would soon enjoy. The C house was just large enough for a gathering of friends to celebrate various holidays.

The mining company continued building more apartments and homes for its employees. Where you lived, in the community, depended on the job you had with the company. It did not matter if you were from Venezuela or from another country, the criteria was always the same. There were a number of apartments for workers (trabajadores) who were single and had no families. The workers who had families were usually moved into a house in an area known as the B area or the C area. The houses in the B area were comfortable and, over time, there were more houses in the "B" area than in any of the other areas of Puerto Ordaz.

"During our first week in Puerto Ordaz, Mother and I walked to the center of town, the area known as the Centro Cívico, (Civic Center) which was designed and built like the traditional Venezuelan plaza and would soon included a new Catholic church. It was an easy walk to the Civic Center because there were no streets and no cars. The only cars were the company cars or the company trucks. Ironically, most company cars were station wagons or four wheel drive vehicles. The Orinoco Mining Company, often known simply as OMC, had built a commissary that had a variety of food for people to buy. "We had to spend bolívars, not dollars at the commissary. Some of the food was familiar to me and some unfamiliar. Mother knew we would want milk to drink. The milk she could buy was sold in cardboard cartons and seemed thinner than the milk we drank in Ohio. Mother decided not to buy that milk. Instead, she bought KLIM, a powdery substance that has to be mixed with water to make milk. It was easy to remember the word KLIM because it is milk spelled backwards. I didn't care for KLIM except when Mother would add chocolate syrup to it making it much tastier. The one cereal that we could buy at the commissary was Frosted Flakes, which I did like. I ate a lot of Frosted Flakes that first year." "Although we looked, it was hard to find a loaf of bread at the commissary. We learned that the majority of Venezuelan people ate arepas rather than bread. Arepas could be filled with a variety of foods

like shredded beef, beans, guacamole or anything else that was tasty to the person eating the arepas. As the years passed, I would grow to love arepas, especially those filled with black beans and a soft white cheese known as questo guyanés. That cheese would simply melt inside the warm arepas. I learned that arepas are generally made with a base of maize or corn flour mixed with a bit of salt and water, rolled into a ball, flattened, and then deep fat fried."

Terry remembered one important task that was required every day. "We all had to learn to be careful when getting into bed or putting our clothes or shoes on since we were told to check between the sheets, under the bed and under the mattress for centipedes, scorpions, a snake or any bug that might be trying to hide from us. We also had to shake our shoes before putting them on. I quickly learned to give everything a couple shakes before putting on any of my clothes or shoes because it was an absolute necessity. Actually, I didn't mind shaking and checking my clothes and shoes because it just added to the fun and excitement of being in Venezuela. I preferred wearing sandals because, I decided, there would be no place for a creature to hide in my sandals."

Another surprise for the family might have been the toilet paper. That paper was a brown stretchy kind of paper, almost like crepe paper. As Terry was learning, there were many knowns and unknowns in Puerto

Ordaz. There was no post office. Mail was sent and received through the Orinoco Mining Company ship or a company plane, if possible.

Walking to the Civic Center proved to be an enjoyable experience for Terry. "It seemed that everyone we saw, as we walked to the Civic Center were, primarily Venezuelans, who always greeted us with a smile and a friendly word. Consequently, one of the first Spanish words that I learned was 'hola'. I wanted to be able to return the friendly greeting, correctly. I didn't understand what the people were saying in Spanish but I, instantly, loved the sounds of the Spanish words, I heard. The Venezuelan people were so nice. I always felt welcome and I wanted to respond to everyone's cheerful greeting with one of my own. I learned that when walking to the commissary, or anywhere, I should not put a banana in my pocket. I had a banana in my pocket one day, while walking to the Civic Center, and several monkeys came down from the trees trying to grab the banana right out of my pocket which I couldn't believe. That, certainly, was a big surprise." As a result of that experience, Terry often took bananas with her to feed the monkeys but she no longer put a banana in her pocket. There were bananas growing on the banana trees near the Orinoco River which provided the monkeys with a good supply of food.

"I remember while walking to Civic Center, some Venezuelan people would, actually, stop and stare at me. I think it was because of my very light complexion, blond hair and blue eyes which was, certainly, different from many of the Venezuelan teenagers who had darker skin, brown hair and brown eyes. It really was no problem as we all simply accepted one another."

Terry continued to learn more about the two communities that the mining company was building. When you saw the community near the mountain, that was Ciudad Piar. The community near the sea port was Puerto Ordaz. Many of the people living in one community had friends living in the other community with most everyone working together for Orinoco Mining Company.

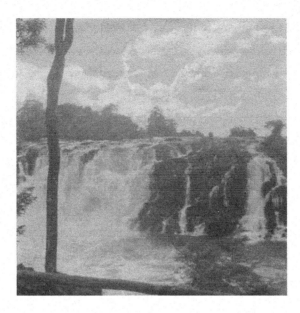

"In my bedroom in Puerto Ordaz, especially during the rainy season, I loved going to sleep at night with the windows open listening to the sounds of the tree frogs. At other times, I remember listening to the calming sounds made by La Llovisna, the beautiful waterfall on the Caroní River.

With my bedroom window open at night, the sound of the waterfall would soon put me to sleep. I loved that sound. "Years later, in 1962, the La Llovizna Waterfall was part of the La Llovizna Park where tourists enjoyed walking as close to the waterfall as possible. Park visitors were cautioned to be aware of the tufted capuchin monkeys, the many snakes including the anacondas, and the variety of spiders that lived in the park. However, a sad event happened the summer when a teachers' convention was being held in Venezuela with three hundred Venezuelan teachers attending the event. One of the tourist sights scheduled for the group was a trip to the La Llovizna Waterfall. There was a wooden bridge that provided visitors a closer look at the falls. As many of the teachers walked across the wooden bridge, in order to have a better view of the falls, the bridge collapsed and the teachers fell into the Caroní River. Falling into the river was dangerous enough but the danger increased with the large rocks sitting on the

bottom of the river that a person could hit hard causing even more imme-
diate damage to a person's body. It was estimated that, at least fifty teachers
died when the bridge collapsed. Everyone was very sad about that disaster,
including my dad because many of the Venezuelan teachers who died were
teachers he had hired to teach in Puerto Ordaz."

"Between the waterfall and the cool breezes that seem to always be
blowing at night, sleeping was very comfortable. There was no air-condi-
tioner in our house or in any other houses in Puerto Ordaz, at that time.
The cool breezes seemed to be enough to keep everyone comfortable"

"As I continued to walk around Puerto Ordaz, it seemed to me,
recalled Terry, that the Venezuelan people I met were very welcoming
and openly affectionate. They seemed to always greet one another with
smiles and hugs which was wonderful to see. I don't remember my par-
ents or grandparents ever hugging anyone when our family would be gath-
ered together for a meal or a family event. That wasn't the custom in our
family. The Venezuelan families seemed to always greet one another with
a smile and a hug, even in public. That was their custom and everyone
seemed happy and comfortable with it. I never did get comfortable greet-
ing someone with a hug and, even today, I am the last person to give a fam-
ily member or friend a hug. It is just not automatic for me which bothers
me at times; especially, when my daughters immediately hug me while I
stand hesitating."

"Because, in 1953, there were no restaurants in Puerto Ordaz
and, certainly, no fast food restaurants, Mother had to cook everything,
Sometimes her meals had to be very creative depending on what food was
available for her to buy at the commissary. Mother did make a number of
changes to our family meals. Learning that black beans were a regular part
of most Venezuelan meals, Mother decided to frequently make black beans
for our family; however, she fixed them her way which meant adding slices
of bacon and brown sugar to the bean pot. Our family enjoyed those beans
as did our Venezuelan friends who were a bit surprised at the different
taste the black beans had because of the bacon and brown sugar. Mother

also cooked many fish meals since our family soon learned to enjoy fishing on the Orinoco River. One fish that was the ugliest but the most delicious tasting fish was the payara, a Venezuelan fish that was new to us but which I learned about on a family fishing trip."

"When we first moved to Puerto Ordaz, in the evenings after dinner, Mother, Dad, Derry and I would often walk around the area. In Ohio, in 1953, we watched television programs together after dinner but since there was no television in Puerto Ordaz, we walked together. Television didn't appear in Puerto Ordaz until sometime after 1973. When we walked, it was usually night time which meant if was dark. Dad would always walk between Mother and me, holding both our hands. We always felt safe but nonetheless we all knew we had to think about the possibility that we could very easily encounter a wild animal, snake, or some other critter on our walk. Usually, we only encountered another family out walking. However, one night, as we were finishing our walk, we saw a beautiful black panther walking near the back wall of our patio. The panther seemed to be out for an evening stroll as it slowly walked across our patio and out of our yard. The panther simply walked away never getting near us."

On one afternoon while out walking Terry and her friend saw, much to their surprise, several capybaras passing in front of them. The capybara is the largest living rodent in the world. It is a large rodent that enjoys being in the river or on the land. The girls stopped, stood still and made no sounds as they tried to ignore the big capybaras walking near them. Fortunately, the capybaras had their own plans since they ignored the girls and continued walking. The capybara is often called the chigüire in Venezuela. The capybara or chigüire can be nearly four feet long and weight over 130 pounds. That is why the girls were happy that the capybaras ignored them. Many families would eat the capybara during Lent insisting they are eating fish and not meat. Eventually, the Catholic Church agreed and in 2011, the Vatican declared that the capybara does qualify as a fish. That announcement meant the capybara could be eaten during Lent with no one needing to feel guilty about eating it.

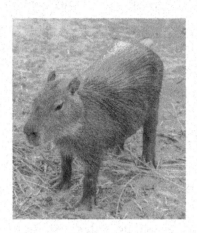

Another time, while Terry and Derry were walking they saw several women washing clothes near the river. They were pounding the clothes with rocks to clean their clothes, after which they would rinse the clothes in the river water. Derry remembered seeing two little boys, who were with the women, just playing together next to the river. Suddenly, a crocodile grabbed one of the boys and pulled him under water. The women screamed and yelled and ran after the crocodile. The women were able to rescue that little boy from the crocodile; however, while the women were rescuing the one little boy another crocodile grabbed the other little boy and took that little boy under water. Although the women tried, they were not able to rescue the second child. It was hard to believe the unforgettable incident lasted only a few seconds.

While walking around Puerto Ordaz, Terry and Derry saw many of the Venezuelan people wearing an unusual shoe they had never seen before. The shoe was black and all, or part of the shoe, was made from rubber collected from old tires. Since most of the Venezuelan people wore those shoes, Terry and Derry were happy to buy a pair and walk around Puerto Ordaz wearing them. The shoe was called the Albagata and looked a bit like a sandal. The first pair of Albagatas that Terry and Derry bought cost one dollar.

Already, Terry was beginning to feel absolute freedom in Venezuela. She felt she could walk anywhere, see anything and do anything without her Mother telling her to be careful, perhaps that was because there wasn't much to do in Puerto Ordaz. Terry was excited to have her first parrot while in Puerto Ordaz. She named the parrot Querido Juan, (Dear John); however, no matter how much Terry tried to get Querido Juan to talk, he never did. Much to her surprise, Terry learned that not every parrot talks.

As everyone was getting settled into Puerto Ordaz, Terry decided it was time to learn more about her Dad's work and what he did.

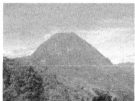
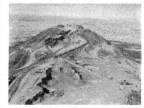

"Dad continued to hire people to work on the mine, on the railroad, on the ships plus other professionals, including accountants, managers, and human resource people. All the employees were needed to make the company perform well. Dad spent a great deal of time interviewing people, hiring people, and explaining to the new workers the expectations associated with the job they were to have. Many of the North American workers came from Ohio, Pennsylvania, Alaska, Louisiana, California plus many other states. The workers from North America were helping to build the middle class in Puerto Ordaz and Ciudad Piar. They were helping to build the Venezuelan workers' skills, the skills needed to carry out the various jobs necessary to accomplish the goal of mining and transporting the iron ore to the United States. To accomplish this endeavor, each North American worker continued to have a Venezuelan worker accompany him and learn the North American man's work. Not only were the North American men working at their jobs but they were also educating a Venezuelan man so that man would understand and be able to do the same job as the North American man. Terry learned that Gabriel was, basically, her dad's understudy. Gabriel and many of the other Venezuelan workers referred to her dad as Señor Joaquin, Mr. Jack. My dad was very happy to be representing the mining company, the United States and himself to the Venezuelan people he met. It was as if he were the unofficial American ambassador to Puerto Ordaz respecting and caring for the workers, their families and the growing community that was to be shared by everyone."

"I would learn, later, that as the mining company grew so did the community of Puerto Ordaz with more and more people working. It looked like life was definitely going to be very different in Venezuela. My dad, seeing the puzzled look on my face said soon Puerto Ordaz would become a city with many people working different jobs for the mining company and other companies. He said more and more houses were being built. One of the goals of Orinoco Mining Company was to create a community where people enjoyed working and playing together. A community similar to what you might find in the States. I could only hope Dad was

right. All this was good but the bottom line to me was that there were no telephones in Puerto Ordaz, no way to call and chat with my friends in Ohio. Dad explained there was, in fact, one telephone in one building in Puerto Ordaz that was only available for emergency calls. I did notice you could see a person riding a horse around Puerto Ordaz since there were no paved roads. The horse could walk wherever it wanted. I continued to be amazed as I adjusted."

"According to my dad, it seemed everyone working for the mining company decided to move to Puerto Ordaz for a variety of reasons. Some people looked forward to being part of a new company, some looked forward to a new experience, some to a new location next to the jungle, some saw an opportunity to be involved in planning and building a new town in Venezuela. There were many opportunities and experiences for those wanting to experience those opportunities. I think, for my dad, going to Venezuela meant an exciting new challenge. He would be the person to see that the many important projects would be finished and would allow Puerto Ordaz to grow. The Venezuelan citizens of Puerto Ordaz were becoming part of a town where the men were given the opportunity to work and to make a better life for themselves and their families, if they wanted to do so. It was a choice each worker had to make."

The men of Puerto Ordaz were learning skills related to management, accounting, shipping, scheduling, mining, and everything else necessary to getting the iron ore off the top of the mountain, into the ships, and off to America.

"One of Dad's primary jobs was to make certain the train tracks were built as required and that the tracks were built correctly, from the top of the mountain down ninety miles to the seaport where the ships would be waiting to transport the iron ore."

"My dad said the men understood the job and worked hard to build the tracks. Much of the material for the train tracks was made by Morrison-Knudsen, an American company, and delivered by ship to Puerto Ordaz

with the workers then putting the tracks together in the right place. I was learning that Dad seemed to understand everything that needed to be done."

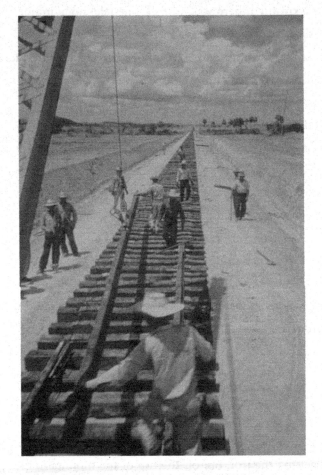

The workers built only one train track which meant someone had to be responsible for making certain there was only one train going up the mountain or coming down the mountain at any one time. To accomplish this challenge, a microwave system was developed which enabled the train engineers and the train dispatcher to know when and if another train would be on the tracks. The last thing anyone wanted was to have train cars carrying iron ore be in an accident. Once the main track was completed and the train cars filled with iron ore, the train could travel down to the

seaport where the iron ore would be transferred to the waiting ships as directed by the Ore Handling Division of the company.

In January of 1954, the very first shipment of iron ore was being sent from Puerto Ordaz to the United States. Before leaving the port, there was a grand celebration with many people including such dignitaries as Marcos Pérez Jiménez, the man who was president of Venezuela, members of the diplomatic corp, and other distinguished guests of US Steel and the Orinoco Mining Company attending the event. Music was played, speeches were given and the work of the North Americans and Venezuelans who had accomplished the necessary work together, was recognized. The New York Times reported on January 10th, 1954 that the first shipment of iron ore from Cerro Bolívar had happened. A bit of history had been made and the people involved were celebrating the work that had been accomplished, by so many, in just a few short months.

As the work continued, the New York Times once again reported on happenings in Puerto Ordaz telling its readers that once Orinoco Mining Company had started processing the iron ore, more companies would soon be moving to Puerto Ordaz. Venezuela was moving forward with plans near Puerto Ordaz to build a sixty million dollar steel mill and a forty million dollar power plant to serve the steel mill. Work was progressing and moving forward for both countries with more workers being hired, more homes being built, and more businesses and services being added to the community.

A detail description of the process needed to mine the iron ore and ship it to America was reported in the local Orinoco Mining Company newspaper that the company created for its two communities, Puerto Ordaz and Ciudad Piar. That paper included work, community, and social information thought to be of interest to both committees which included information about workers as well as their families. Below is a detailed description written in the August 28, 1954 "El Minero" regarding delivery of iron ore from the mountain to the docks with the information provided by a Mr. Fred Harris, General Superintendent at that time.

The ore is hauled by truck from the mining area near the top of the mountain, to the ore-loading dock which is situated approximately two-thirds of the way up the mountain. At the dock the trucks dump into railroad cars at a rate of approximately 25 carloads per hour; 14,000 tons of ore per day. The yard engine crew then pulls groups of 30 cars from the dock into the assembly yard where two trains are assembled; one of 100 cars and one of 120 cars. Before the train leaves for its trip down the mountain, all equipment is mechanically tested; particularly the air brakes which operate on every wheel of the entire train. Each train is handled by two diesel locomotives coupled together to operate as a single 3200 horsepower engine. As the train starts its seven mile journey down the mountain, the Centralized Traffic Control System goes into action. electrically operated colored light signals on the switches of the runaway tracks indicate the setting of each switch at all times. The engineer, conductor and dispatcher at Puerto Ordaz can talk with each other during the entire trip by radio-phone connections. As an additional safety measure two "runaway tracks" are located at intervals on the down-ward trip with switch controls that are thrown automatically if the speed of the train exceed 35 kilometers (21 miles) per hour. If a switch is thrown, the train passes onto one of these sidings where it can be readily brought to a stop. A truly thrilling sight is to watch an ore train crawling down the mountain with the smoke from the brakes enveloping the entire rear section of the train. The trip to Puerto Ordaz normally takes 5 1/2 hours. With the recent heavy rains and relatively new roadbed, higher speeds are not justified and besides, there are no commuter passengers rushing home to dinner. Upon its arrival at the port, the train is split into groups of 25 cars for ease in handling. A yard engine then feeds each group onto the car dumper where the ore continues it travels into the ore handling system."

Terry realized that her dad's job was a twenty-four hour job. He could be called at anytime to help fix a problem on top of the mountain or at the seaport. Traveling up to Simon Bolívar, the mountain of iron ore, meant driving on a dusty dirty road that had very little greenery because

it was too far away from the rivers and the green jungle that was near Puerto Ordaz.

"Derry enjoyed the story Dad told about the crocodiles flying in the air. Apparently, in order to make the waterway deep enough for the iron ore ships to travel, the company had to make certain that the necessary waterway was dredged to a depth of 35 feet to allow the ships, heavy with iron ore, to move safely in and out of the river port. Many of those areas were filled with large rocks which meant blasting had to be done to remove the large rocks. As the men continued the blasting they were surprised one day to see that they had blasted two crocodiles out of the water and into the air. When the crocodiles returned to the ground, the men captured them and sent them to the zoo in Mobile, Alabama where they lived for many years and may still be living there today, I don't know."

Terry and Derry had to learn about the schools they would attend in Puerto Ordaz. Terry learned there was no high school which meant no school for her to attend. Consequently, at the company's suggestion, she took a variety of correspondence courses through the Calvert Correspondence Academy. She took several correspondence courses including Spanish, English, Social Studies, and History. Terry spent many afternoons reading, studying, and answering questions in order to pass the various tests associated with the courses she had taken. Terry wanted to do well with her studies in order to not fall behind her Ohio classmates.

Terry's brother, Derry, was able to attend the small school that the company had arranged for students of the North American workers. Classes were held in a room in the paper barracks. At Derry's school, there were only about twelve students in grades one through eight. The students were all together in the same classroom with two North American teachers. Attendance was taken, grades reported, and books available for the students to read. Derry, an 8th grader and one of his friends, Joe, spent most of their time in the extra room across the hall from the classroom. The extra room had a ping-pong table and a pool table. Other than learning Spanish, Derry and Joe spent more time in the extra room perfecting

their ping-pong skills rather than their academic skills. On the last day of school in Puerto Ordaz Joe arrived, surprising everyone with his parrot on his shoulder. Derry thought that was a great ending to the school year. Apparently, not all parrots are interested in talking but Joe's parrot did talk and bringing his parrot to school on the last day was outstanding and made for a great eighth grade graduation picture, Derry thought.

In 1954 and 1955, the Orinoco Mining Company began the construction of two new school buildings in Puerto Ordaz. One school for the children of the Venezuelan workers and a second school for the children of the North American workers. The Venezuelan school would be a Spanish speaking school. The first classes, for both schools, had been held in the paper barracks. The Venezuelan school had thirty boys, twenty girls and four teachers. That location, in the paper barracks, was temporary until the construction of the new school, Escuela Diego de Ordaz, was completed. The school for the children of the North American workers would be an English speaking school. That school would be called The American School with the highest grade being eighth grade. That meant most North American students would return to a hometown school or attend a boarding school for their high school education. It was said that there were years when the Venezuelan and the North American children would all attend kindergarten together at the Escuela Diego de Ordaz to provide an opportunity for children from different countries to play together and hear other languages before going to separate schools for first grade.

"As my family continued to adjust to life in Puerto Ordaz, it was apparent that Mother was not as comfortable in Venezuela as Dad was; however, she adjusted. When I would go to the commissary with her she often would answer a question in French, the language she had studied in high school. She, eventually, became more and more comfortable speaking Spanish. I continued to enjoy the sounds of the Spanish language. The sound and the rhythm of the Spanish language continued to be music to my ears. Radio was always in Spanish and I loved the Spanish music. Since Mother was not the adventurer that Dad was she went nowhere without

Dad. She continued to enjoy her Ohio friends as they all supported one another while adjusting to their new homes and new environment. In order to help Dad, as he hired new people, Mother often would invite a new family to our house to welcome them by sharing a meal and providing information about Puerto Ordaz and Venezulea."

"With Dad who was always looking for an adventure, it was exciting to go anywhere with him, especially when he was driving and telling Derry and me to keep looking out the window to see if there might be an animal nearby. If either of us saw an animal, no matter what the size, Dad would immediately follow the animal, turn the car around, if necessary, and follow the animal to wherever it was going, which meant we were usually heading into the jungle. Often the animal, like the coatimundi, which I remember seeing several times, would travel a greater distance into the jungle than we could go in the car. I think the coatimundi belongs to the raccoon family. It was fun to see the coatimundi with its long tail and quick movements.

Admittedly, the animals knew the jungle much better than we did. In a car, we could only go so far before we had to stop because the trees were thick and there was no roads to follow in the jungle. There were times when getting the car turned around and out of the jungle was as challenging and as exciting as chasing an animal into the jungle. Dad always told us to keep looking, don't stop looking. He loved to follow any animal as far as he could into the jungle."

Since there was very little to do in the evenings, in Puerto Ordaz, the mining company came up with a plan to show movies. The men built a wooden wall which was set in a field and painted white. Families could

walk to the field with their chairs and watch the movie as many times during the week as they wanted. No one had to pay to watch the movies.

Eventually, the company built an open air theater near the Civic Center. The reason it was called an open air theater is because there was no roof on the building. If you went to see a movie during the rainy season, which was from May to December, that could be a challenge because you now had to pay to watch a movie in that theater and possibly get wet. However, the rains could come quickly and vanish just as quickly. During the movie, young children would walk up and down the aisles selling candy, mints, and cigarettes.

Terry and Derry wanted to go see the two mighty rivers. One river was the Orinoco River (Rio Orinoco). The second river was the Caroní River (Rio Caroní). The Caroní River was blue in color and transparent. The Orinoco River was a yellow brownish color and opaque. The different colors of the rivers were, basically, due to what the river collected as each river flowed along the land picking up dirt, acid, sediments and anything else a river would flow over as it traveled down stream. Since there was dense vegetation near the river, walking to the rivers could not be done. Beside the Orinoco River, there was grove after grove of tall stately palm trees, basically, a permanent rain forest known as the wet lands with the river flowing silently in the middle of it. If you walked south, the dense vegetation would become the jungle. "I learned there was no path to walk beside the rivers because, not only due to the enormous amount of vegetation, there were snakes, crocodiles, scorpions and other critters hiding out of sight ready and willing to attack a walker that shouldn't be in their territory. After learning that, I saw no need to walk to the river. Riding in a boat on the river with Dad was much safer."

The two rivers, Rio Orinoco and Rio Caroní would meet but never flow together. It is amazing to see the two distinctly different rivers just flow beside each other but never flow together. There is a legend related to the two rivers. One river was a male, the other river a female. The two rivers fell in love and wanted to flow together out to the high seas, to the

ocean. However, the rivers were told to stay apart. The rivers listened and, to this day, the rivers meet and touch one another but do not flow together, the waters never mix.

As Terry continued to explore Puerto Ordaz, she learned many Venezuelan families did not sleep in beds but rather slept in hammocks in their bedrooms. The houses that were built by the mining company accommodated this tradition with two large pegs nailed onto the bedroom wall where hammocks could be hung from those pegs. A large hammock would be attached to the pegs and several family members could sleep together crosswise, not lengthwise, in the hammock. Years laters, beds would, eventually, replace the hammocks for many Venezuelan families.

The family house was comfortable but Terry realized that in the warm climate of Venezuela there was nowhere to swim, other than in the rivers. Periodically, Terry and family would decide to swim in the Caroní River. "Mother always worried and thought about keeping her family safe.

Therefore, when we would go the the river, Mother would take a bag of bologna with her. She would throw pieces of the bologna into the Caroní River. If the bologna was quickly grabbed and eaten by the piranhas, we would leave that area and find a different location where Mother felt it would be safe for us to swim. If the bologna floated, so did we. We never swam in the Orinoco River because we were told it was the river known to have lots of crocodiles. In fact the rare crocodile known as the Orinoco Crocodile swims in that river. We did, however, fish in the Orinoco River while staying safely in our boat."

In the summer of August,1954 because there was no swimming pool for the children, several of the dads decided to build a swimming pool between two houses in the B area. The men dug, usually at night after work, and finished the concrete pool in several weeks.

The mining company's local newspaper, "El Minero" included an article about the new neighborhood swimming pool for the children. The children enjoyed the pool and continued to enjoy it until the company built Club Caranoco which included a large swimming pool. When that happened the neighborhood pool was emptied, the hole filled with dirt, and everyone went to the club to swim in the very large swimming pool.

Terry continued to question and learn more about the variety of fresh fruits in Puerto Ordaz, especially mangoes and bananas. Terry knew bananas but she had never eaten a mango.

"I thought the mango was a tasty fruit with a hint of apple and strawberry flavors mixed together. It's a pretty color but the mango's skin will gradually be covered with black spots as it ripens. The mango would be the tastiest when it is completely black."

Carambola was another new fruit Terry enjoyed. It is often called the star fruit. The fruit would grow with about five ridges down the side of it When you sliced the fruit in a cross section, the sliced piece of fruit looked like a star shaped piece of fruit. The raw fruit usually had a fairly tart taste; however, the juice was often bottled and used for drinks.

Mamones were another new fruit to Terry. That fruit is about the size of grapes and to eat it she learned that you must first pop open the outer shell with your teeth which you would have to do carefully since you could easily stain your teeth. The fruit might best be described as a bit tangy and a little sweet, perhaps similar to a lime. Learning about all the new foods was fascinating and enjoyable to Terry as she continued to learn more and more about Venezuela.

"During our first year in Puerto Ordaz, the men could get their hair cut in a room in the paper barracks by one barber. There were no beauty shops where the ladies could get their hair cut. When Maria and her husband moved to Puerto Ordaz, Maria decided to turn one room in her house into a beauty shop where she could wash and cut hair for the ladies. I think everyone learned that since there was, basically, very little to do in Puerto Ordaz, especially in the early fifties, newcomers learned to be self sufficient and to do the best they could with very little; consequently, people developed new hobbies, new interests and learned from one another which might mean learning to play a new card game, trying a new recipe, developing a new hobby, or simply exploring the area surrounded by the rivers, the jungle, the colorful birds and a variety of unexpected animals."

As Terry said, many times, the colorful birds were always spectacular to her and she seemed to be drawn to them.

Terry and the family soon learned that one of the popular Venezuelan dishes was known as Pabellón Criollo which was a combination of

shredded beef, rice, and black beans all served on one plate with, possibly, an arepa and slices of fried ripe plantains all creating a tasty and delicious meal. Plantains are similar to bananas but with a thinker skin and not a fruit to eat raw. The darker the skin, the sweeter the plantains which are then enjoyed sliced and fried.

Because many of the Venezuelan meals contained meat, it was not unusual to see small herds of cattle being raised by a Venezuelan farmer when traveling to Cuidad Piar or to Caracas. One of the largest herds of cattle was at the American, Nelson Rockefeller's family ranch. In the 1950s, Nelson Rockefeller had encouraged America and Latin American countries to work together to provide growth for both countries but especially for the Latin American countries. Nelson Rockefeller formed a corporation that would encourage investors to create businesses to further a country's economy. He set an example by establishing a ranch in Venezuela that had over 6000 acres with the land primarily used to raise cattle. The cattle would produce the meat that would then be sold to the large grocery stores in Caracas. Nelson Rockefeller supported and encouraged the Venezuelan people to provide the food and services needed by other Venezuelan people. He was very much against communism and encouraged independence for the country and its people. On February 26th, 1969, the "Desert Sun", a California publication, reported that the communist guerrilla front in Venezuela claimed ownership of the Rockefeller ranch, its businesses and

other holdings. There was no evidence to support that claim. However, in the early 1980s the Rockefeller ranch was sold to a Venezuelan family. Several years later, the Venezuelan government decided to seize the property by nationalizing it and allowing the owner and family to only keep the main house plus a number of acres around the house. Apparently, the purpose of the Venezuelan government was to divide and distribute the land to individual Venezuelan farmers; however, those individual Venezuelan farmers continued to be challenged due to the lack of supplies available to them. Important supplies like seed, fertilizer, and water. Venezuelans have seen both democracy and socialism in their country, one wonders which they prefer.

"While in Puerto Ordaz, one of our Venezuelan friends suggested to us that if we were in a car driving somewhere in Venezuela and a family of sloths began crossing the road, in front of us, we should stop and be patient because it could take a long time for a slow moving family of sloths to cross the road. A family of sloths could easily stop traffic in both directions as everyone waited patiently for all the sloths to make their way across the road." It is known that sloths don't move very much and they might only travel forty yards, at the most, in any one day. Generally, when a sloth is moving, it is moving slowly because sloths spend a great deal of time stopping and eating leaves, twigs, branches, flowers or whatever else they might find along the way. Terry said that she had not been stopped by a family of sloths crossing the road but that she had seen a sloth hanging upside down in a tree. "A friend of Derry's gave him a sloth that just hung upside down in the tree behind our house. It really didn't do much of anything and rarely moved at all. The sloth is known as the slowest moving mammal on earth. Eventually, Derry decided to give the sloth to a friend who said he needed a pet. Getting the sloth down from the tree took patience because the sloth was strong and had long sharp claws; however, Derry managed. Derry's friend now had a pet and the sloth had a new tree where it could continue to just hang upside down. nimble, and hardly move at all."

Terry noticed the variety of land areas in Venezuela. Traveling up the Simon Bolívar mountain meant driving on a dusty dirty road with no vegetation. The area where the two rivers came together was like a green oasis, greenery everywhere. Living near the jungle area you enjoyed a variety of vegetation, animals, flowers, and birds. Living near the river you were surrounded with many palm trees and green vegetation. The few dry areas were filled with dusty brown dirt, little greenery and few houses. Terry enjoyed the greenery around Puerto Ordaz but knew that many trees had been cut down to build the houses for the workers. Terry was hopeful that workers would soon be planting new trees in Puerto Ordaz.

Terry remembers the first party she attended in Puerto Ordaz. "I was invited to a party during my first year. Most everyone at the party were Venezuelans and spoke Spanish. I was just beginning to learn Spanish and thought speaking Spanish at the party would be a good idea. I told the group that I was somewhat embarrassed that I didn't understand a lot of Spanish but that I was trying. However, in Spanish I hadn't told the group that I was embarrassed but that I was "embarazada" which, in Spanish, means pregnant. I had told them I was pregnant, which, of course, I wasn't. Everyone smiled and chuckled about my mistake as they explained to me what I had really said. I knew I had a lot of Spanish to learn; however,

everyone was nice and made me feel happy to be with them. I decided it was important for me to learn as much Spanish as I could, as soon as I could."

"As the years went by and as I attended more parties in Venezuela, I thought the parties in Venezuela were, actually, much different from the parties that I had attended in Ohio. In Toledo, a teenage party seemed to always have the boys standing on one side of the room and the girls on the other side. There was not a lot of mixing, laughing, and dancing. In Venezuela, from the very first party that I attended, every party seemed to be a family event. From the little children to the grandparents, everyone moved and danced. I had never seen my parents dance in Ohio but I saw them dance many times in Venezuela because dancing in Venezuela was usual, everyone did it and everyone seemed to enjoy it. Parents, teenagers, young children and toddlers all came to the same party, talked with one another, danced together, and enjoyed the music together. That always amazed me. I decided the reason Venezuelan teenagers knew more about what was happening in the world than I did was because they talked and listened to the adults. Teenagers were welcome to listen and participate in adult conversations. Conversations could be about a local event or an event that happened elsewhere in the world, including political events. It seemed that everything was discussed at the parties. I was very impressed. The Venezuelan people made me and my family feel very welcome, even the teenagers were friendly and welcoming to newcomers. I could only describe Venezuela, at that time, as a free and welcoming country, a country I loved."

"On another day, as our family was driving in the car, something unusual happened. Once again, Dad was stopped by the local Guardia Nacional, the men in uniform holding their guns. The official asked my dad if he knew he had just passed a government car. I didn't understand why it was bad to pass a government car. My dad, not being intimated by the question took out his little red book.

His red book was just a bit bigger than a credit card. Dad handed the government man his red book which read 'Upon presenting this card John Curran, as a functionary (agent) of the Guardia Nacional, is given every support to facilitate his tenure (time) of office. The government man read the information in the little red book and quickly handed the book back to my dad saying, 'perdón, perdón, senior'. At that time, my dad and one of the highest Guardia Nacional officials in Puerto Ordaz were good friends. That official was the officer who had given Dad the important red book. Since nothing else was said, we continued on our way. I was certainly glad Dad had that red book with him because uniform men with guns continued to be very intimidating to me."

Terry continued to learn more and more about her dad and what he did for the community they now called home. When someone in the community; such as, the priest at the local church, or a man with the Guardia Nacional, or a worker who needed something Terry's dad was often the person who would be asked to help. "Dad would often have the men who worked in his railroad department help whomever and do whatever they could. One day, when a new family arrived in Puerto Ordaz, with their toddler, they had a house with a backyard but there was no fence around the backyard. Dad, understanding that young children are inquisitive and like

to roam here and there, made a suggestion. He told the father of the toddler that, for a case of beer, he would have a fence built around the backyard in one day which would keep the toddler safe. The man agreed and within a day the house had a fence around the backyard and Dad had a case of beer to share with his men. Community cooperation was very typical."

The Americans who moved to Puerto Ordaz brought their familiar holidays with them. Both countries enjoyed Easter and Christmas holidays. Before Lent began, Carnival was the party that folks attended. Music, dancing, food and drink and costumes were typical of Carnival parties, a festive occasion for all who attended which was then followed by Semana Santa (Holy Week) observed by many.

Terry enjoyed the first Christmas she and her family spent in Puerto Ordaz because it was interesting and very creative. During the Christmas holiday many North Americans would search for a dead tree or large branch in the jungle. The tree or branch would be taken home and pushed into the ground and covered with a gooey mix of Ivory Snow and water. The gooey mix would be spread over the tree branches and decorated for Christmas

generally standing on the family's back patio and decorated with several ornaments or something more creative. Being creative and flexible was an important part of living in Puerto Ordaz. Years later, the mining company would ship live Christmas trees to the Americans in Puerto Ordaz.

"Our family enjoyed seeing the Venezuelan children walking around the Civic Center singing Christmas carols in hopes that adults would enjoy their singing and contribute aguinaldos (gifts) to them, hoping the gifts would be coins. We enjoyed hearing the children singing and we were happy to donate bolivars to them. I only heard the word aguinaldos at Christmas time because I was told the word meant a gift given at the holiday."

"The 4th of July and the 5th of July meant that the Americans and the Venezuelans joined together to celebrate their countries independence. Americans celebrated independence from Great Britain. Venezuelans celebrated independence from Spain. After the clubs were built in Puerto Ordaz there would be bands playing, people dancing, families celebrating together with a holiday on July 4th followed by the holiday on July 5th. It was simply one long holiday that often didn't begin until late in the evening because that's when the music and dancing would begin and would continue for hours and hours. Everyone danced and everyone seemed to love to dance.

It was soon time for Terry and Derry to think about high school. Where they would go?

CHAPTER FIVE:

High School *and* College *in* Ohio

Eventually, as the months passed and the family adjusted to living in Puerto Ordaz, a decision had to be made regarding high school. Since there was no high school in Puerto Ordaz, the question focused on where Terry and Derry should go for high school. Would Terry and Derry return to Ohio or would they, like many other students, attend a boarding school? "As it turned out, my parents thought it would be wise for Derry and me to return to Ohio during the school year. Derry and I felt fortunate to return to Ohio and attend the high school we both knew so well and to be with our friends. Once in Toledo and before I could even begin my sophomore year, the school gave me a battery of tests to make certain I had taken and passed enough correspondence courses to qualify as a sophomore at Clay High School. I was happy that I had passed all the tests. I was now a sophomore in high school and Derry was a freshman at the same high school. Derry hadn't had the same educational experience in Puerto Ordaz that I had; consequently, starting as a freshman for Derry meant he had to work extra hard to pass all his classes. When returning to Ohio and to school, many of my friends asked me questions about Venezuela and I was happy to respond to their questions. The girls asked me what the Venezuelan boys were like. I didn't really know much but I told them that I thought most of the Venezuelan boys were good looking and polite, which they were."

"Our grandparents had moved into our house on Randall Drive which really made me feel like I was just returning home from vacation and going to school. After seeing so many people in Venezuela greeting one another with hugs, I, once again, realized hugging wasn't the customary greeting with my grandparents. A smile and a friendly 'hello' was more typical but we were family and I was happy to be with them rather than in a boarding school somewhere."

While high school was a positive experience for Terry and Derry, there were several challenges along the way. They would be living with their grandparents who had lots of rules to follow which meant there might be ups and downs with the grandparents. "I think it was during the time Derry and I lived with our grandparents that we began to really support and care for one another. We saved arguing for the summers in Puerto Ordaz when we were more independent and free of one another but in Ohio we protected and supported each other."

Traveling back and forth between Venezuela and Ohio for school varied from the usual to the unusual. "Most of us, who were students and whose parents worked for the mining company, could secure a ride on one of the iron ore ships, providing there was extra room for students. I thought riding on one of the iron ore ships with other teenagers was great because we could talk about Puerto Ordaz, play cards, talk about our likes and dislikes about school and enjoy the meals together, on the ship. We also enjoyed playing our 45rpm records including such songs as "Rock Around the Clock" by Bill Haley & His Comets, "Only You" by The Platters, "Sixteen Tons" by Ernie Ford, and "Sincerely" by the McGuire Sisters. Those were just several of the many songs we listened to while traveling on the ship or during the summer parties in Puerto Ordaz. The trip to the States would take about three or four days and everything seemed exciting to me. I had so much to learn from the other students including what their lives were like in their hometown, what they thought about living in Puerto Ordaz, and their thoughts about seeing a town being built from almost

nothing. Of course, we always talked about the jungle and the experiences we each had while adjusting to life in Puerto Ordaz."

"Grandpa's name was Forrest, which meant Derry could annoy Grandpa by calling him Woods and that's what Derry did one afternoon as he and I were washing dishing at the kitchen sink. Derry yelled something like, 'Woods, remember to water the rose bush next to the house'. Hearing that, Grandpa turned the house on both of us, right through the kitchen window, water everywhere which didn't please Grandma but we thought it was pretty funny."

"Eventually, since my parents didn't want my grandparents to have to drive us everywhere and when Derry and I were old enough to drive, my parents bought us a car to have in Toledo. My parents knew we would want to attend basketball games, football games, and other events at school, which was true. My dad came to Ohio just in time to go with me to get my driver's license on my sixteenth birthday. I was ready and anxious to get my license. I passed the test and I was happy. Dad and I celebrated with a chocolate malt. After returning home, I dropped Dad at home and drove several blocks to visit a friend, which I did. On the way home, I managed to hit the curb by our neighbors' house. I lost a hubcap which I didn't realize until that evening when Dad saw the car and asked me about the missing hubcap. I decided I wasn't a perfect driver, just yet."

"During the holiday season, I worked, part-time at LaSalles, a local department store in downtown Toledo. Working during the holidays was always a combination of work and fun because everyone went downtown to do their shopping. It was always fun to be working with other high school students or to see friends in the store shopping for the holidays. At that time, everyone shopped downtown because shopping malls or shopping by mail was not part of life in the fifties."

"One night, Derry and his friend, Dick, decided to help themselves to gasoline from a nearby farmer's truck without asking permission to do so. The farmer saw the two boys and started shooting buck shots at them with many of those buck shots hitting the car door. The farmer called the police. The police came and took the boys to jail. That evening, when the phone rang at my grandparents' house, it was Derry telling them that he was being held in the local jail. Since it was April first, I thought it was simply an April Fool's joke; however, it wasn't a joke and the next morning Derry was brought home from jail by grandfather. I think because our grandparents kept such a watchful eye on Derry and me and wanted to know what we were doing, all the time, doing something fun and different was justified, even when it wasn't. Going back to Venezuela was more exciting to me then going to Ohio to be with grandparents. Venezuela gave me much more freedom to explore and appreciate everything around me. There were no rules which was different from my grandparents who had lots of rules and few smiles. Nonetheless, Derry and I appreciated being with our grandparents because we continued to enjoy being in high school with our friends."

Terry's parents always knew the grades Terry and Derry were earning and how they were doing in school. "One time Mother said to me that she didn't know why Derry didn't get better grades because he is so much smarter than you. I didn't respond because I didn't know what to say."

"I believe we teenagers adjusted to whatever situation we had for school and looked forward to seeing one another in Puerto Ordaz during the summers. We loved sharing stories about our school year, listening to our favorite music and to simply enjoy being together again for the summer. Many of us worked for the Orinoco Mining Company during the summer which was, generally, a good learning experience with a variety of job opportunities.

During her senior year of high school, Terry had to decide if she wanted to continue her education and attend college or look for a job. If she wanted to go to college, she had to decide where she would go. After doing her research, Terry decided she would like to go to Bowling Green State University (BGSU) in Ohio.

Terry had read and learned that the education BGSU offered its students, who wanted to become teachers, was excellent. Terry wanted to be a Physical Education teacher; therefore, PE was her major at BG. "Perhaps, I wanted to be a PE major because my mother made sports look so effortless. Mother was a good swimmer and tennis player and seemed to make both sports look easy, pleasurable, and fun. Being a PE major seemed right for me and I think it was."

One school year, Terry's mother decided to visit Terry at BG. Terry asked her mother if she would like to go to Biology class with her. Terry enjoyed the Biology class and learned a great deal about animals, especially

when she had to dissect an animal. However, the day Terry's mother went to class with her she had no interest in watching Terry or anyone dissect a frog, cat, or any other animal. While sitting in class with Terry, her mother said she didn't know how or why Terry could manage to dissect anything. She couldn't stand the smell in the classroom, which was probably the formaldehyde. Terry's mother couldn't believe Terry could handle the smell and dissect an animal; consequently, because of the smell, Terry's mother left the classroom. Terry reminded herself that her mother was the parent who was the most fearful of everything. Terry had been hopeful that her mother would enjoy being in class with her but that didn't happen. Mother and daughter had two different personalities with many different likes and dislikes. Terry's mother agreed that Father was the adventurer and she was not.

The back and forth trips between Toledo and Puerto Ordaz would continue for several more years. Summers continued to be the most exciting time of the year for Terry and Derry. Each year there would be more people, more buildings, and more activities in Puerto Ordaz. The community was growing and becoming a town. Terry noticed there seemed to be a variety of people with small carts pushing their carts around Puerto Ordaz selling breads, vegetables, fruits or an assortment of homemade items. Since many living in Puerto Ordaz were from a variety of countries, the items that people were selling were often unique and usual which Terry enjoyed.

Terry and Derry both knew that some of their teenage friends would be temporary friends depending on the length of time their parents would be working in Puerto Ordaz. Some employees and their families just stayed for a year or two in order to fulfill a contract or to complete the job they had agreed to do. There were other families that stayed for years and years which presented the opportunity for life long friendships.

When a college friend asked Terry what she and her family liked most about living in Venezuela, Terry gave the following answer without hesitation. "We loved Venezuela so much when we lived there. We always

felt safe and loved the environment. The Venezuelan people were so kind and welcoming to us. While, admittedly, there were different levels of workers, which didn't really matter because families were all working together in an area that was becoming a community with activities and services for everyone. We all respected one another no matter skin color, language spoken, hometown, or the work they were doing. Plus, I loved the colors of the birds, the greenery of the jungle, the unfamiliar food, and the variety of unfamiliar animals. The varied colors in Venezuela were so different from Ohio. I loved everything green or had color from the flowers to the animals to the birds. It was all breath taking to me, especially the beautiful orchids that grew wild in the jungle…wild orchids, I loved it!"

"Once Derry graduated from high school, my parents thought it would be of value for him to have another year of education before going to college. Because his birthday was in December, Derry had always been the youngest student in his class. Therefore, Derry and several friends from Puerto Ordaz spent a year at a military school in the States. That turned out to be a wise move for him. That extra year of education was beneficial and made him a more intelligent thoughtful freshman in college. Derry and I both ended up attending and graduating from Bowling Green State University. I graduated with a degree in Liberal Arts but went another semester to have a degree in education should I decide to teach. In addition to being a PE major, I was a member of the Alpha Phi Sorority. Derry

played college basketball at BGSU and was a member of the Sigma Chi Fraternity. He, also, graduated with a degree in Liberal Arts.

While we both enjoyed our high school and college experience, the summers in Venezuela were even more memorable to us. The question was always, what will we do this summer?

CHAPTER SIX:

Summers *in* Venezuela

By 1955, the Orinoco Mining Company had built several clubs for its workers in both Puerto Ordaz and Ciudad Piar. Terry was most familiar with the two clubs in Puerto Ordaz, called Club Caranoco and Club Arichuna. Club Arichuna was named after a Venezuelan chief. Club Caronoco was a combination of the names of the two rivers in Puerto Ordaz, the Caroní and Orinoco rivers. The two clubs were similar with Club Caronoco having a large swimming pool, small restaurant, two bowling lanes, tennis courts, a pool table, a bar, a library plus one of the club's walls was painted white where, once again, outdoor movies could be shown. Club Caronoco was close to the houses in "C" area. Club Arichuna was in the middle of Puerto Ordaz, near the Civic Center. Most workers knew which club they would prefer for their families and for themselves which was generally the club closest to their home. Terry and her family went most often to Club Caranoco but they frequently went to Club Arichuna because there was always more music, more singing and more dancing at that club, which Terry's parents enjoyed, especially the dancing. There was more Spanish music at Club Arichuna with someone frequently playing the cuatro, the small Venezuelan guitar.

Terry and Derry spent many summer days going to the the area where the club was to be built to watch the men building the club and the

new swimming pool. "In fact, we were at the club on the day the pool was finally filled with water. After the announcement that the pool was nearly ready for everyone to jump in, Derry was the first person to actually be in the pool. I, quickly and gently, had given Derry a sisterly push into the pool. I don't think he cared that I had done that because years later he could always mention, in conversation with others, that he was the first person to swim in the club pool."

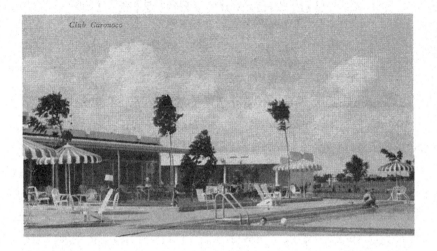

Club Caronoco

"I learned from my parents that a new man, Ray, who was a recent graduate from law school and had been working for US Steel in Pittsburg had read a notice on the company bulletin board indicating there were several new jobs available in Puerto Ordaz. Ray was curious and thought he might be interested in a new job but he had never been to Venezuela. Ray's friends were a bit puzzled and wondered why he would even consider going to Puerto Ordaz, an area considered to be a wilderness at that time. Because of his interest, US Steel sent Ray to Puerto Ordaz for several weeks to consider job opportunities available to him. Ray went to Puerto Ordaz and liked what he saw which included the challenge of being involved in a community that was growing with many unknown possibilities. Ray became a good friend with my family. He eventually met and married Carla and they lived in Puerto Ordaz for nearly twenty years."

A variety of changes were happening in Puerto Ordaz including more houses, more workers, more office buildings, more streets, and more opportunities for the Venezuelan worker. In 1958, while Terry was in college, the six mile road from the center of Puerto Ordaz to the airport was to be paved. The airport had one landing strip and one small shack. It was nothing like the large airport in Caracas. Ray and Carla, who were living in Puerto Ordaz at that time, told Terry what happened when the road to the airport was being paved. They reported that the road was covered with coral snakes, six miles of coral snakes which was an unforgettable sight to see. The question that had to be asked is, where were all those snakes hiding before the road was paved?

In 1958, Vice President Richard Nixon was on a goodwill tour through a number of Latin American countries, including Venezuela. However, there was not much good will towards Vice-President Nixon in Venezuela. As Vice-President Nixon was being driven through Caracas, his car was attacked by an angry group of people who did not like some of the Cold War policies that the United States held. Nixon was not harmed but several of his aides were injured. The good feelings between the United States and Latin America seemed to be diminishing. What had happened? A number of Latin American countries wanted more economic assistance from the United States. Many countries also wanted the United States to help fight communism because they did not want their countries to become communist countries. President Eisenhower did not realize the level of discontent among Latin American countries until a year later, in 1959, when the new ruler of Cuba, Fidel Castro, was a supporter of communism and became a strong leader of his communist country.

When the incident occurred with Vice-President Nixon, Terry and Derry were both in school in Ohio. Terry's dad was against communism and thought the attack had been organized by the communist party headquartered in Caracas. Many changes seemed to be happening in Venezuela including the overthrow of the Venezuelan dictator, who at that time was

Marcos Pérez Jiménez. He had been given asylum by the United States but ended the rest of his life living in Spain, another anti-communist country.

"After going to Ohio for school and returning to Venezuela for the summer Dad had a surprise for Derry. Dad had seen a Lambretta, a scooter, parked in the shack near the airport in Puerto Ordaz. By asking a few questions, Dad found the owner of the Lambretta and was able to buy the scooter for Derry. Of course, Derry loved the scooter and could drive anywhere, which he did."

"One time when Derry was driving his scooter with his friend Joe riding on the back seat, they were riding down the hill towards the center of town. The two teenagers decided there was more activity in the center of town than out in the jungle on that particular day. While driving into the center of town a traffic inspector stopped Derry and asked him for his driver's license. Derry said he didn't have one. The traffic inspector took the scooter. Derry, not knowing what to do at that point, decided to walk to Dad's office. Dad said he would called an official in the Guardia Nacional and explain the situation. The man was a close friend of Dad's who might be able to help. The Guardia Nacional man called the traffic inspector and within a short time, the traffic inspector brought Derry's scooter to Dad's office. I think the Guardia Nacional man knew the good things Orinoco Mining Company and my dad were doing for the Puerto Ordaz community. He was happy to help with the situation."

"Admittedly, Dad was somewhat concerned about Derry and his scooter knowing that Derry would and could go anywhere on his scooter, including into the jungle.

In addition, there were times when the scooter would just stop and Derry could be anywhere when that happened. In fact, that did happen one time when Derry and a friend had to walk from the jungle onto a dusty road until someone came along and could stop to help the boys. Consequently, when Derry returned to Ohio for school Dad had the scooter painted red. Dad decided that by painting the scooter red, if Derry were ever in trouble or lost in the jungle or if the scooter suddenly stopped, rescue helicopters would be able to see Derry's red scooter. A red scooter would be very visible in the green jungle. Admittedly, Derry was an adventurer like our dad so painting the scooter red was a very smart move."

With a red water tower in Puerto Ordaz, a group of teenage boys would often try to climb to the top of the tower. The real challenge would be when a boy from another group of teenagers would pull the safety ladder or rope away from the water tower causing the climber to find another safe way down the water tower. Then the chase would be on to capture the boy who had pulled the safety ladder or rope away from the water tower. The boys, indeed, had to create their own variety of activities in Puerto Ordaz.

"In Venezuela, I soon learned that while living there, I had a choice. I could just socialize with other North American friends or I could learn more about Venezuela, the people, the country, the food, the music, and the customs if I had Venezuelan friends, which is what I chose to do. I was also eager to learn about other countries from friends who moved to Puerto Ordaz from other countries, primarily European countries. Many of the teenagers I met were nationalize citizens of Venezuela as were their parents. Many of their parents had moved to Venezuela from France, Germany, and Italy, especially after WWII. I always wondered what life was like for them and their families before moving to Venezuela, some would tell me, some did not. One of the benefits of being with teenagers, during the summer in Puerto Ordaz, is that we all worked together, explored together, partied

together, and chatted together. It was a great way to learn about other countries and their traditions. Admittedly, we teenagers had lots of parties celebrating birthdays, welcoming friends back to Puerto Ordaz, celebrating the end of a school year or the beginning of summer. Sometimes we gathered together to just eat, drink, talk, and dance together. It was always fun to be together. There was also the realization that friends might be in Puerto Ordaz for one summer but then not be there the next summer. With some teenagers, being in Venezuela was, for them, like being on vacation for a year. While other friends had parents who lived in Puerto Ordaz for nearly twenty years, which included my parents. Learning to accept a friend for a day, for the summer, for a year, or for a lifetime was an important lesson that I and other teenagers had to learn."

"Many of us had heard about the Guaraguao Lagoon and the monster who, supposedly, lived there. Derry and I decided to go to the lagoon one day and look for the monster. We had no maps; however, based on conversations with friends we thought we had a pretty good idea where to find the lagoon. Derry and I felt safe going there even though we only had vague directions to the lagoon. The lagoon was a tidal lagoon which meant water could be held back or released in massive quantities. Directions to the lagoon and landmarks mentioned would vary based on the level of water on any day. The level of the water in the lagoon could vary by as much as 35 feet which meant a landmark visible one day might be under water another day. We knew the general area of the lagoon and we wanted to see the monster who lived in the lagoon. We, actually, found the lagoon and our next step was to see the monster. We waited patiently, sitting quietly in the boat, for several hours waiting and hoping the monster would appear and it did! The monster appeared in the distance. It was far away from us and we could barely see it. Looking carefully, we could see the top part of the monster and it appeared to be grey or white or pink in color. Did I see a blow hole? I wondered. What was that? The monster moved so quickly it was hard to know what it was. The monster appeared to be strong and powerful as it crashed through the water at high speeds, splashing loudly, moving swiftly.

Not knowing if the monster would head towards us, we left the lagoon knowing we could tell our friends that we had, indeed, seen the monster and that we had not been chased or captured by the monster. Descriptions of the monster varied among the teenagers but just seeing it and telling our friends about the monster would be exciting. It wasn't until years later that I heard the the monster was really a whitish grey porpoise that had hurt no one but which explained the blow hole I had seen when I first saw the monster. Being a teenager with a monster story was a great memory."

The mining company offered a variety of jobs to the teenagers who were spending their summers in Puerto Ordaz, which pleased everyone, plus work permits were not required and the jobs varied. Working, exploring, and having parties was fun for the teenagers. Mona, an Ohio friend of Terry's was spending a couple weeks with Terry in Puerto Ordaz. That happened to be during the time when Becky, was having a party, a sock hop, for the teenagers and, of course, all the teenagers and any friends were invited. At her house that day, Becky had moved all the furniture out of the family's living-room so there would be lots of room for music and dancing. Terry, Mona, and Derry, like all the other guests arrived at Becky's house and, upon entering, had to remove their shoes. Becky had learned that the teenage son of the mining company's president had been escorting the Rockefeller twins around town. The Rockefeller twins were spending part of their summer at the family's ranch and exploring Venezuela. Since Becky had invited everyone, the Rockefeller teenagers were also welcome to attend the party. Perhaps, the young men didn't know the party was a sock hop because when the Rockefeller twins, along with the other teenager, arrived at the party and removed their shoes, they were wearing socks that had holes in them. Very few teenagers noticed socks with holes and, realistically, chances are no one cared. The teenagers were more interested in dancing, talking, eating and enjoying the party. Notably, at the party there was a great deal of conversation about the well known Venezuelan prison called the El Dorado Prison. That well known prison was over a hundred miles from Puerto Ordaz; however, the stories about prisoners,

including Papillón escaping from prisons around the world were intriguing but not of great concern until the teenagers learned that a prisoner had recently escaped from El Dorado and might be headed for Puerto Ordaz. That night when Terry, Derry, and Mona returned home from the party their parents were not there. As they walked into the house, they saw the shadow of a man running across their back patio. Was that man the escaped prisoner? They didn't know. Derry, quickly and silently, ran to his bedroom and grabbed his 30-30 hunting gun and returned well prepared should the strange man try to enter the house. The teenagers sat silently watching to see if the man would enter the house, he didn't. When their parents returned home, the teenagers had several stories to tell about the sock hop and the man running across the patio. The day ended well with several memorable stories for one evening.

"On another night, Dad woke Derry up, in the middle of the night, telling him that there was a fight happening down near the sea port and Derry needed to go with Dad to see what it was all about in case they might be able to help. According to Derry, when he and Dad arrived there was, indeed, a fight happening. There was one big guy, a North American, who was trying to fight another guy. Dad tried talking to the big man to get him to stop the fight but the man ignored Dad. Unexpectedly, Dad hit the man hard which knocked him down and that was the end of the fight. We never learned what the fight was about but everyone was glad Dad ended the fight quickly."

While walking around Puerto Ordaz, it was possible to see children kicking a ball back and forth or playing marbles together. However, Dad quickly realized that there seemed to be no organized sports in Puerto Ordaz. Perhaps there were no sports because, before the Orinoco Mining Company started hiring people, the Venezuelan people in Puerto Ordaz may not have had enough money to build the necessary fields and courts for ball games plus the necessary equipment. Many Venezuelan families had no one earning bolivars until the American companies brought jobs to Puerto Ordaz. After being hired by the American mining company,

many Venezuelan families were able do things they had only been able to dreamed about.

Realizing that sports were needed for the workers, Jack Curran was instrumental in getting the young Puerto Ordaz men and women involved in sports. He had the mining company build basketball courts and softball fields so teams could be formed and workers, from various departments, could participate in group games together. After building the basketball court, it unexpectedly, sat empty and unused until Derry and his high school friend, Dick, were in Puerto Ordaz for the summer. The two teenagers, by just playing, appeared to put on a workshop shooting baskets, dribbling the basketball, passing the ball, defending and blocking one another plus making many baskets. That was helpful for the Venezuelan men to see. After watching Derry and Dick and seeing the excitement of playing basketball, many of the Puerto Ordaz men decided they wanted to play basketball and be on a team. Consequently, several teams were formed with a couple teams playing well enough to play against other Venezuelan teams. One Puerto Ordaz team played in the Venezuelan national tournament. The one requirement for the basketball teams playing other Venezuelan teams was that there could be no more than two North American players on the team, which worked out well as more and more Venezuelan men wanted to be part of a team.

Habilísimo en el pase y el esquive y fatalmente certero en sus tiros al cesto, Dick —aquí en una de ·sus intervenciones— convirtió el mayor número de tantos del equipo campeón.

Very skilled in the pass and the dodge and fatally accurate in his shots to the basket, Dick, here in one of his interventions, converted the highest number of goals of the champion team.

Although the photograph above is an old photo, the local citizens of Puerto Ordaz were happy to watch the basketball games and then to read an article about the game in the local paper.

"My dad continued to encourage the young men and women to play basketball. He decided to coach one of the teams. It was exciting when, a couple years later, my dad took one of the teams to Caracas to play in the national tournament. The championship game was actually played in the bull ring in Caracas. A wooden floor had be set in the middle of the bull ring for the game. It was an uneven floor which meant that when the ball bounced it could go anywhere and not always where you wanted it to go. Mother and I sat together to watch the game since Dad was coaching and Derry was playing. Before the game started, there was a band playing. The band was sitting in the stands across from us. We were enjoying the music until, suddenly, the tuba player started to walk down a couple steps and fell. The tuba player and his tuba fell over and over, one on top of the other, making painful sounds which sounded dreadful. After the tuba player received appropriate care, the basketball game began and it was a fun game to watch. However, there was another surprise in the middle of the game when someone had, accidentally, let the bulls out of their pen. The bulls immediately ran for the basketball court and the players. Almost instantly, when one of the officials in charge of the game, saw the bulls running, he hopped into his truck, drove onto the basketball court and told all the players, coaches, and referees to get into his truck immediately in order to get them safely away from the charging bulls. Mother and I were watching all this and very happy that we had decided to attend the basketball game since it was more exciting than we had expected. Eventually, the bulls were back in their pen and the game restarted. Later, as the game continued, Dad was kicked out of the game by one of the referees. Dad didn't like the call the referee had made and expressed his opinion in his usual way, using a combination of English and Spanish words while thrashing his hands and arms about. I'm not certain the referee understood everything my dad was saying because we had been told the referees only spoke

Spanish; nonetheless, I think, the referee knew that whatever my dad was saying wasn't very nice. Dad was kicked out of the game. Dad yelling at the referee reminded me of the times, when we lived in Ohio, and he coached the church basketball team. Before leaving for practice or a game, Mother would remind him not to yell and swear at the referees. I'm not certain Dad paid any attention to Mother's advice because he always wanted his teams to win."

"Another summer, Derry and Wheeler, one of the boys who lived next door to us, played together on the same basketball team. Derry and Wheeler were the two North American players on the Puerto Ordaz team. The team was traveling to San Cristobal in order to play several other Venezuelan teams. San Cristobal was on the other side of Venezuela, several hundred miles from Puerto Ordaz. The team traveled and ate together for a week. After several days of the traditional Venezuelan meals which included lots of black beans and rice, Derry and Wheeler decided to walk around San Cristobal. The two teenagers were hoping they might find something other than beans and rice to eat. As the two teenagers walked around the town and as they rounded one corner, much to their surprise there was a Tastee Freeze. Derry and Wheeler looked at one another wondering if it was true, was it really a Tastee Freeze or were they dreaming. They looked again at the building and the sign and without hesitating, wearing big smiles, the two young men dashed into the restaurant and enjoyed a meal of hot dogs, hamburgs, and French fries.

The two never ate anywhere else that week in San Cristobal. I was told that that particular Tastee Freeze was the only one in South America at the time. It certainly made two North American teenagers very happy; although, the team lost every game they played. Nonetheless, the team was excited because teams from Puerto Ordaz were being recognized and becoming known to other Venezuelan teams."

One summer, as Terry and Derry were to return to Ohio for the school year, they, once again, returned to the United States by riding on one of the company's iron ore ships to Baltimore, Maryland. After arriving in Baltimore and leaving the ship, Terry and Derry went to a rental car agency to rent a car to drive to Ohio for the start of their school year. At this time, neither had a driver's license. The car rental agent asked the young teenagers their ages and if either had a driver's license. Hearing their answers, there was no way the car rental agent was going to rent the teenagers a car. Since neither had a driver's license and neither was old enough to rent a car, Terry and Derry had to figure out another way to get to Ohio. Actually, the siblings were disappointed because it seemed to them they could do anything they wanted to do in Venezuela but that wasn't true in the States. The rental car agent directed Terry and Derry to the nearby bus station. Riding the bus was how they returned to Ohio. Terry didn't mind the bus ride. She felt then and she continues to feel today that life is filled with many learning experiences and she might just as well accept those learning experiences and enjoy them.

As the years progressed, not only houses but streets were being constructed and paved in Puerto Ordaz. One lady living in the "C" area was frequently working in her garden in the front yard. However, while working in her front yard, she was wearing only her bright red bikini. Consequently, the North American in charge of constructing and paving the roads stopped and told her that it would be greatly appreciated if she would stop working in her front yard until after his men had finished paving the road. He didn't want his men wasting time watching the lady working in her garden.

Terry recalls that many years after they first moved to Puerto Ordaz she learned of an area down the hill from Puerto Ordaz called Castillito. "I was told that poor people lived there. My family went there one day. I remember we drove on a paved road, over a bumpy cattle guard and then onto a dirt road. The rest of the drive was simply on a bumpy dirt road to Castillito. I didn't think everyone was poor who lived there because some of the men who worked for the mining company lived in Castillito, especially if they had a large family. Many Venezuelan families lived together which could include, parents, children, aunts, uncles, grandparents, and even cousins. We knew that Romero had built a restaurant in Castillito and we were happy to go there to eat. The beef served at Romero's restaurant was cut differently from what we were use to eating in the States. The meat was super tender. It seemed to just melt in my mouth. It was an excellent restaurant and I loved it. The food was so good that our family went to Romero's many times over the years. My delicious meal cost around one dollar, another reason to love Venezuela; especially, in the early years when we first lived there."

As building of houses and offices continued in Puerto Ordaz, the Orinoco Mining Company also built the industrial area were office buildings were located and large equipment was stored. Major offices included the railroad division, the seaport division, the mining division, the ore handling division, accounting, personnel, legal, transportation and anything else the company needed or wanted to be kept secure. That area was surrounded with a fence and you needed an identification card in order to enter the industrial area. Many of Terry's summer jobs, when she was in high school, included working in one of the company offices where she would work doing primarily, typing and filing. She worked in Personnel Management and the accounting department or wherever else she was needed. "I worked with another girl who was Venezuelan and we became good friends. Actually, I was about seventeen and she was twenty. One day she had a puzzled look on her face and said she wanted to ask me a question. She asked me what happened to the hair on my legs. I told her that

I shaved my legs. Shaving your legs was unknown to her. The next day, I invited her to come home with me so we could have lunch together. While we were home, I took her into the bathroom and showed her how I shaved my legs. From then on my friend always shaved her legs. It was something new to her and a piece of information from her American friend that she, happily, shared with her Venezuelan friends."

Learning to waterski was fun and challenging for Terry. Knowing the Caroní River had piranhas and, supposedly, no crocodiles Terry decided to only ski on the Caroní River. Terry would stand on the skis while the skis were still on the sandy beach. Once Terry was comfortable on the skis and ready to take off, the driver of the boat would pull Terry off the sand and onto the river. Terry would ski on the river for a good length of time. When she finished skiing, the driver of the boat would bring her back to the sandy beach where she could step off the skis and onto the sandy beach happy that she had not fallen in the water. "I only skied on the Caroní River except for the one time when I tried water skiing on the Orinoco River. Derry was in another boat watching the crocodiles that kept popping up out of that water. That one time ended my water skiing career on the Orinoco River."

Terry and the family enjoyed taking a boat ride up and down the river exploring the area. Dad, with the help of his men, built a pontoon boat. He kept the boat in the gated industrial area because launching the boat into the water was easier from that area since it was closer to the water. Summer was the rainy season which meant the rivers were high. Due to the high river, the family boat would not be skimming along the base of the trees but would be skimming pass the tops of the trees. "While in the boat with my parents on the Orinoco River, we could hear the yelling or loud cries from the red howler monkeys. We could hear them but could not see them. The loud cries from those monkeys could be heard as far away as three miles. After hearing those monkeys, I had to read more about the red howler monkeys. I learned they live, primarily, in the upper branches of the trees and rarely travel on the ground. The loud cries from a male

red howler monkey might be to announce his territory and to tell other monkeys to stay away. The sounds from those red howler monkeys was so incredibly loud and piercing; however, I never saw them in the trees, I only heard them."

"On one of our family's first outing on the Orinoco River we did get lost. Eventually, Dad saw a man in his boat not far from us. We were able to get close enough to ask the man for directions. I think the man knew we were lost and pointed us in the correct direction. To thank the man, Dad gave him the only apple we had. The man smiled at us and waved a thank you. We wondered how he would eat the apple since he had no teeth but decided he would just use his machete to cut the apple into pieces. After that experience of getting lost, Mother cut up dish towels and on our next boat trip she hung the towels on the branches of the trees so we could find our way back to the dock and not get lost on the river. She learned to be cautious when reaching for a branch to tie the towel on it because one time a snake fell off the branch and fell into our boat. Our friend Dick and his shotgun were with us. Dad immediately told Dick not to shot the snake because Dad didn't want a hole in the boat. Consequently, as quickly as possible, the snake was carefully flipped out of the boat. Mother decided to cut up pieces of towels to also take with us to mark branches in the jungle, especially when Dad would suddenly be driving into the jungle trying to

follow an animal and having no idea where he was going or how to get out of the jungle. Those pieces of towels were very helpful and often kept us from getting lost."

"On another fishing trip while heading out to a favorite fishing spot, Terry's parents passed a man, wearing a straw hat, who was fishing and traveling along the river in his log boat. The boat resembled a canoe. It was likely the man had made the boat himself after gathering enough logs from the jungle. After fishing and heading back to shore, Terry's parents saw the log boat again but this time there was no fisherman in the boat. They only saw the man's straw hat floating on top of the water. No one knew what had happened to the man and that was scary."

Fishing continued to be a favorite family activity. As the family was fishing one summer day, Terry's mother caught a very large dog tooth fish known as the payara, which the family took home for dinner. "Actually", recalls Terry, "the fish was delicious but it was a very ugly fish. My dad thought it was the biggest and the best fish he had seen in a long time. He decided to have the fish's head mounted on a wooden plaque as a gift for my mother. Years later, when I was teaching Spanish in Florida I had that plaque in my classroom. When I was getting close to retiring, I told my students that if there was anything that I had in the room that they would like, they would be welcome to have it. One student, who didn't really like Spanish and who never said a word in class, came up to me after class and asked if he could have the plaque with the fish head. I told him that he certainly could and if my mother knew he had it, she would be thrilled and happy to know he wanted it. Several years later, when I saw that student, I asked him what he had done with the plaque. He told me that the plaque was still in his house over the family's television set. From that same fish, my dad removed the otoliths, the ear stones found in the head of a fish close to the brain, and had a necklace and a pin made for my mother using the otoliths from the fish she had caught."

"When Mother baked fish for dinner, the fish was always good and I enjoyed those meals; however, when Derry and I were in Ohio with grandparents, they would have fish dinners for family and friends but they left the bones in the fish which, I thought, made the fish hard to eat. I preferred fish without bones."

"I think Mother enjoyed the boat rides and fishing with Dad since she rarely went anywhere without Dad. She was always a fairly cautious fearful person. I remember when I was young, she would tell me, every time I would go outside to play, to be careful. She would give me a quarter if I didn't stumble or fall down while outside playing. Years later, as a physical education major in college, I learned how to teach children to fall safely, a skill I would liked to have had when I was a child." Does telling a child to be careful everyday cause the child to be fearful of doing anything that's exciting and challenging or might that child become brave and experiment on her own?

"I do believe my parents were happy living in Venezuela. They enjoyed the climate, the jungle, the animals, flowers, trees, and the many new friends they had made over the years. Each day the unusual and unexpected might happen, you just never knew and that's why Venezuela was exciting to our family. It was required that my parents and other Americans had to return to the States once a year to maintain their United States citizenship and that was important to everyone." It seemed that the Venezuelan people were comfortable greeting and working with the Americans who had come to work in Puerto Ordaz. The Venezuelan people saw the Americans building

a town with homes, schools, churches, entertainment, sports, a hospital and clubs for everyone to enjoy. There was one Venezuelan man who felt that Terry's dad and the mining company had worked hard hiring people to do the work required to get the iron ore off the mountain and down to the ships while providing the workers with a new comfortable community that was affordable and enjoyable, something many of the workers and their families had never had. With those thoughts in mind, the man went to Terry's parents' house to see her dad and to say thank you. He took the family a gift. The gift was a live chicken and, as soon as Terry's dad opened the door, the chicken quickly slipped into the house squawking and running around. Although Terry's dad appreciated the thank you gift, Terry's mother was happy to see the chicken run through the house, out the backdoor and into the yard.

"One summer, the vegetable man, who rode around the community selling his vegetables gave Derry a three-toe toad, an animal I had never seen before but just another unusual animal in Venezuela. I always looked for a variety of different animals like the jaguar which was interesting and unique to me. A friend of mine had a baby jaguar but only for a short time. My friend and her family had planned to take the jaguar to the States but the jaguar unexpectedly died. I don't know why it died but I often think it must be hard for any animal who wants to run and be free to live in a cage."

"Another day a stranger, Dominic, came to our house looking for a job with the mining company. My mother answered the door and told Dominic that he needed to speak to my dad who was working in the backyard. Dad was working in his garden. Dominic walked to the backyard to speak to my dad. Dad always had a towel around his neck because he said that he had to sweat out the beer he had been drinking. Dominic stood and watched my dad working in the garden and then ask Dad about a job. While asking about available jobs, Dominic made several suggestions that would make Dad's garden grow bigger and better vegetables. My dad liked Dominic's suggestions and instantly hired him to work for the mining company and to work helping Dad with his garden. The garden grew

and grew until I, personally, thought it was huge. I didn't know of anyone else in the neighborhood who had a garden. Dad had brought seeds for his garden from Ohio, plus friends would often bring him seeds from other hometowns. Dad and Dominic worked well together and worked hard caring for the garden. Dominic would send money to Anna, his wife in Italy, until Anna had enough money to join Dominic in Puerto Ordaz. After Anna arrived in Puerto Ordaz, Dominic and Anna lived in the apartment that was connected to our house. Some people in the C area houses used their apartment for servants. Since we never had servants we were happy to have Dominic and Anna live in that apartment. Anna didn't cook for us but it was exciting when once a week Anna would make Chicken Cacciatore. One of the most delicious meals I had ever eaten. In later years, when I had my dog, Red Boy, Anna would always save some of the Chicken Cacciatore for Red Boy. I think Red Boy loved the meal as much as our family did."

Realistically, some people thought the C area was the wealthier area of Puerto Ordaz. However, Terry's father didn't see it that way at all. Terry recalls what happened one day when she went to see a friend. "I had gone to the hospital to see a good friend who had emergency surgery. I was visiting her as was another friend Joe, a Venezuelan. At that time, my family had just moved to the C area and Joe must have heard that because he said to me, 'how does it feel to be living up on the hill with all the rich people?' I walked out of the hospital and walked to my Dad's office crying, yes, a teenage girl walking and crying. When I told Dad what had just happened he drove me back to the hospital and made Joe apologize. Dad did not believe we were better than anyone else in Venezuela and he wanted Joe to know and understand that. I very much appreciated Dad doing that for me. Actually, our C house was not much bigger than our B house but the C house was on a larger plot of ground which meant we had a bigger backyard for Dad's garden and we were not quite as close to our neighbor's house, those were the only differences."

While visiting her friend in the hospital, Terry learned most doctors in the hospital were Venezuelans including a number of German and Hungary doctors who had moved to Venezuela after the war and were now naturalized citizens of Venezuela. Terry did not see any American doctors at the hospital, at that time. All the American employees of the mining company and their families were required to return to the United States once a year in order to maintain their citizenship. The North Americans were residents of Venezuela and citizens of the United States. It was usually during the annual visit to the States when many American families arranged to see their personal physician for a yearly check-up but the Puerto Ordaz hospital and medical staff were always available, especially for emergencies.

Since Terry's dad was against communism and expressed his feelings verbally, both Terry and Derry wondered if their dad might have a connection to America's CIA (Central Intelligence Agency). The two teenagers didn't know, for sure, and their dad never talked about it; however, one summer when their dad had to go to Chicago for what seemed like a mysterious trip, they were both thinking CIA. Was the CIA located in Chicago? They didn't know. Why go there? Realistically, working for the mining company, helping build and coach various teams, tending to the garden, being a dad, husband, friend left little time for the CIA; nonetheless, the teenagers continued to wonder but never asked. It wasn't until years later at a Venezuelan reunion when both Terry and Derry actually learned the reason their dad went to Chicago. It was to look, review, evaluate, and possibly purchase new train engines for the mining company. There was no connection to the CIA.

"I think Dad's salary was probably average when we lived in Ohio. After moving to Venezuela, his salary must have been above average because my parents didn't seem to worry as much about Derry and me going to college, the family traveling back and forth to the States and having extra spending money. The reason I believe that to be true is because we did so much more in Venezuela than we had ever done in Ohio. The mining

company paid the United States employees in both dollars and bolivars. A percentage of an employee's salary was paid in dollars. Those dollars were sent to the employees' bank in their home country. The remainder of the employee's salary was in bolivars to be spent in Venezuela. With that procedure, workers had the correct money to spend in both Venezuela and in their home country."

Hearing the story and learning about Angel Falls was amazing and exciting. Terry and Derry learned that Angel Falls is twenty times taller than Niagara Falls and that Angel Falls is the tallest or highest uninterrupted waterfall in the world. With more research, Terry and Derry learned that in the 1930s, the falls were seen by outsiders, including the American pilot Jimmie Angel. After seeing the falls, Jimmie Angel, in 1937 returned to the falls with his wife and two friends. Jimmie tried to land his plane on the top of the mountain in a flat area known as the mesa, but the wheels of the plane were damaged and quickly sunk six feet into the mushy muddy wet ground on top of Devil's Mountain. Jimmie Angel and his three companions were stranded and they had to spend the next eleven days walking through the dense jungle before reaching another human being. History records that Jimmie's plane stayed on top of that mountain for thirty-three years before finally being lifted out of the wet ground by a helicopter. As the years passed, tourists were eager to visit the Angel Falls, named after Jimmie Angel; however, Angel Falls is in an isolated area of the jungle and there is no easy way to get to it.

Next door neighbors and their children, along with Terry and Derry, made the trip to Angel Falls during the summer of 1958. As they flew close to the camp where they would be staying, the pilot flew the plane sideways so the group could see Jimmie Angel's plane that was still visible and stuck on the mountain. After the plane landed safely, the group had to walk to Camp Canaima, where they would be staying. Camp Canaima would be their base camp for a several days. Derry knew several teenagers who worked at the camp during the summers. The camp was in the jungle. There were tin shacks with aluminum roofs that were partially open,

girls in one shack and boys in the other. At least, the shacks provided a place where people could sleep at night. Everyone had brought a sleeping bag and snacks and were comfortable until Terry, in her sleeping bag, had a rat run right across her sleeping bag and scurry back into the jungle. The group was, indeed, camping in the jungle. There was a small food shack and a couple horses. Derry decided to get on one of the horses and that horse immediately took Derry to the food shack that had a thatched roof. Derry was tall enough so that as the horse entered the food shack the thatch roof knocked Derry off the horse. If need be, Jungle Rudy was ready to lead the group to the falls. Walking through the jungle to see Angel Falls was a challenging hike but worth every step of the way when the group actually saw the magnificent Angel Falls. The falls were greater than anyone could have imagined and the beaches around the falls were pink in color.

Derry and a couple of the guys decided to kayak on the fast moving water that flowed over the nearby Canaima Falls; however, since the water was moving so rapidly towards the falls the guys realized they had to jump out of their kayaks or they would go over the falls. They swam to the side of the river where they were safe. Jungle Rudy didn't need to rescue

the guys but he had rescued several young men who were caught in the same situation.

"While in college I, frequently, had to give a speech on various topics for my speech class. I was pretty scared about giving speeches. I, usually, focused on something interesting about life in Venezuela. During those years, the fifties and sixties, I think people were becoming more aware of Venezuela, especially since President Kennedy visited Venezuela in 1961 and President Betancourt of Venezuela had visited President Kennedy in 1963. I learned in my speech class that I would give a better presentation when I would speak about something I really liked. One of my most popular presentations was about Angel Falls. Most of my classmates were surprised to learn that Angel Falls, at 3212 feet is twenty time higher than Niagara Falls at 165 feet.

The day we returned home from seeing Angle Falls, Terry learned there was a dinner scheduled for several of the men from the mining company, including Terry's dad. The dinner was to be held on the company yacht. "I didn't even know the company had a yacht. The yacht was named The Virginia which was the name of the wife of one of US Steel's top executives. Dad said our family was also invited to the dinner which was exciting because I had never been on a yacht before and, as it turned out, it was the first time I ate Baked Alaska."

Periodically, someone important would visit Puerto Ordaz, someone like the president of US Steel or Clark Gable, a well known movie star. For several days, everyone in Puerto Ordaz was talking about the well known zoologist, Marlin Perkins who hosted an American television program called "The Wild Kingdom". His love and care for animals was well known including his experience as the Director of Chicago's Lincoln Park Zoo and the St. Louis Zoo which is why he was invited to Puerto Ordaz to help with the animals that could easily be flooded out of their homes or could possibly loose their lives as the new dam, the Guir Dam, was being built. The government of Venezuela was building one of the world's largest and the second highest hydroelectric powers plants which required the building

of the Guir Dam. When Marlin Perkins arrived in Venezuela, he knew that, as the power plant and dam were being built over 20,000 animals had already been rescued and saved but there were many more animals needing to be rescued. Where animals once lived on the land, that land was now covered with water and known as Lake Guir. Animals as the peccary (boars), pumas, monkeys, snakes, otters, porcupines, ocelots, howler monkeys, jaguars and other animals were all in need of being saved. The animals needed to be transported to dry ground away from the dam and the lake. Marlin Perkins, with the help of others, including the director of the Caracas Zoo, helped with this effort. The Guir Dam started construction in 1963 and was completed in 1968. The Guri Dam was built as part of the hydroelectric project necessary for Venezuela to reduce it dependence on fossil fuels. The Guri power plant is one of the biggest power plants in the world . The plant, the lake, the dam and all the animals needing to be rescued were only twenty miles from Puerto Ordaz. Many of the people living in Puerto Ordaz, who treasured the animals, were pleased that the United States and Venezuela were working together to save the animals. "The Wild Kingdom" featured the rescue of those animals on two of its programs which can still be seen on the internet.

Soon Terry and her friends discovered the pipeline that brought water from one of the rivers to Puerto Ordaz. The teenagers learned that the pipeline provided a narrow pathway through the jungle and the jungle was everywhere, behind the houses, behind the club and behind the school. Finding a new pathway to the jungle was an important discovery.

There were a couple weeks when someone was breaking into the unoccupied houses in the C area. The houses were only unoccupied for a short period of time as more families continued to move into Puerto Ordaz. The Orinoco Mining Company had prepared and furnished houses for new arrivals until the ships bringing personal family household goods would arrive. A burglar was busy taking various items from the house; such as, furniture, silverware, appliances, and even a bed which seemed puzzling. Consequently, one night, Terry's dad and another man decided to

watch several of the houses to see what was happening. They saw the man who was stealing from the houses and they recognized him and chased after him. The man was running along the pipe line but made a turn into a wild pineapple patch. He was one of the company workers. When that man showed up for work the next day covered with scratches from the pineapple patch, he was fired. Stealing from the company that had hired him was not a smart thing to do plus it was disappointing to everyone else.

On another day, as Terry was riding in the Jeep with two friends, Danny and Dave. They drove on the main road of Puerto Ordaz, when it was still a dirt road. "Suddenly, standing in the middle of the road was a huge iguana, at least a four foot tall iguana. Instantly and without hesitation, the two guys stopped the car, jumped out and because they were fast runners, thought they could catch the iguana. The iguana saw them, stretched tall, looked at the two guys and disappeared like a flash into the jungle. There was no way Danny and Dave could have caught that iguana but they thought it was fun to try. Iguanas are capable of running 20mph. With that speed the iguana was able to dash back into the jungle before Danny or Dave could even get close to it."

"One time when my dad had a meeting in Caracas, there were people, perhaps protesters, yelling and shouting in the middle of the street. Some had even turned cars over. Dad had a meeting to attend and had no time to waste; consequently, he put his head out the window of the taxi and yelled, 'fuera de mi camino, muévete' which meant, 'get out of my way, move on' and the people did. Another expression that my dad enjoyed shouting in such a situation was 'Viva La Patria' which meant 'Long live the Homeland.' Maybe the people moved because of my dad's loud voice or because they were surprised at an American man yelling at them. We never knew."

One summer when Derry and his friend, Burley, were working for the mining company in the River Department, they had a job on the barges. The men on the barges had to make certain the waterway, the navigation route was deep enough for the heavy iron ore ships. It was important to make certain all the buoys were in the right location to guide the ships into

port. Derry and Burley were to clean each of the buoys that were along the 180 nautical miles from the port to the delta, where the ocean began. There were lots of buoys to clean but it was a good summer job. One day as Derry and Burley were nearly back to Puerto Ordaz where food and friends waited, a call came to the captain of the barge indicating that there was a broken buoy that needed immediate attention. The barge turned around and the two young men had to travel back another ninety miles to do their job. Friends and food had to wait for another day.

Derry had several other interesting summer jobs including working in the company warehouse, organizing all the machinery parts for the mining equipment. Another summer he worked in a small building where he handed out various Caterpillar parts to the workers needing them.

When working in the parts building, Derry saw a car hit a donkey that was just walking down the unpaved road. The donkey walked to the building where Derry was working. Derry, seeing the wound on the back end of the donkey immediately poured a large amount of antiseptic lotion onto the donkey hoping the lotion would heal the wound. The donkey yelled and screamed and quickly ran off. However, several days later the donkey returned to see Derry. The donkey's wound had healed.

"There were so many different and unusual experiences for everyone in Puerto Ordaz. Although I attended school in Ohio, there's no doubt in my mind that I grew up in Puerto Ordaz. I loved the people I met and the freedom I had there. I think Derry and I had a great feeling of freedom growing up in Venezuela, during the time we were there."

But, Terry had to wonder what her next step would be after graduating from college.

CHAPTER SEVEN:

Teaching *in* Puerto Ordaz

After graduating from college with a degree in Liberal Arts, Terry wanted to also graduate with a degree in education. To fulfill the requirements for her education degree, Terry completed student teaching during the fall semester at BGSU which then ended her college education. After finishing, Terry considered joining the Peace Corp. However, Terry's mother was upset that Terry would even consider joining the Peace Corps. She asked Terry to please return to Venezuela before making that decision which Terry did. Terry decided to return to Puerto Ordaz thinking she might be able to get a job working in one of the mining company's offices or as a lifeguard, both jobs she had enjoyed during her summers in Puerto Ordaz. As it turned out, shortly after arriving in Puerto Ordaz, Terry was hired to be a life guard at Club Caronoco's swimming pool. While on duty at the pool, Dan Alcalá, principal of The American School stopped by to see her. "Dan asked me questions about my education and wondered why I was working at the pool rather than teaching somewhere. He then asked me if I would be interested in teaching at The American School in Puerto Ordaz for the next school year. I, immediately, said I would be very interested as long as I didn't have to teach math. I was a bit surprised that he even asked me because it was my understanding that teachers had to have, at least, two years teaching experience before they could be hired to teach at

The American School. When I mentioned that to Dan, Dan said that the number of years I had been living and growing up in Puerto Ordaz were as meaningful or more meaningful than two years of teaching elsewhere. Perhaps Dan was right because; although, I attended school in Ohio, there's no doubt in my mind that I grew up in Puerto Ordaz. I loved the people I met and the freedom I felt in Venezuela. Once again, I remembered all the rules Derry and I had when we were younger and living at home in Ohio and we had none of those rules in Puerto Ordaz. Dan said he wanted me to be the Spanish and Physical Education (PE) teacher. I would teach Spanish and Physical Education classes in the morning and swimming to all classes in the afternoon. I thanked him several times. I was happy because soon I would be teaching at The American School in Puerto Ordaz, perfect! Without a doubt, I was excited"

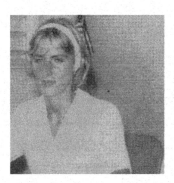

Before the school year began, like everyone else, Terry had to fly to Pittsburgh, to the US Steel headquarters to sign papers indicating she had agreed to teach in Puerto Ordaz for, at least, two years. Following the meetings at US Steel, Terry flew from Pittsburg to Miami, Florida on her way back to Venezuela. Terry wanted to do some shopping in Miami since Puerto Ordaz had no department stores and she would need a variety of clothes for teaching since she would be teaching several different kinds of classes. After arriving in Miami and checking into a hotel, Terry spent the entire day shopping and spending money on clothes. Terry felt she was spending more money than she had ever spent before and that was before her first paycheck, which was a bit scary to her. Prior to this shopping

trip, Terry's mother had shopped and paid for all the clothes Terry needed. While shopping was somewhat enjoyable, when Terry finished shopping she returned to her hotel room and threw up. Her unusual shopping trip was more taxing on her than she expected. The next day she returned to Venezuela and was looking forward to the beginning of the school year in Puerto Ordaz.

In the fall, the school year started and teaching was exciting for Terry. When in college and after completing student teaching, Terry felt teaching was perfect for her. Teaching was what she enjoyed doing, very much. At The American School she taught Spanish to the upper grades and PE to all grades. Terry taught swimming, in the afternoon, to all students. During her first year of teaching, she lived with her parents and adjusted to her new role as an elementary school teacher. While walking to school, there were only two streets with houses on them and only seven houses on each street in the C area. Many students would be coming from the B area and the B area seemed to be the fastest growing area. Actually, all of Puerto Ordaz was growing. The Orinoco Mining Company, in their quest to make employees and families comfortable in Venezuela, continued to build more homes in Puerto Ordaz, encourage more businesses to open, and within a couple years they had built a golf course next to the jungle hoping everyone would feel as comfortable in Puerto Ordaz as they did in their American or European hometowns.

While teaching, Terry had no official parent conferences. Terry and the parents of her students knew one another well enough that they could discuss a students' abilities, both positive and negative, through casual conversations on a walk or while attending a party together.

Several years earlier, in the summer of 1956, there had been a plane crash that involved many of the Toledo families who were flying to Venezuela to live in Puerto Ordaz. The plane was a Venezuelan plane, LAV, (Línea Aeropostal Venezolana). Shortly after takeoff in New York, it crashed into the ocean killing everyone on board. Terry remembers how sad her dad was when he learned so many lives had been lost. Those were

the families of the men he had hired, men who were working for the mining company in Puerto Ordaz. Terry remembered that crash and because of it when teaching swimming to the older students she taught her students life-saving skills which included treading water in the swimming pool, fully dressed, for a lengthy period of time plus swimming numerous laps across the pool. The students had to swim the number of laps that would be required to swim across the Caroní River and make it safely to the small town of San Felix. That was a significant challenge for the students. Terry discussed, with the mining company's river department, the actual distance needed to cross the Caroní River. That information would allow her to determine the number of laps students had to swim across the pool, should they every need to swim across the river. One mother wasn't too happy about the swimming challenge; however, when her son, Matt, left Puerto Ordaz to attend boarding school, on the very first day of high school he and the other students were taken by boat to the middle of the lake, told to jump in the water and swim to shore, if they could. The mother was amazed and pleased to learn that Matt was one of the only students able to swim the required distance. Matt's mother proudly visited school to thank Terry for teaching her son the life-saving skill that he had needed and had learned from her.

As Terry often said, you never know what's going to happen on any one day. Things happen just the way they're meant to happen. For example, Terry was on a field trip with many of her students when it started to rain. She was wearing the watch her parents had given her at college graduation; however, with the rain starting to fall, Terry took her watch off and put it in her back pocket. While she was standing, a little old lady bumped into her which didn't bother Terry until, Martin, one of her students, ran up to her and told her that he saw that little old lady take Terry's watch right out of her pocket. Martin chased the lady asking for Terry's watch back. The lady gave Martin Terry's watch which he returned to Terry. Terry said that little old lady was, indeed, a little old lady but a very clever little old lady.

As Terry walked around Puerto Ordaz, she could see the mango trees that had been planted everywhere. For years, Terry's dad had encouraged the mining company to plant the mango trees in Puerto Ordaz because so many trees and vegetation had been cut down in order to have space for houses to be built. Jack knew having mango trees would allow food to be available for everyone, even for the people who did not work for the company. The company liked the suggestion and planted many mango trees all over the community. The mango is a sweet fruit with a large seed inside. The mango is a good source of vitamins and minerals making it a healthy fruit for everyone. It is also a fairly fast growing tree that can produce fruit several times a year. The color or the ripen fruit varies between yellow, gold, or orange and can be eaten alone or chopped and mixed, in a variety of ways for such dishes as salsa or salads or just to drink the mango juice.

Terry continued to believe it was the mining company that brought workers to Puerto Ordaz, paid them well and built a middle-class of Venezuelan people. A middle class was growing and developing which had been unusual in Puerto Ordaz because so many families lived in poverty and had no work to allow them to move out of poverty. With work available more families could enjoy having a home and being able to buy the food they needed and perhaps, share home and food with their extended families. There was no doubt that life was becoming more enjoyable for the families in Puerto Ordaz. The Spanish speaking school for the Venezuelan children was getting larger and larger which meant the Orinoco Mining Company was continually building and increasing the size of that school for the Venezuelan children. As it turned out, The American School remained the same size.

Of course, teaching for Terry meant preparing class work for the children in all eight grades, checking student's work, and encouraging students to learn while doing their best. Periodically, such preparation could be accomplished in the teachers' lounge. There were, approximately, 14-20 students in each class up to and including the eighth grade.

As a project for her students, Terry was able to get enough empty oil cans from the mining company to give an empty can to each of her students. With a large supply of paint, the students painted the oil cans a variety of colors, with many students adding drawings or words onto their oil cans. The students enjoyed that project and were happy to take the cans home to be used as the family's garbage can or to donate the painted can to the town for everyone to use. It was a very useful project for the students and a meaningful use of empty oil cans.

Another unique assignment that Terry gave her students, who were learning Spanish, was to read about a Spanish artist and then select and copy a painting that the Spanish artist had created. The copy had to be the students own art work. At first, students thought that was an impossible assignment until they began to discover it was a very interesting and challenging assignment. The paintings were to be posted at the club's art show and possibly sold. Terry recalled that one student had created and painted her own copy, or impression, of Picasso's painting "Old Guitarist". Terry thought that painting was so well done she wanted to buy it; however, the student's parents were happy to keep the painting for their family, which was understandable.

Going to sleep at night in her parents' house meant she loved sleeping with the windows open and listening to the frogs singing, especially during the rainy season. Terry was well aware that her dad really enjoyed having and working in his garden. He had a small garden in Ohio, and a much bigger garden in Venezuela. "Dad said that when he retired to Florida he would also have a garden and would dry a lot of papaya seeds and plant papaya trees because it was another fast growing tree and he looked forward to sharing the fruit. After planting the papaya seeds and caring for them, a person would have to wait six to twelve months before the tree would begin to produce fruit. The fresh fruit could be given to friends or sold, whatever the gardener decided to do. The redder the papaya, the sweeter the fruit.

Although, Terry always felt safe in Venezuela there was one incident that caused her dad great concern. Terry saw a map showing the neighborhood houses but, for some unknown reason, Terry's family's house had a large X on it and Terry didn't know why. She asked her dad about it. Her dad said the X was simply on the map to show which house was their house; however, Derry learned the real reason for the X. Apparently, there was a group of young men who planned to kidnap Terry. That is why, on one particular night when the kidnapping was suppose to occur, a group of men from the Guardia Nacional were standing on top of the family's home, guns loaded and drawn, ready to attack anyone foolish enough to try to kidnap Terry. The kidnapping never happened and the Guardia Nacional expected that no one would ever try a kidnapping again. Terry never learned about the possible kidnapping until years later when Derry told her the correct story that he had heard from their dad; therefore, Terry continued to feel safe and secure living in Puerto Ordaz. Terry's dad did not like communism and did not want communism to rule the people of Venezuela so he fought communism with his words and kind deeds that supported the free citizens of Venezuela. However, there were a number of Venezuelans who supported communism and wanted only communism for the Venezuelan people. Was that the reason for the possible kidnapping? No one knew then and no one knows today.

During her first year teaching in Puerto Ordaz, Terry bought a horse which she named Escarpin, a Spanish name that basically means booty, because it appeared as if the horse had white socks or boots on each leg. When first riding her horse, Terry rode bareback but eventually ordered a saddle out of the Sears & Roebuck catalog so she could either ride bareback or with the saddle. Terry enjoyed riding the horse, as did her mother. Terry, eventually, gave Escarpin to her mother and bought Dooley for herself. Terry always felt that it was the horses who taught her to ride because she had no previous experience riding a horse. Dooley would soon become her favorite horse. Dooley seemed to be such a smart horse and seemed to understand when he needed to take care of Terry. "There were times

when I rode Dooley using a saddle and sometimes I would just ride bare-back. Thankfully, Dooley was skilled at moving just right so I wouldn't fall off when riding bareback. It was amazing but true that nothing spooked Dooley. With Dooley, I could ride through the jungle heading to the Caroní River. Sometimes we would travel on a familiar path and sometimes we would just slowly walk through the jungle as Dooley stepped between the bushes, trees, and any vegetation or critters resting on the jungle floor. He was such a comfortable horse. Walking though the jungle to get to the river was very relaxing because Dooley would simply step his way, care-fully, through the jungle recognizing there was no rush."

"Trying to be helpful, Derry and his friend, Tommy, volunteered to build stalls for the two horses that Mother and I had. Tommy was driving the truck and Derry, was leaning out the window of the truck with the jack-hammer to pound the fence posts deeper into the ground. Suddenly, a part of the jack-hammer flew off and hit Derry in the chest which he didn't immediately realize. However, when Derry stepped out of the truck and saw the blood all over his shirt and spilling onto the ground he knew he had been hit. Seeing that, Tommy rushed Derry to the hospital where Derry received emergency care and a number of stitches. After that, Tommy drove Derry home. Mother was having a group of ladies playing cards that after-noon on the back patio when Derry arrived home. When Derry walked in, with his bloody shirt, Derry said he would never forget the amazing and puzzled looks that the ladies gave him. The ladies were all concerned so Derry told them about the accident and that he was fine. It seemed to me that whenever Derry went anywhere, you wanted to be around when he returned home because something always interesting or exciting seemed to happen to him. I believe my mother grew to enjoy the adventures of liv-ing in Venezuela more and more even though there were times when not knowing what adventure Derry might be having or what critter he might decide to bring home caused her great concern, but we all adjusted."

"While teaching, I decided my students, who had horses, might enjoy being part of a horse show, something for which I had no previous

experience. I encourage the students to bring their horses to school where we would practice for the show after school, which we did for several weeks. I bought ribbons to decorate the horses' tails. We had a maypole that would connect the horses and riders. I bought more ribbons that would glow in the dark plus blue lights. The show would be across the road from Club Caronoco allowing family and friends to watch the horse show. It turned out to be a great event and, I believe, students enjoyed the practice and presenting an actual horse show for the community."

"There was a day when Dooley saved me from a sunstroke. I was tired and worn out from helping my students prepare for the horse show and it been a very hot day. Gradually, I was able to mount Dooley and simply hang on to his neck as he gently took me back to my parents' house. I think Dooley simply decided where I needed to go. At my parents' house, where I rested and relaxed, I soon felt better. I knew I had to ride Dooley again to get him back to the stable and to get my car. Once again, Dooley seemed to know just where to go as he gently took me back to the stable. Interestingly, when I bought Dooley I was told that he was a horse that might be a bit rough because he had thrown other riders; however, that was not the Dooley I knew. He was a gentle horse that I was happy with and I always enjoyed the time when I was with him. While riding Dooley, we would often go through the jungle to the Caroní River where we could walk into the river knowing there were no crocodiles in that river to bother Dooley or me. During the Christmas holiday, I rode Dooley, with others while Christmas caroling. I was very comfortable Christmas caroling on my horse, something I had never done before. It was exiting, relaxing and very special to me."

Terry spent time helping her dad decorate several apartments for potential employees visiting Puerto Ordaz to decide if they wanted to stay, work there, and bring their families to Venezuela. At her dad's suggestion, Terry was able to purchase a number of items, at the Civic Center, which were typical of Venezuela and which would make the apartments more interesting and inviting to visitors. "It seemed to me," said Terry, "that the

mining company invited potential employees to visit for a couple weeks to allow those possible employees an opportunity to decide if a move to Puerto Ordaz would be comfortable for the employee and for the employee's family. I thought that was a smart move since not every person would be comfortable moving to an unfamiliar country with their family."

"When I was ready to begin my second year of teaching in Puerto Ordaz, I thought it would be time to move from my parents' home and into one of the apartments the mining company had built for single teachers. The company provided houses and apartments for workers and there was no rent to be paid, as far as I knew. Moving to my own apartment seemed like a good idea because I knew I was missing out on getting to know the other teachers, being involved in adventures and parties with them and even learning to smoke cigarettes with them. However, because I was moving out of my parents' home, several of my parents' friends, both North American and Venezuelan friends questioned why I would be moving out of my parents' home since that wasn't typical of families in Venezuela. Families in Venezuela were happy living together for as long as possible. It was especially true that young women usually lived with parents until the young women were married. I had a strong family bond but decided it was right for me to make the move and become more independent, which I did."

"After moving into my own apartment, I decided it would also be good for me to have my own car to drive back and forth to school and to explore more of Venezuela. Plus, there were now several paved streets in Puerto Ordaz. I wanted to buy my car in Ohio since Derry was still in college in Ohio. Derry said he would be happy to select a car for me, which he did. I flew to Ohio and learned that Derry had selected a white convertible for me, an Austin-Healy. He was happy to show the car to me and to give me instructions about how I should drive the car. I listened and feeling fairly knowledgable about the car, the next day I drove it to my dental appointment. However, on the twenty-five mile drive back to Derry's apartment I realized that I didn't know everything I needed to know about

my new car. As a result, I was driving the twenty-five miles back to Derry's apartment in the rain in my new convertible with no top. I had no idea where the top was located or even how to put the top up on that car. Just basic information that Derry forgot to give me. Consequently, I learned more about the car and soon my car was on one of the iron ore ships heading for Puerto Ordaz."

"Earlier that summer, I had met my friend Glennda in Ohio. Her dad, who was in the car business, had asked Glennda and me to drive a car to California for him, which we did. After arriving in California, Glennda and I flew to Hawaii where we were going to take scuba lessons. While in Hawaii, I saw a beautiful ring that I really wanted to buy but not certain I had enough money to do so. Looking at the ring, a second time, I bought the ring that I loved and still wear it today. However, after spending my money for the ring, I wondered if I would have enough money to return to Venezuela. I did make it back to Venezuela and was happy to be in Puerto Ordaz for the rest of the summer. Shortly after returning to Puerto Ordaz, I went to Club Caronoco to swim where I stopped to greet several friends sitting together at one of the tables. Those friends introduced me to a young man I did not know. His name was Musuí and he lived with his uncle, a local doctor, in Puerto Ordaz. Unknown to me at that time, Musuí would be the man I would, one day, marry.

When Terry and her car were back in Puerto Ordaz, as was Derry, Derry borrowed her car to go for a ride. "When Derry returned my car to me, he told me while out driving he suddenly saw, in the middle of the road, a huge boa constrictor. Stopping the car and seeing no movement, Derry realized the boa constrictor was dead. Derry picked up the dead boa constrictor, put it in the trunk of my car and drove to his friend Tim's apartment. Tim shared the apartment with another friend, Larry. Larry was well liked by everyone but also known to drop by anyone's house and stay for days without being invited. Larry was also known for enjoying food. Larry had asked Derry to bring him some vegetables from Dad's garden. Before Larry returned to the apartment, Derry and Tim decided to

put the dead boa constrictor into a big old grocery bag so Larry would think it was a grocery bag full of vegetables. As expected, Larry walked in, saw the grocery bag and wondered what was in it. Derry reminded Larry that he had asked for vegetables from Dad's garden. Larry quickly opened the grocery bag; however, when he saw the huge boa constrictor he immediately fell backwards onto the floor, shocked! Derry and Tim were laughing hysterically because, for once, they had fooled Larry. Guys are interesting and Derry's experiences in Puerto Ordaz were, in many ways, very different from mine. Derry was just more adventuresome that I was. In fact, on another day, Derry and Tim were walking around a burned out area of the jungle, an area that had been blackened by fire. As the two boys were walking around the burned area, Tim almost stepped on a large anaconda. Either the anaconda quickly slithered away and avoided Tim's foot or it was dead. The boys, not knowing which and taking no chances, dashed away from the anaconda only to walk back and realize the ana-conda hadn't moved because it was, indeed, dead, one dead snake."

"As the school year began, I met a new friend, Audrey. Audrey had come from New York to teach in Puerto Ordaz. Being in Venezuela was a new experience for her. Her father was a judge in New York City and her mother was from Scotland. Audrey, accepting a teaching position in Puerto Ordaz was a surprise to her family. Like many others, Audrey had answered a newspaper ad asking for teachers to work in Puerto Ordaz. She went to Pittsburg to be interviewed by US Steel and committed to teaching for at least two years in Puerto Ordaz. Audrey taught in The American School where she and Terry soon became good friends.

Terry introduced Audrey to her parents. Terry was a bit surprised when her dad suggested, in the course of the conversation, that if Audrey wanted to drive around Puerto Ordaz she might consider keeping 100 boli-vars, about $30, tucked under the sun visor of her car. That way, if she hap-pened to be stopped by one of the Guardia Nacional men she might be able to share the dollars with them and go her merry way. Terry was surprised at her dad's suggestion because he had never made that suggestion to her

but, perhaps, the Guardia Nacional knew that Terry and Derry were Jack's children and Jack had a positive relationship with the Guardia Nacional.

Terry was very happy to be friends with Audrey because Terry thought Audrey was pretty carefree and the kind of person who wanted to enjoy Venezuela by having experiences that were new and unfamiliar to her. Audrey lived in an apartment just below's Terry's apartment, where all the single teachers lived. While living in her apartment, Terry acquired her first macaw. "I've had a number of birds throughout my life which I have always enjoyed. I quickly learned that macaws are very friendly and the macaws that I have had would actually give me a hug, using their feathered wings for hugging. My first macaw was a blue and gold macaw that I named Sig. Derry was a Sigma Chi and the Sigma Chi colors were blue and gold so I thought Sig was the appropriate name for my blue and gold macaw.

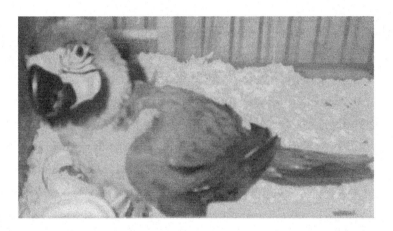

Actually, Derry wanted to take Sig back to college with him so Sig could live in the fraternity house; however, I told Derry that Sig would never be comfortable living in the cold winter weather of Ohio. Sig stayed with me in Venezuela in my teacher's apartment. The apartments were stacked on a hillside. My apartment, on the hillside, was higher than Audrey's apartment. If I wanted to chat with Audrey, I could just step outside and call down to Audrey who would hear me and answer. After hearing me call Audrey a number of times, Sig started to call her. Sig, would walk onto the patio, and yell, 'Audrey' in his loud macaw voice, which he

did, frequently, imitating me. After a couple weeks passed with Audrey answering Sig, Audrey called me and suggested that since we now had telephones, I should use the phone when I wanted to chat with her. Knowing we would use the telephones, Audrey could now ignore Sig calling her. In addition to calling Audrey, Sig also enjoyed sitting in his cage on the front patio where he could chat away. His cage was just outside my front door. At times, Sig would jump out of his cage, walk in the front door, flap his wings, walk right over to see me and say 'hi'. He enjoyed imitating a variety of words and sounds including the sound of my washing machine, which was a surprise."

There were other times, when Terry would be driving in her car, the convertible, and Sig would be happily riding along with her. He never flew away from Terry. Actually, Sig was busy saying 'hi' to the people he would see. At times, when Terry would be brushing and grooming her horse, Sig, sitting on the nearby fence, would carry on his own conversation happily chatting away by imitating words and phrases he had learned from Terry. Sig was very good at talking and imitating Terry. Of course, if anyone walked by, Sig would shout a loud greeting to them. Sig was a very happy and enjoyable bird.

Audrey was eager to learn about Venezuela and was happy to know that Terry had Venezuelan friends, not just North American friends. Audrey wanted to be part of and learn more about the country of Venezuela and the citizens of Venezuela. Audrey bought a horse that she learned to ride and would let her horse lead the way through the jungle, just as Terry did. Eventually, Audrey decided a motorcycle would be fun and easier to care for than the horse. She could more easily go anywhere and everywhere in Venezuela. Realistically, it was true that many Americans only socialized with Americans but that was not what Terry had learned from her dad. Her dad had socialized with everyone, Venezuelans, Europeans, and North Americans. Terry did the same. "First of all," said Terry, "there were Venezuelans representing a variety of skin colors and I was comfortable with everyone. Plus, I had the feeling that in my past life I was black and

had lived in Africa. I remember looking down at my feet and my feet were black and I was wearing sandals. Interestingly, I have always worn sandals, never shoes. I believe I was a nun in my earlier life. I think between reading my dad's books and the comments about an after life, I felt it to be true that I had been a part of a previous life. I know that not everyone agrees with me but it's the way I feel and that feeling has affected my entire life in various and unusual ways. I don't think Mother or Derry had the same belief; however, one day, years later in Florida, when Derry was looking for a particular car he wanted to buy, a car like my dad use to have. Derry couldn't remember the model of the car until one day he called to tell me that he had a dream and in the dream Dad had told him exactly the kind of car Derry should be looking for which surprised and pleased Derry."

"I remember when Audrey and I flew to Caracas one weekend to watch the Eartha Kitt show. Eartha Kitt was a popular American singer at that time. Audrey and I looked forward to attending her show the two nights we would be in Caracas. We were staying at the same hotel where Eartha Kitt was staying so Audrey decided to write a personal note to her. She wrote her note after seeing Eartha Kitt's first performance. Audrey, in her note, asked Eartha Kitt to sing a favorite song of ours the next night. She also mentioned that we were both teachers in Puerto Ordaz. She wrote the note and slipped it under the door to Eartha Kitt's room, the room the desk clerk said was her room. We never knew if she received our note but she sang so many of our favorite songs the second night, we were happy. I always wondered if the desk clerk had really given us Eartha Kitt's correct room number or if he had just given us a room number so we wouldn't bother Miss Kitt."

It seemed that Terry's family, including her parents, continued to be very happy living in Venezuela. The family had all made new friends in Puerto Ordaz, friends from the United States, friends from Europe and most of all, friends who were native Venezuelans. It appeared that the people who worked for the mining company enjoyed the challenge of their work, the opportunity to be part of something new, the opportunity to

learn about Venezuela, including the people, the traditions and the customs. There was no doubt, people all cared about one another.

Terry commented, "Venezuela had good vibrations for me. Every day was different, exciting, and you never knew what would happen that day or what you might see, I loved it."

However, there was concern in the United States regarding Venezuela and communism. In the Senate's Congressional Record of February 25th, 1963 "Senator Hubert Humphrey expressed his concern that the Communist party has now occupied Cuba and that they are trying to do the same in Venezuela with a torrent of intimidation, violence and terror. Senator Humphrey stated that an attack on Venezuela by the communist would not be tolerated by the US. The current government of Venezuela supports private industry and social services for its people. With the help of the United States Venezuela will survive."

During that same year, in the fall of 1963, the publication titled, "Venezuela Up-To-Date" the leader of Venezuela, President Betancourt, was asked about the threat of communism in Venezuela. He responded, "if the Communists have been so hostile to my regime, it is not only for international reasons but also because we are carrying out the type of social action that strips the Communists of support and followers." In that same publication, it was learned that a bridge would soon be built over the Orinoco River and the the cumbersome ferry boats would no longer be needed . However, the prediction was that it would take three years to build and complete the first bridge, across the river, with the expectation that Orinoco Mining Company would build the bridge. The first bridge would begin to be built, at least ten years after Terry first arrived in Venezuela and traveled across the river in one of the rickety looking but sturdy ferry boats.

Carla and Ray, two friends of Terry's were married and went to Caracas for their honeymoon. The couple were in their late twenties or early thirties; however, it appeared they weren't old enough to enjoy dinner at an elegant restaurant in Caracas by themselves. Upon entering the

restaurant the manager wouldn't seat them because the couple had no chaperone with them. They were told they couldn't dine in the restaurant without a chaperone. The tradition of having a family member as a chaperone was genuine; therefore, the couple could not be seated. The couple left but returned the next night with a family member and were allowed to enter and enjoy a meal in that elegant restaurant. Ironically, the age of the couple didn't matter, a chaperone was needed and required. As Terry said, "families were important to Venezuelans and I loved that."

"The number of birds that flew around Venezuela amazed me. There were toucans, parrots, macaws, of every color, plus the national bird of Venezuela which was the black and orange colored troupial. The birds seem to always be flying freely and I loved seeing those beautiful birds."

In addition to birds flying freely, many families in Venezuelan kept birds in cages inside or outside their house in order to listen and enjoy the sounds of a favorite bird.

One summer, 1964, Audrey invited Terry to go to New York City with her. Audrey's parent lived in New York City. The girls were going to the World's Fair which was in New York City that year. Audrey's parents, with a car in their garage, insisted the girls take a cab and not drive a car in the city. Terry found that somewhat amusing because just a couple years earlier Terry and several friends had driven a car from Ohio into New York City and down to the docks. Once arriving at the docks, Terry had switched cars with one car going to Venezuela and the other car returning to Ohio. No one had told the Ohio girls, that they couldn't drive in New York City so it was a surprise when Audrey's parents said not to drive the car in the city. The freedom that Terry experienced and enjoyed in Venezuela stayed with her no matter where she was or what she was doing; however, she respected Audrey's parents and the girls only took cabs in the city.

Another summer when Terry was teaching, Derry and his friend, Dick, returned to Puerto Ordaz on one of the iron ore ships named the Ore Chief. Derry and Dick brought a new puppy with them. "It was an Irish Setter puppy that we named Red Boy. They also brought several hunting guns that my dad and other family members had used when hunting in Ohio. Dad had taken Derry and me hunting with him one time in Ohio. Dad was friendly with several of the high ranking Guardia Nacional officers who worked in Puerto Ordaz and the guns were to be a gift for one of Dad's good friends. Dad decided he should keep one of the guns to protect the family from an intruder or a dangerous jungle animal, neither of which ever happened. When the ship with Derry arrived, Dad told Derry to stay onboard and he would bring his friend with him to accept the guns. The puppy, Red Boy, was more exciting to me than the guns. When we first arrived in Puerto Ordaz, it didn't appear that the Venezuelan people had dogs for pets. Some families might have a couple dogs tied up in their yard to act as guard dogs but not in the house. Every now and then you

would see packs of wild dogs; however, as Americans brought their pets to Puerto Ordaz, the Venezuelan people, that we knew, seemed to be more comfortable with the idea that dogs could be a family pet. Although, our family called the dog Red Boy the Venezuelan people referred to him as Muchacho Rojo. Red Boy was great and able to please everyone he met. Of course a puppy will often do puppy things and Red Boy was no exception. As I returned home from school one day, Red Boy had chewed all the toilet paper in the bathroom plus my new book titled, 'How to Train Your Puppy.'"

"Thinking about our new Irish Setter puppy reminded me that my dad always had an Irish Setter, sometimes he had two. I know that he had a Red Boy and a Red Girl for many years. He loved to tell us one of his favorite stories about Red Boy. When Dad was hunting, in Ohio, Red Boy would be with him because Irish Setters are hunting dogs and good at detecting and pointing at the birds necessary for the hunt. One day, before Dad started hunting he noticed that Red Boy was limping. After checking, Dad removed a thorn from Red Boy's paw and then off they went into the field looking for birds. Red Boy was suppose to stop, freeze, and point when he saw the birds; however, on that particular day Red Boy went charging into the flock of birds, scattering the birds everywhere. Dad was not happy with that behavior. He called Red Boy. Red Boy knew he had done something wrong. Consequently, hoping for sympathy, Red Boy came walking back to Dad very slowly and limping very carefully; however, Red Boy was limping on the wrong foot so he didn't fool Dad at all. Red Boy was a clever dog."

"Dad's Red Boy, in Toledo, also enjoyed roaming the neighborhood where he would find small wrapped packages of butter on a neighbor's porch. The butter was placed on the porch, along with milk delivered by the milkman. Red Boy would happily bring the butter to our house, still wrapped. Red Boy did that several times until the milkman followed Red Boy to our house and my parents had to pay for the butter that Red Boy had stolen. Each Red Boy has his own personality and have always been great pets."

"In Venezuela, our new Red Boy was a busy puppy who grew and enjoyed meeting people and exploring Puerto Ordaz. He was never on a leash which meant he could roam freely. There was a bus that drove into our area taking people to their jobs in the industrial area or to bring service workers to the C area to do various jobs at several houses. Red Boy was happy to hop onto the bus and ride along with the passengers. No one objected. After completing his run, the bus driver would bring Red Boy back home and drop him off at my parents' house where he would stay or walk to my school, find me, and get comfortable sitting under my desk or just enjoy being with my students and me. I think few people had ever seen an Irish Setter which made Red Boy pretty unique. He was a hero to one family when, as he was a bit older, he barked enough to scare an unfamiliar person away from a neighbor's house. That unfamiliar person was a burglar. Sundays were special. Red Boy would wait patiently outside Anna's door, only on Sundays, while she prepared one of his favorite meals, the chicken cacciatore."

"As Red Boy grew bigger, I would, sometimes, take him, in my car, to the river. At the river we would often meet a German couple who had had, at one time, their own Irish Setter. They were always happy when I had Red Boy with me. We all would just talk and swim in the river together. I value the joy a dog can bring to me and to others."

After having taught in Puerto Ordaz for several years, Terry was asked what she would say to prospective applicants considering teaching in Puerto Ordaz. Terry's reply, "Teaching in Puerto Ordaz is a great experience for teachers because we had classrooms with a small number of students from all over the world who were, usually, filled with their own personal adventures. Teachers had the freedom to be creative and were paid well which allowed teachers to discover and enjoy their own personal adventures."

The educational system in Puerto Ordaz was unique for many children. In the early years, it was believed that kindergarten should only be held in the Venezuelan school. All children, North American, European,

and Venezuelan had the opportunity to attend the Venezuelan school for kindergarten. This was the first opportunity for many children to play together and to be immersed in the Spanish language. It was also the first opportunity for many children, from different countries, to play and interact with one another. Many of the families who had students attending The American School felt that the education their children had received was excellent. After completing eighth grade the students went elsewhere for high school. As new companies continued moving into Puerto Ordaz, they brought more workers and more families; therefore, several of the new companies would provide their own schools for the children of their workers. Those schools would usually be in several rooms of a company's office building.

Teaching in Puerto Ordaz was a pleasure but would Terry's personal life remain the same or would it soon change?

CHAPTER EIGHT:

A Secret Marriage

"I had met Musiú briefly that summer day when I returned from my trip to Hawaii and had stopped at the club to greet a number of friends. Musiú was sitting at the table with them. We barely exchanged a word. A couple weeks later, when I answered the phone, I heard Musiú's voice. It actually felt like it was the first time I had really heard it and I recognized it. We had a great first conversation. Several days later, while living in my apartment Musiú knocked on the louvers outside my bedroom window. He asked me if I would open the door. I told him that I had to see his hand in order to identify him. Musiú put his hand between the louvers and I recognized it. How did I recognize his hand? I really didn't know; however, I knew it was Musiú and I invited him in to my apartment. We talked and talked and that was the beginning of many conversations that the two of us would have together. It seemed as if we both already knew each other. Had we both been in a previous life together? The more we talked, the more it seemed possible. From that day on, many of our conversations were about events that had happened to each of us in our past lives. He believed, as did I, that he had a past life. Later, as I remember, there was a time when Musiú and I were driving together and something unusual happened. Musiú was driving and I had my left hand resting on his right leg. My right hand was on my right leg when, suddenly, I felt that God had taken my right hand and

held it for several seconds. It was one of the most calming moments of my life. Why had that happened? Perhaps that would seem strange if that had happened to someone else, but it didn't seem strange to me because it was such a wonderful calm feeling."

"After introducing my friend Audrey to Musiú, the three of us would often be together riding horses or motorcycles exploring the area around Puerto Ordaz. One day, Audrey, Musiú, Victor, who was Musiú's cousin, and I flew to Caracas to see a bullfight. The bullfight was a new experience for Audrey and me. The various assistants, at the bull fight, including the picadors and banderilleros came out before the matador. When the matador appeared, I thought his costume was beautiful and elegant. I learned the word matador means bullfighter and matador de toros means killer of bulls. I loved the music being played and learned that the steps the matador was taking was to the rhythm of the music being played. The music that accompanied the matador was the well known dance of Venezuela known as the Joropo. The Joropo has 36 steps and that was the dance we were watching the matador perform. The music and watching the matador perform was more exciting to me that watching the matador, actually, kill the bull. I did learn that the meat from the bull would be donated to poor people living in Caracas, which I hoped was true. Although I enjoyed the colors, the excitement, the music and the rhythm of the matador, I never found the time to go to another bullfight."

Terry and Musiú spent a great deal of time together talking and exploring Venezuela. They frequently talked about and shared information regarding their previous lives. "I believed I had a lot to learn in this life but soul to soul Musiú and I knew we had been together in our previous lives." For Terry and Musiú, it seemed a natural progression that the young couple would carry their friendship into marriage. It was during one of their lengthy conversations that the couple decided they would get married. Terry knew that life with Musiú would not be boring because he was a creative exciting person. She also knew that getting married to Musiú would have to be a secret. If Terry were to get married she would be immediately

fired from her teaching position at The American School since, at that time, in 1964, US Steel, the parent company of Orinoco Mining Company, continued to have the rule that only single teachers could be hired to teach in Puerto Ordaz, married teachers were not to be hired. The mining company had no choice. They would have to follow the rules and fire Terry if they learned she was married. The bottom line was married teachers could not teach at The American School, there were no exceptions.

After dating for several months and without telling family or friends, the couple decided to get married in Caracas on the weekend of Musiú's birthday. They would be staying at Hotel Tamanaco, a beautiful hotel in Caracas. That was the same hotel where Terry and her family had stayed the first night they arrived in Venezuelea. While in Caracas, the couple had one job to do for Musiú's mother who made flower arrangements for special events. The couple had an arrangement they were to deliver to a lady in Caracas, which they did.

In order to get married, the young couple had to go to the government civic center to answer questions, sign documents, and provide three witnesses. Each witness had to guarantee that he knew Terry and Musiú and could vouch that Terry and Musiú were outstanding citizens. The problem was the couple knew no one in Caracas who could vouch for them. Leaving Terry alone in the hotel, Musiú took a cab to the nearby university where he found several students and a cab driver willing to attend the wedding and to confirm that Terry and Musiú were trustworthy and outstanding citizens of Venezuela. The witnesses were happy to help the young couple for the correct amount of bolivars. Terry didn't know the names of the three witnesses and the three witnesses each spoke a different language. In the wedding document Terry and Musiú had to confirm that they were both legitimate children of their parents. Both Terry and Musiú's full name were written on the document. Although, he was called Musiú, because Musiú's grandmother didn't think he looked Venezuelan. She called him Musiú which means foreign or different, Musiú wasn't his legal name. Several phrases in the marriage license read "Today, being two in the afternoon

of the seventeenth day of July, 1964 appeared Luis Ciryl Robert Croquer Leuz, a single Venezuelan student, twenty-two years old, legitimate son of Luis Croquer, merchant and Carlota Leux de Croquer, of household chores. Also appeared Teryle Lyne Curran Flegle, Norteamerican, legitimate daughter of John Nedry Curran, superintendent and Genevieve Lucille Flegle Curran of household crafts, both domiciled in Puerto Ordaz Bolivar States. The witnesses confirmed that information given. The First Book of the Civil Code that establishes the duties and right of the spouses was read to the couple by the Secretary of the Civil Chief and witnesses were named. After providing that information the Civil Chief asked both Terry and Musiú if each would take the other to be husband or wife, both agreed. Therefore, they were declared to be husband and wife. If you were to ask Terry to describe her wedding day she would tell you that it was a bizarre experience, especially waiting in the hotel for hours while Musiú searched for witnesses.

After the wedding the banns of marriage were posted by the civil court onto the door of the local Catholic church for, at least, one week. The banns were the public announcement of a marriage with names listed. Posting names would allow anyone who objected to the marriage to step forward and announce the reason why the couple should not be married. Terry and Musiú were married, the banns were posted and no one contested their marriage, all was good. After marrying Musui, Terry's official name in Venezuela was Terry Curran de Croquer which indicated you still are who you are with one additional name as a result of being married.

After the couple returned to Puerto Ordaz, they kept their marriage a secret. Musiú continued to work in Caracas while Terry continued to prepare for the upcoming school year. Terry described Musiú as an artistic person who, especially, enjoyed painting portraits; however, that didn't provide much income. Terry was happy to keep her marriage a secret in order to keep her teaching job. Unknown to Terry, Musiú had quietly and secretly told his father about getting married but had told no one else. Terry did not tell her parents because her father would have been the

person to fire her from her teaching position since he was now superintendent over everything related to Orinoco Mining Company including the staff at The American School. Finally, in October when the school year was fully underway and when it would have been very difficult to replace a teacher, Terry told her parents that she and Musiú had gotten married in July. With that information and with Terry's birthday approaching her parents decided it would be appropriate to have a reception and announce the marriage to friends. Terry's mother secretly, and with the help of two Venezuelan friends, planned the reception which included a wedding cake with the bride and groom figures on top of the cake. Friends where invited thinking they were just being invited to a birthday party for Terry where, perhaps, an engagement announcement might be made. The friends were greatly surprised when Terry's dad announced that his daughter and Musiú were married. Friends looked at one another wondering if they had heard correctly, married? Did he say married, several asked. They had expected an engagement announcement, not a marriage announcement. Family and friends were happy for the young couple and expressed words of kindness and support to Terry and Musiú. Everyone enjoyed celebrating Terry and Musiú's marriage including Musiú's parents, his sister Ivelisse, and several other family members. Terry loved Musiú's family, her Venezuelan family, and she was very happy they were at the reception and could share the celebration of Terry and Musiú's marriage. It was an excellent party for everyone. In addition, there were other times when she and Musiú would join his family for a delightful evening of music with almost everyone playing a musical instrument or singing and dancing together.

The mining company, now recognizing that Terry was married, allowed her to move from her small apartment into a house, complete with the furniture provided by the company for married workers. Life was good for the couple. "Shortly after being married", Terry recalls, "Musiú and I went with friends to several night clubs in Caracas. One nightclub was 'El Garaje' (The Garage) and various car parts turned out to be the decorating theme of that club. The second club we visited was named 'Mi Vaca y Yo'

(My Cow and I). That club had a band and when the band played a certain song, and only that song, a cow would walk slowly through the restaurant and out the back door which was a pretty unusual sight to see. Another stop was the the Humbolt Hotel which was located at the top of El Avila. It was a lighthouse shaped structure that could be seen from almost anywhere in Caracas as it sat on the top of the mountain in a national park, a park filled with greenery and flowers including giant white lilies. Eating dinner at the hotel required all men to dress appropriately which meant, preferably a suit and definitely a tie. Should a customer not be wearing a tie, the hotel assisted those men by providing ties on a large tie rack where the customer could select a tie and enter the dining area."

While they had good times, Terry and Musiú also continued to learn more about each other. Terry learned that Musiú did not like the Catholic religion, which was his family's religion. In fact, if Terry and Musiú were walking down the street together and a Catholic priest was walking towards them, Musiú would, immediately, cross the street to walk on the other side of the street, away from the priest. Terry never understood why Musiú did that but he did indicate that, as a young boy, he had been abused, presumably by a priest thought Terry. Terry did know that controlled religion was not suited for Musiú.

When asked by a friend, Terry admitted that she really didn't know what her parents thought of Musiú "Maybe they would have picked someone else for me to marry, I don't know. I knew that I would never be bored with Musiú and that was important to me. I didn't seem to have interesting conversations with other dates but I did with Musiú. We both believed in our previous lives we had plus we both loved Venezuela."

One day, while out riding horses, Terry and Musiú stopped to get a drink of water at her parents' house. Musiú stayed outside with the horses while Terry went inside for water. Of course, at that time Terry had to get glasses of water since there were no bottles of water. While in the kitchen, getting water, Terry recalls an interesting comment her mother made to her. "Mother came into the kitchen and asked me, out of the blue, if I had

ever thought about what my children would look like. I was puzzled and asked her what she was talking about. For some reason, Mother thought my children would be black which didn't make any sense, what was she thinking? I never knew but there were statements that Mother made that I was happy to ignore and forget."

Terry and Musiú lived in Puerto Ordaz for the remainder of the school year. Terry knew, since the school year had started, she would be able to finish teaching that school year but would not be hired for the next year since she was married. Several years later, Terry wrote a letter to US Steel suggesting there was great value in having married as well as single teachers in Puerto Ordaz. It was not unusual for a single teacher to enjoy the single life in Venezuela, often times to the disadvantage of her students. US Steel considered Terry's letter and decided her opinion was valuable. With that, US Steel would eventually hire both single and married teachers to teach in Puerto Ordaz. Terry thought that was a good decision because she knew a single teacher had been hired to teach at The American School but that teacher had never been to a foreign country and wasn't happy. Consequently, she had a difficult time adjusting to Puerto Ordaz. The teacher soon quit and left Venezuela. Replacing a teacher in the middle of the school year was almost impossible.

"Because Musiú and I were married, I knew I would not be able to teach the next school year. The company had provided an apartment and a house for me while I was teaching. However, once I was no longer teaching and working for the Orinoco Mining Company we would have no place to live. Musiú was working part-time for one of the Venezuelan companies but he wasn't making much money. I wasn't certain what his job was in Caracas. It seemed that the economy in Venezuela had taken a down turn making it difficult for Musiú to find a job, anywhere. My income, as a teacher, was higher than his income. As Musiú and I considered what our next move might be, we decided that, perhaps, we should consider going to Florida where my brother, who had graduated from college, was now living. Musiú and I knew we would be on our own in Florida but decided

we had to go and try our best to find work. Musiú was fluent in English because, as a young man, he had attended a military academy in the US. Actually, the reason Musiú was able to attend a military academy in the United States was because his father worked for the Venezuelan government. It must have been a fairly high position because not only could Musiú attend a private military academy in the US, his father had his own driver in addition to the family having a number of servants. This all happened before I met Musiú. When I met Musiú, the Venezuelan government, his father had worked for, had been overthrown. His father no longer had the government job which meant no income to pay for the military school for Musiú; consequently, Musiú had to immediately leave the military school and return to Venezuela. I thought the weather in Florida would be similar to the weather in Puerto Ordaz; therefore, we only considered a move to Florida and didn't consider a move north to Ohio. Perhaps, more importantly, after having spent many years in Venezuela among so many colors, the color green, especially, had become very important to me. Colors and scents had become huge to me. Everything has to smell good. Night-blooming jasmines, gardenias, those are the smells that will always stick with me when I think of Venezuela."

Because the couple had decided they would move to Florida, Terry's dad had to help Musiú complete the paperwork necessary for Musiú to become a resident of the United States. "Dad had to share his bank records and agree to be financially responsible for Musiú while he lived in the United States. The importance of Dad's financial information was to prove that Musiú would not become indigent or a burden to the United States. Once all the documents were signed, including the information regarding Musiú's, age, birth country, health and occupation we were ready to go to Florida. Before leaving, I decided to give my wonderful horse Dooley to George, one of my students."

With the decision made to leave for Florida, at the end of the school year, Terry and Musiú decided to have an end of the year party. They wanted to say good-by to friends and colleagues in Puerto Ordaz, especially to the

124

staff at The American School where Terry had enjoyed her several years of teaching there.

Terry did a number of fun things for the party including cutting off the top of beer cans and serving warm chili in the cans. She hollowed out a loaf of bread and filled it with a tasty filling. She hollowed out a large watermelon and filled the center with vodka while putting chunks of watermelon in the vodka the day before the party. The party was fun but Terry was sorry that the school principal enjoyed the watermelon/vodka chunks so much that he ended up sitting in the bushes trying to return to normal. A large piece of canvas hung on the patio wall with paint nearby so friends could paint whatever they wanted on the canvas. All in all, it was a typical Venezuelan party, fun, different and lively. Having said all their good-byes, the couple headed to Florida. Would moving to Florida be as exciting and comfortable as living in Venezuela, Terry wondered, but she wouldn't know until years later.

CHAPTER NINE:
Colorful *and* Challenging Florida

Thinking about Florida, Terry knew Derry was now working in Florida because Terry's dad and several other North American workers, from Puerto Ordaz, had pooled their money together and bought an apartment complex named Wilton Manor. Upon arriving at the apartment complex and seeing the bright candy apple red Avanta parked in the driveway, Terry knew that had to be Derry's car. From a red motorcycle in Venezuela to a red car in Florida, so typical Derry. Derry was managing the apartment complex so that's where Terry and Musiú would go. Neither Terry nor Musiú knew what kind of work they might be able to find in Florida but both knew they would have to find some kind work in order to live in Florida. Upon entering the United States, in 1964, Musiú had to, once again, provide the United States' officials with a great deal of information about himself, including his health, age, occupation, and business, if he had a business. Terry thought she might teach but realized she did not have the required teaching credentials for Florida plus there appeared to be no teaching jobs available for her; consequently, she took a variety of other jobs. Terry worked at a nursery school for a short time. She also worked for a veterinarian which brought her to tears almost everyday. "Musiú worked for the local humane society rescuing injured animals. Since we had Red Boy, our Irish Setter, with us in Florida, Musiú decided to take Red Boy

for obedience training at the armory. As it turned out, while Red Boy was getting trained, Musiú learned how to train dogs, himself. Musiú decided to start training dogs which was a skill he would use for the rest of his life." Nonetheless, the family needed more income so Musiú found a job working part time at a local gas station. While working at the gas station, he was able to watch the construction workers who were working across the street building an office building. Musiú watched and one day decided to walk across the street to ask the construction workers how they had learned the skills they had. The men, basically, told Musiú to just pick up a hammer, get started and he would learn. Musiú watched, studied, and learned to do construction work which was helpful building a variety of structures, like the aviaries that he built for Terry's birds in the family home.

One day, while her parents were still living in Venezuela, Terry stopped by her parents' condo to pick up something. During earlier years, while living in Venezuela, Terry's parents had purchased an apartment complex in Florida named 'Curran Casa' which Derry was able to maintain and manage for them. The condo was where her parents would stay when they traveled to the United States for their annual visit. As Terry unlocked the door and started to walk into the condo, she stopped because she, suddenly, knew something was wrong. "I stood at the door but didn't go in. What was wrong? As I looked into the condo I knew something wasn't right. Then I saw it, a broken kitchen screen, something was definitely wrong. As I stood there, I could see Dad's gun case at the top of the stairs and it was wide open and his guns were gone. Since Derry was in Venezuela, I, immediately, called Derry's friend who was a local detective. Within a few minutes, the detective and a police officer arrived at the condo looking at everything and reviewing the scene. While silently standing and watching the men, I heard a name suddenly pop right out of my mouth. I said the man's name out loud and told the detective that was the man who took my dad's guns. How did that happen? Why that man's name? To my knowledge, that man was not a burglar, who was he? Why did I say his name? However, after doing the investigation, the detective and the police

officer learned, I was correct. The name that had popped out of my mouth was, in fact, the name of the man who had stolen my dad's guns and he was arrested. I had no idea how his name simply popped out of my mouth but when such things happen, I gratefully accept them."

Several months after moving to Florida, much to Terry's surprise, Musiú received an official government letter indicating that he was to report for a physical at the local Army headquarters in Florida. In Venezuela, at that time, because Musiú was the only son in his family, he would not be required to serve in the Venezuelan military. However, military rules were different in the United States, especially with the United States fighting against Viet Nam. Musiú was not a citizen of the United State but he was a resident and, as a resident he was eligible to be drafted into the US Army. Following instructions, Musiú went for his physical and passed which meant he could soon be drafted. Since Terry was not excited about Musiú going into the Army, she had another suggestion. Terry suggested she might be able to teach in Spain. She knew several people who had worked in Puerto Ordaz and who now lived in Spain. Perhaps they could help her find a teaching job in Spain. Since Terry was fluent in both Spanish and English she thought that skill would be helpful when searching for a teaching job in Spain. The couple decided that going to Spain might work out well for them.

Terry called her parents to tell them that she and Musiú were planning to leave for Europe and they needed to sell their car in order to have the money to travel to Spain. Without hesitation, Terry's parents bought the car. With dollars in hand Terry and Musiú, along with Red Boy, decided to fly to Germany where they would buy a car and drive to Spain. Terry was hopeful she would be able to get a teaching job in Spain. As it turned out, during the time Terry and Musiú were in Germany, an official letter was sent to Musiú directing him to report for active duty with the US Army; however, since Musiú was in Europe, that wasn't possible. Since Terry's dad had returned to Florida, he saw the letter and wrote "out of the country" on the envelope which ended the Army's request to draft Musiú at that time.

The plan to travel to Spain and teach didn't go quite as well as hoped. Terry, Musiú and Red Boy flew to Germany where they did, indeed, buy a car and that was good. As they drove from Germany to France Terry recalls a conversation that she and Musiú had. "I was pretty certain that I had all the documents necessary for Musiú, Red Boy, and me to enter Spain. Musiú said he needed to get a visa before he could enter Spain. I told him he would be fine with the papers, including his passport, that we already had. I told Musiú he didn't need a visa." Ironically, as they soon learned, Terry and Red Boy had the necessary and required documents to travel from Germany to France and then to Spain but Musiú did not. He did not have the mandatory papers that would allow him to enter Spain which meant that the threesome were now sitting somewhere between France and Spain. The guard at the crossing gate said the couple could not enter Spain because Musiú did not have a visa which meant they would have to return to France and get the proper documents. The guard gave the couple an address where a man lived who could help them acquire the necessary document for Musiú. By this time, it was getting late and it appeared nothing was open. However, with the address in hand, the couple decided to drive to that location. As it turned out there was an open iron fence, at that location, which they drove through because they could see a man standing inside the complex. Musiú told the man he needed the correct document in order to enter Spain. After the man asked Musiú several questions, Musiú received his visa and the couple was ready to enter Spain the next day. The couple entered Spain in Bilbao, Spain. After spending a couple days in Spain Terry and Musiú were having second thoughts about living there. The duty they would have to pay on their new Volkswagen would be as much as they had paid for the car in Germany. However, before making a final decision, the couple looked at an apartment in their price range. The apartment was not in the best of condition and the floor was bumpy and curvy. Musiú told Terry he thought the Army had to be better than this. Terry recalled their next decision. "It seemed apparent that we weren't going to make it in Spain. There were no teaching jobs available

to me. I sent a cable to my parents who, fortunately, were still in Florida, telling them that Musiú and I were planning to return to Florida. I told them we had no money so my parents wired the money to us through the office of the ship we would be traveling on to return to the States, which I greatly appreciated."

Terry, Musiú and Red Boy spent the night at a hostel in Spain and left the next morning for America. "As it turned out, we were the last people and the last car to board that Israeli ship heading for New York. The ocean was extraordinarily rough as was evidenced by the movement of the ship, the number of passengers who were sick, passengers falling down trying to walk, and the table cloths being sprayed with water so dishes of food would stay on the the table and not slide off. "I saw one woman fall and because of the swaying of the ship she just kept sliding under several more tables before someone could reach her to help her up. Even Red Boy was sick on that ship. That rough trip across the ocean lasted for almost a week, a long week. All of us, passengers and crew were happy to arrive in New York City and walk on solid ground again. Since we had been the last to drive onto the ship, we were the first to drive off the ship, which was great. We were anxious to return to Florida."

By the time the couple returned to Florida, Terry was pregnant. When Terry told her parents about expecting a baby, her mother responded telling Terry she should not be pregnant because she couldn't afford a baby. That was to be the standard comment made each time Terry told her mother she was pregnant. Terry ignored her mother's comments as was evident by the fact that she gave birth to four daughters and she treasures each one with unending love.

Because Terry was now pregnant, Musiú s name had been lowered on the list of men to be drafted and he never was drafted. Terry's parents gave the young couple an apartment complex in Florida named the Teryle Lynne Apartments. Those apartments were a wedding gift to the young couple with Terry and Musiú responsible for managing the apartment complex. The complex consisted of four apartments and a duplex in the

back of the apartments, which is where the couple lived. While managing the apartments, Terry gave birth to her first daughter, Joelle Lynne who was born in October, 1966. Terry's mother came from Venezuela to meet her first grandchild and help Terry as best she could. A notable gift that Terry received after the birth of each daughter was the traditional jet black hand amulet thought to protect the baby against violence or bad luck. A skilled artist was often able to cross two of the fingers on the hand to form a cross. Approximately, fifteen months later in January 1968 Mia Ivelisse was born. "Much to my shock, when Mia was born, Mother, actually, tore up Mia's baby pictures because she told me that Mia was not pretty. I couldn't believe she would do that to my beautiful baby girl." Although, Terry had no extra help with the girls, she was happy whenever her mother or Musui's mother would come to help with the girls. "I loved having the extra help and appreciated it whether it was for a day or for several weeks."

While living in Florida, Terry learned that her dad, after living in Venezuela and working for the Orinoco Mining Company for nearly twenty years had decided it was time for him to retire. "I think my mother was ready to return to the United States and she may have encouraged my dad to retire. I'm not certain Dad was ready to leave Puerto Ordaz and his work for the mining company, but he did retire. The Orinoco Mining Company gave Dad a beautiful twelve inch solid gold train engine when he retired, the company's way of thanking him for all the work he had done in Puerto Ordaz. That gold train reminded Dad of the many memories he had made in Puerto Ordaz. Dad had always been very involved in Puerto Ordaz with his work, sports, friends and even with his garden as he shared vegetables with so many people. He saw a community that had started with nothing grow to become an active busy town that continued to grow yearly with more companies moving into Puerto Ordaz and more families living there."

"I do believe my parents had been happy living in Venezuela and all it had to offer. They enjoyed the climate, the jungle, the animals, flowers, trees, and the many new friends they had made over the years. During the time living in Puerto Ordaz, Mother learned to play different card games

with the ladies and to enjoy a glass of scotch, every now and then. Because of Dad's position with the company she was encouraged to give dinner parties to help new employees and their families feel welcome and comfortable in the new community of Puerto Ordaz. All of this was a fairly new experience for Mother since she had rarely hosted any parties when we lived in Ohio but it became an experience she grew to enjoy, even when the president of the Orinoco Mining Company joined my parents for dinner one evening.

Despedida al señor Curran

En la residencia del señor Raymond E. Vintilla, Director de Relaciones Industriales, en Puerto Ordaz, éste ofreció un coctel de despedida al señor John H. Curran, quien se desempeñó en la Empresa como Superintendente General de la entonces División de Puerto y Ferrocarril.

Esta reunión social tuvo lugar el 17 de enero y fue con motivo del regreso del señor Curran a los Estados Unidos, después de haber prestado sus servicios en la Orinoco Mining Company por un lapso de más de 16 años.

El señor Curran había ingresado a la O.M.C. en julio de 1953 con el cargo de Superintendente de Operaciones Ferroviarias, actividad que ejerció hasta abril de 1955 cuando pasó a ocupar la posición arriba menciona-

En la residencia de los esposos Vintilla éstos ofrecieron un coctel en honor del Sr. John Curran, con asistencia de numerosos invitados. Están, de izquierda a derecha: Raymond Vintilla, John Curran, Carla de Vintilla y Genevieve de Curran.

At the residence of Mr. Raymond E. Vintilla, director of Industrial Relations, in Puerto Ordaz, he offered a farewell cocktail to Mr. John Curran, who served the Company as General Superintendent of the Port and Railroad Division. This social meeting took place on January 17 and was on the occasion of the return of Mr. Curran to the United States, after having served in the Orinoco Mining Company for a period of more than 16 years. Mr. Curran had joined the OMC in July 1953 with the position of superintendent of railway operations, an activity that he exercised until April 1955 when he took up the position mentioned above.

After retiring and leaving Puerto Ordaz, Terry's parents moved to Florida where they would live full-time with the warmth and greenery of Florida reminding them of Venezuela. They were very aware of the changes happening in Venezuela both with the government and for the people. Many of their friends in Venezuela were now leaving Venezuela and returning to their home countries.

Becoming permanent residents in Florida, Terry's parents sold the apartment complex and bought at home on Lighthouse Point, near the waters off the Florida shore. They wanted to be near the water where they could enjoy boating, fishing, swimming, tennis and socializing. Their house on Lighthouse Point was near a big canal because Jack enjoyed being on his boat and traveling on the water. In fact, Jack was happy to drive his boat to Derry's house which was now on the island of Bimini, in the Bahamas. Bimini was best known for Earnest Hemingway having lived there and the opportunity it provided fishermen to engage in deep water fishing.

Because their family was growing, Terry and Musui decided it was time to sell the apartment complex and build their own house. They decided they needed more than a two bedroom apartment for the family of four; consequently, they moved into a house on Lauderdale Lakes in Florida. A neighbor Terry met had suggested to Terry, since he taught math at the local high school, perhaps Terry would consider being a substitute teacher, especially for him. The idea of getting back into teaching was worth considering but with the little girls it hardly seemed possible. Terry had met a lady at the bowling alley, where she and Musiú belonged to the bowling league. When that lady heard about Terry's interest in teaching she said she would be happy to watch the girls whenever Terry needed a baby-sitter. Terry did substitute for the math teacher several times that year. Terry knew there are times when students, having a substitute teacher, can become a bit more active, chatty and challenging. Consequently, when introducing herself to the students, Terry would generally say, "I am required to tell you I have a black belt". Of course, the students assumed

Terry meant a black belt in karate and, as a result, Terry had no discipline issues when she was the substitute teacher.

At home, a retired neighbor enjoyed hearing the girls singing and laughing when they would be swimming in the family pool. That neighbor made a great chocolate pie and would invite the girls over for a slice of pie allowing the girl to cover their slice of pie with lots of whipped cream. Neighbors were great in Venezuela and in Florida.

After living in their house for several years, Terry and Musiú wanted to buy a larger piece of property in order to have a variety of animals. They were both very fond of animals. Terry's parents helped Terry and Musiú sell their home in Lauderdale Lakes allowing Terry and Musiú to buy a larger piece of property and build a larger home for the growing family. "Dad even held the mortgage on the house we sold in Lauderdale Lakes in order to help a teacher purchase the house. He also paid for the several acres of land that we wanted to buy on Godfrey Road. Because of Dad's help Musiú and I were able to qualify for a loan to build our house. Dad also, helped us with the final touches to our hew home including painting and landscaping. He was such a great help to us and I appreciated all that he did." Terry was happy to be involved in the process of designing the new home, selecting colors and watching the progress of their new home being built. Terry was pregnant with her third daughter, Brittany, who was born in 1970, shortly after the family had moved into their new home.

"I was very pleased that Musiú's mother came to Florida after our third daughter, Brittany, was born and stayed for a month. Since we were in our new house on Godfrey Road we had an extra room for visitors which made my mother-in-law more comfortable staying with us. I had to sharpen my Spanish speaking skills as did the girls. We only spoke Spanish when the Venezuelan grandparents were with us. Living in Florida, the girls were learning and speaking English much more than speaking Spanish."

Musiú had screened in an area for the aviary at the side of the house. Terry could continue to enjoy the sounds of the birds since the aviary was home to a variety of finches plus a number of other birds. In addition to the

birds, the family had horses, ponies, chickens, cows, dogs and cats while living there. "One day, Musiú came home with a large hawk. Wearing his large leather gloves Musiú was able to train the hawk to fly and return to him for food. When Musiú added a second hawk, Joelle learned to also fly the hawks with her dad, which was good except for the day when Joelle and I were running down the street chasing after the hawk that had escaped. Another time, we had a pig and piglets that escaped. Joelle was on the fence but not ready to jump down and rescue the piglets because the mother pig was, definitely, mad at us. Fortunately, the neighbors helped us catch those squirming piglets."

As with most families the days were mixed with good days, busy days, and several bad days. Several bad days included the day Red Boy died and several years later when Macho died which meant they no longer had a family dog. After Macho died, Musiú read an ad in the local paper that said either the dog goes or I go. According to the article, the dog had recently eaten the family's ham which was for their holiday dinner. After reading the ad, Musui thought, since it was a puppy, the family would enjoy having a new dog. The girls went with Musiú to see the puppy. Terry remembers what happened when the family returned home with the new dog. "When the family returned home, I was sitting in the living-room. I could hear the garage door open and, suddenly, walking through the door was one of the largest puppies I had ever seen. It was a Blue Merle Great Dane puppy.

That dog looked at me, came right over to me and from that moment on, we were best friends. The dog's name was Bismark and Bismark was a big dog. Bismark was a treasure to have. He was an elegant dog and as he continued to grow he seemed to become more elegant and more regal. Macho, our Irish Setter, had had the same sort of regal elegant when he would walk into the ring at the dog show. Bismark decided it was his job to protect our family, especially the girls and me, from all friends and foes."

"One of our neighbors was a retired couple who enjoyed sitting on their patio listening to our birds singing. The husband was a retired minister and came to our house to baptize Brittany. Several days later, I was walking outside, holding Brittany as I was on my way to greet the neighbor as he and his wife drove into our yard. However, as I approached our neighbors, out of the corner of my eye I saw Bismark running full speed toward them. I knew Bismark was going to attack our neighbor so I quickly handed our neighbor the baby and I was able to grab Bismark's collar and hang on to him with all my strength until Bismark decided our neighbor was a friend and that he need not attack our neighbor. After a few words to explain to Bismark that we were all okay, I walked him back to the house knowing that Bismark only wanted to protect us. We never locked our house as long as we had Bismark because we knew we were all safe."

Another day a friend stopped by and set his hat down on top of the baby buggy. When getting ready to leave, he reached for his hat. Bismark saw that and thought the man was going to hurt the baby so he grabbed the man's arm and held onto it until Terry told him all was well. Bismark was the protector and Terry had to be the enforcer in order to protect friends.

"I was surprised, or perhaps I was shocked one day, when Kike, Musiú's nephew, came to Florida to attend high school and live with us. No one had told me he was coming and no one told me he was planning to live with us while he attended high school in Florida. I had learned in Venezuela that there is no hesitation to help or to care for a family member but it would have been nice if Musiú had told me about his nephew coming to live with us. Sometimes, I just had to adjust to the situation, no matter

what the situation. Kike lived with us for several years and we all adjusted; although, having three girls, the animals plus Musiú and Kike, I was pretty busy most every day."

Musiú, especially, enjoyed the local horse park and the various activities at the park including the horse club. One Saturday, while at the park, Musiú asked Terry to warm up his horse as he was busy preparing for several events. Musiú's horse was a working horse, an aggressive horse that was good at running the barrels, a contest Musiú enjoyed. Terry's horse was a more relaxed pleasure horse. To accommodate Musiú, since he was busy, Terry boarded his horse forgetting that a horse that runs barrels has short reins while a pleasure horse has long reins. Terry, not giving any thought about the difference in the length of the reins pulled the reins too hard or too long. With that one pull, Terry and the horse both fell over backwards with the big horse landing on top of Terry. "I was afraid the horse would try to kick me as it was trying to stand up. Somehow, without knowing how, I managed to slide my head under a nearby truck. With that move, the horse was able to get off me. In great pain, I was taken to the hospital where I was told that I, probably, had a broken pelvis. The hospital workers were trying to pull the jeans off me which was incredibly painful. I screamed for them to just cut the jeans off, but they didn't. They even rolled me over and over the next day to change the sheets on the bed. I was in such pain and I couldn't believe the medical staff didn't just leave me alone. There was no doctor available to see me until Monday. Finally, after the doctor examined me and took x-rays on Monday, he confirmed the fact that I had broken my pelvis in several places. Eventually, after surgery, pain pills and as much rest as possible my pelvis slowly healed; however, I had to learn to walk all over again which took many months. Being in so much pain, for so long, caused me to believe that it was much easier giving birth to my babies than having broken bones in my pelvis."

"Several years later, while driving down a familiar road in Florida, I made a turn and as I made that turn, something came over me. It was a voice telling me that it is time to return to Venezuela. I knew, at that

moment, that we were going to be moving back to Venezuela. Just like that. I didn't know what to think but I let the words soak into my head because I knew that soon my family and I would be returning to Venezuela. It was a very curious thought since Musiú and I had not even discussed the possibility of returning to Venezuela. Even to this day, I find it interesting how words and thoughts happen to me and I don't know where they come from or why those words come to me, it just happens. I remember another one of those unusual moments when I watched the birth of one of my daughters. It seemed as if I was watching myself give birth to one of my babies. How was that possible? Was it an out of body experience or what? I gave birth to four daughter but that experience only happened one time which was puzzling and something I simply cannot explain to others. I believe, spiritually, things that have happened to me which are the basis of everything I do. It's not something I can call on, just something that happens to me and which I, truly, treasure and respect."

Terry thought both of Musiú's parents were kind and helpful people. While living in Florida if Musiú's parents came to visit, his dad most often helped with the animals, the garden or the yard work while his mother helped with the girls, cooking and inside the house work. Terry readily admits their help was always appreciated. Once again, more Spanish needed to be spoken to Musiú's parents. As Terry said, "Musiú and I were comfortable speaking Spanish recognizing we were away from Venezuela but Venezuela was always in our hearts and never far away from us."

While Terry and her family were living in Florida, changes were happening in Venezuela. When the government of Venezuela announced they would be nationalizing many of the American companies, more and more of the workers from the United States and Europe left Venezuela to return to their home countries. Once a company has been nationalized by a government, that government may or may not focus on caring for employees which could include promoting employees to higher levels, providing more responsibilities and offering more educational opportunities. It's possible that when a government nationalizes a company they have just

one main concern which is to generate more dollars for the country with the government officials making all the decision regarding the use of those dollars. Private assets would become public assets. Often when a government nationalizes a company the government may not pay the original company a fair amount of money but might just take over the company no matter what the true value of the original company might be. For example, an American company like the Orinoco Mining Company was nationalized by the Venezuelan government and the company received less than full value for their company. On November 28th 1974 the Venezuelan government announced that on January1st, 1975, it would nationalized the two American owned iron ore companies in Venezuela. The government would now own the properties. The two companies would receive over a hundred million dollars; however, the company's property was assessed by the government to be worth two hundred million dollars. Years earlier when the two companies were granted mining concessions by Venezuela, those mining concessions were due to expire in the year 2000, not in 1975. Between the two mining company the total work force totaled 3500 workers in Venezuela with only forty-seven of those workers being Americans. The American workers had provided meaningful education and experience to the Venezuelan workers who would no longer be working for Orinoco Mining Company but for the Venezuelan government owned company known as CVG FERROMINERA ORINOCO

Below is the information that was published in the *New York Times* on November 28th, 1974.

"CARACAS, Venezuela, Nov. 27—The Venezuelan Government announced late yesterday that American-owned iron ore companies operating here would be nationalized on Jan. 1, 1975. The Orinoco Mining Company, a subsidiary of the United States Steel Corporation and Iron Mines Company of Venezuela, owned by the Bethlehem Steel Corporation, will receive a little over $100-million in compensation, according to Argenis Gamboa, president of the Corporacion Venezolana de Guayana, the state-owned company that

will administer the iron companies after takeover. The announcement has been expected for several months. It is the nation's first major nationalization plan. The Government of President Carlos Andres Perez has also said that the nation's most important industry, oil, will be nationalized in 1975. Iron ore exports are Venezuela's second most important source of revenue. She exports about 22 million tons of iron ore a year. Most of it goes to the United States. Gamboa said Tuesday that Orinoco Mining would receive $83,720,930 and the iron mines company would receive $17,674,418 for their property. The companies do not own the iron ore deposits but were granted mining concessions by Venezuela that were due to expire in the year 2000. The Government has said that the companies' property here had been assessed at $200 million. The Government will pay the companies in installments over a 10-year period, according to Gamboa. The nationalization of the companies must still be approved by the Venezuelan Supreme Court. And President Perez is expected to announce the takeover early in December. The President and the cabinet approved the nationalization decree yesterday, a spokesman said. Both companies employ a total of 3,500 workers in Venezuela, but only 47 are Americans."

When nationalization happened, many North American and European workers planned to retire early and leave Venezuela and return to their home country. It was, probably, more of a challenge for the Venezuelan workers because they would, more than likely, be at the mercy of the country which could be good or bad, but always an unknown at the beginning. Would the focus continue to be on the workers and their families or would the focus be on generating more dollars for the government. The Orinoco Mining Company and other companies had provided homes, schools, hospitals, bridges and, more importantly, work for the Venezuelan people. That work included respect, fairness, and a decent salary for all the workers. Whether the Venezuelan government would continue this practice would only be known in future years.

Meanwhile, in the United States in the early 1970s, the economy was tumbling. The economic times were distressful for many American families. As the U.S. economy was tumbling, Terry and Musiú had to find more jobs to help boost the family's income. As they had done before, the family would continue to sell eggs, fish, milk, with Joelle, the oldest daughter, helping her parents the most. Friends would leave their milk containers or egg cartons on the porch. After filling the containers with milk and cartons with eggs, Joelle, riding her pony, would deliver all those items to their customers. Joelle also delivered the local newspaper while riding her pony. Because of her work, Joelle paid her way to Girl Scout camp. Joelle, especially, enjoyed helping Musiú whenever she could. Joelle was enamored with watching Musiú, using his slurp gun to catch fish. The slurp gun was similar to a plunger and was used to suck or pull in a small fish and to then sell the fish to the local pet store or put the fish in the family aquarium. As a result of Joelle watching and helping her dad with various tasks, she one day told Terry that her dad, Musiú, liked her more than he likes you. No matter what Joelle thought Terry and Musiú had to focus on the family income and they had to do it together. The man who had delivered feed for the animals, no longer was able to deliver the feed so Musiú started getting the feed for the family's animals as well as delivering feed to others. Terry started delivering newspapers which meant getting up at 3:30 in the morning to fold and then to deliver the newspapers. Terry delivered the newspapers driving her small orange Volkswagen. "One early morning", Terry recalls, "I was delivering the newspapers with the car windows down and the roof off the car making it easier to toss the papers onto various driveways as I drove around. Much to my surprise, on one of those dark mornings, Bismark scared me as he found my car and jumped up beside the open car window. I couldn't believe it but, sure enough, there was Bismark. Bismark didn't like to be enclosed and was happy to run freely around the area looking for me. I insisted Bismark get in the car with me so I could finish delivering the newspapers. Freedom loving Bismark was such a special treasure to me and one of the most caring dogs I had ever had."

As the economic times became more distressful for families in the United States, Musiú's father suggested that Musiú purchase a forklift and return to Venezuela where he would find lots of work. After listening to Musiú's father, Terry and Musiú decided the family needed to return to Venezuela to work. However, Terry knew they would need to sell the house on Godfrey Road before they could think about returning to Venezuela. Terry called her parents and asked them if they would like to buy their house on Godfrey Road. Terry, explained to her parents that her family would be returning to Venezuela and would have to sell the house in order to have the necessary money they would need to live on in Venezuela. Without hesitation, Terry's parents agreed to buy the house and move to Godfrey Road. They would have to sell their own house that was closer to the ocean but happy to help their daughter and family. Since the house on Godfrey Road was on several acres, Terry's dad knew he would be busy planting a garden, planting trees, and, perhaps, building a swimming pool and a tennis court for his wife to enjoy. Life would be good for Terry's folks in Florida. Terry hoped life would be good for her and her family, once again, in Venezuela.

Was Venezuela still the warm and welcoming country Terry had known many years ago? Time would tell.

CHAPTER TEN:

Returning *to* Venezuela

Months earlier, when speaking to his father about the financial situation in America, Musiú's father, once again, suggested that if Musiú would buy a forklift and return to Venezuela he would find lots of work to do, especially in the city of Puerto La Cruz. Puerto La Cruz was a town nearly two hundred miles away from Puerto Ordaz. Musiú listened to his dad and moving back to Venezuela seemed like that right thing to do and Terry agreed. All the family's household goods, including the brand new forklift were shipped to Puerto La Cruz, Venezuela. Returning to Venezuela meant Terry, Musiú, Joelle, Mia, Brittany and Bismark would fly to Caracas and stay with Musiú's parents in their two story apartment until their household good arrived in Puerto La Cruz and that's what they did. The family of five plus Bismark, the Great Dane, whom the Venezuelan friends referred to as el tigre...the tiger, lived in the apartment with Musui's parents, his sister and her dog for several weeks as they waited for their household goods and Musiú's new forklift to arrive in the city of Puerto La Cruz. Terry and family were moving to Puerto La Cruz rather than Puerto Ordaz because Musiú's father had said there would be more work available for him if he had forklift in Puerto La Cruz. Patiently, the family settled into the Caracas apartment as best they could. While living in the apartment, Bismark, who didn't like to be confined anywhere, was on the second floor balcony just

looking out at the world when something caught his eye, perhaps something to chase. Suddenly, before anyone knew it, Bismark had fallen off the balcony and down unto the ground. Dashing to rescue him, the family learned that, amazingly, Bismark was not hurt except for one chipped tooth. Terry recalled, "We all knew that Bismark loved his freedom and the opportunity to run around wherever and whenever he wanted, especially when seeing something he was eager to chase, I'm guessing that's why he fell off the balcony."

No matter where Terry and the family lived, Bismark was a part of their lives. Many Venezuelan people thought Bismark had the same coloring as the wild dogs they had seen running around Venezuela. Bismark was much bigger than most other dogs and that could be fearsome for some people. Years earlier, in Puerto Ordaz, Red Boy roamed freely and seemed to own Puerto Ordaz. Red Boy was everyone's friend. Since Bismark was such a big dog, people were more reluctant to approach him and Bismark didn't roam freely, anywhere, unless he, somehow, was able to slip away from the family and sneak off on his own, which he had been known to do. In thinking about Red Boy roaming freely around Puerto Ordaz, that was because Puerto Ordaz was a much smaller community years ago.

"In Venezuela, one of the things my daughters immediately notice and enjoyed were the hugs. Hugs were given as a greeting or friendly hello. Hugs were also given when leaving to go anywhere. The girls were always willing and happy to give or to receive a hug. It amazed me to see them so comfortable with hugs. Even to this day, as I mentioned before, I don't automatically greet family or friends with a hug. I have to stop and think about it and while I'm thinking about it, the other person has already given me a hug. I just didn't grow up in a family where hugs were given so freely but it seemed natural for the Venezuelan people to greet family and friends with hugs."

After a spending several weeks in Caracas, Terry and Musiú learned that the ship carrying the forklift and the family appliances had arrived in Puerto La Cruz. With that information, the family left Caracas for Puerto

La Cruz eager and anxious to settle into their own house, once again. Terry looked forward to getting her red appliances but that didn't happen. The cost to pay Venezuela the required duty levied on those red appliances would be like buying the appliances all over again; consequently, Terry decided the red appliances were not needed.

"Somehow," said Terry, "Musiú had arranged for our family to move into a very nice house which was just a couple blocks away from the local Venezuelan school where the girls would soon attend. I never learned how Musiú was able to get that house for us but, perhaps, I was so busy with the girls I just didn't pay attention to all the details. The yard around the house had mango trees and vines filled with grapes which I appreciated. The girls missed the fruit they had enjoyed in Florida, like apples and pears; however, apples cost $5 each so I encouraged the girls to enjoy the fruit we had in our yard and the fruits native to Venezuela, which they did. I soon learned that Mia was allergic to mangoes and mango oil which meant no tasty mangoes for her to eat."

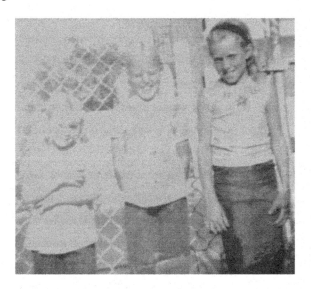

As the family settled into their new home, the girls started school. The girls, Joelle, Mia, and Brittany were nine, eight, and five years old and they would attend the local Venezuelan school which was in walking distance from the new house. The school was a Spanish speaking school. The

girls would be the only English speaking students in the school and the only girls who didn't speak Spanish. The girls didn't, exactly, have to wear specific uniforms to the school but all students were required to wear blue jeans with a yellow shirt. Joelle, Mia, and Brittany walked to school together.

During the first week of school, Joelle and Mia returned home but Brittany wasn't with them. When Terry asked the girls where Brittany was, the girls told her that they hadn't seen her and thought she had just walked home ahead of them but that wasn't what had happened. Terry and the girls quickly returned to school where they saw Brittany and her teacher standing at the door of the school. Brittany was crying. When Terry asked her what was wrong, Brittany explained that she was locked in the bathroom and didn't know how to say "help" in Spanish. Fortunately, the teacher rescued her and Brittany was happy to return home learning that the Spanish word for help is "ayuda". Ayudame means "help me". Remembering Brittany's experience as a young girl, years later when teaching Spanish to her high school students, Terry would always remind the students to be welcoming and helpful to new students; especially, students learning a new language.

Just as Brittany had learned the Spanish word for help, Terry soon learned the Spanish word for lice is "pionjos" which all three girls had, creating a new project for Terry.

Mia liked the school but was distressed about her classmates staring at her blond hair and blue eyes, plus many of her classmates were always trying to touch her hair. Mia wished she could hide her blond hair and blue eyes. The Venezuelan children were use to seeing classmates with dark brown hair, not light blond hair; therefore, they kept touching Mia's hair just to see how it felt and, perhaps, to make certain it was real hair, perhaps proving that young children are curious everywhere, no matter the country.

Joelle was having a different experience at school. In Florida she had begun learning the multiplication tables, in English. In Venezuela, she finished learning her multiplication tables in Spanish. To this day, as an adult, Joelle thinks and remembers her multiplication tables in two languages, English and Spanish.

Upon returning to Venezuela, Mia had asked her parents for a monkey. Terry recalls, "When I think about the various monkeys that I saw in Venezuela, I realized that I was more familiar with the squirrel monkey, therefore; I was pleased when Musiú came home with Luisa, a squirrel monkey.

Luisa was a squirrel monkey who would live in the tree in the backyard of our house. Luisa even came with her own blanket. At night Luisa would cover her head with her blanket unless someone turned the back porch light on. If someone turned the porch the light on, Luisa would peek out from under her blanket to see if anything interesting was happening. Luisa was connected to the tree with a leash and collar. Luisa seemed content because she was being fed a variety of fruit every day without having to search or hunt for food herself. I don't recall Luisa eating much food but I do remember one of the macaws we had, later, who ate everything including the drumstick from Thanksgiving Dinner, happily sitting and chewing on the drumstick for a long time."

Musiú decided that Terry might appreciate having someone help her at home with the girls, the dog and all the various household tasks that needed to be done. Consequently, Musiú brought Isa (Isabel) home to help. It was important that Isa was comfortable with Bismark and she was. Terry liked Isa and appreciated her help. Isa would come to the house

to help a couple days a week. However, Musui expected Terry would take care of him while Isa would take care of raising and teaching the children. That philosophy was typical and customary with many Venezuelan families, including Musiú's parents; however, Terry didn't want someone else raising and teaching her daughters, she wanted the privilege and joy of doing that herself.

As the family continued to adjust to their new home, school, and friends, Musiú was not finding enough work to provide an income for the family. The suggestion that if he bought a forklift he would find lots of jobs wasn't happening. He had only had several small jobs. Realizing the financial situation, Musiú decided to drive to Puerto Ordaz to see if there might be more job opportunities there. In the ten years since Terry and Musiú had left Puerto Ordaz, the town had grown with more companies doing business in Puerto Ordaz which meant more job opportunities, more construction work and more houses being built. Musiú was hired with one of the Venezuelan companies to work in the security department. Musiú having a job in Puerto Ordaz was great but it also meant another move for the family and more adjustments for everyone. Although, the family would be living in Puerto Ordaz, the girls would be crossing the river, daily, to attend the Venezuelan school in San Félix.

The family moved to Puerto Ordaz into a temporary house until the house the company was going to provide for them was complete, which took several months. "The wilderness area of Puerto Ordaz that I first saw in 1953 was now a much larger community with more companies, houses, shops, restaurants, and stores, giving Puerto Ordaz the feeling of a real city. People had planted a variety of fruit trees, including the mango and lime trees which were very popular. It had been nearly twenty years ago that my dad had the company plant mango trees. Those mango trees were now mature and filled with fruit.

The lime trees were a newer tree to me and I, certainly, enjoyed limes. The first drink I had in Venezuela, as a teenager, was a Cuba Libre or rum and coke with a bit of lime, then later a margarita which always had either lime or tamarind juice mixed in the drink. Strange, but I never saw any lemon trees."

Puerto Ordaz was no longer just a port city. It was now a city which, when combined with San Félix, is known as Ciudad Guayana. All the growth of those communities started in 1953 when the Orinoco Mining Company mined the iron ore from the mountain which brought other companies, businesses and retail stores to Puerto Ordaz. In addition to the families who moved to Venezuela for work, it was usual for the country of Venezuela to accept families from many different parts of the world after WWII which included families with children from around the world. The desire to accept immigrants to Venezuela, especially European refugees, began around 1946 when Venezuela agreed that they would not return refugees to their home countries after World War Two. The Venezuelan immigration program was one of the most successful refugee programs after WWII. Venezuela opened its borders to citizens from other countries that wanted or needed to move away from a war torn country; such as, Germany, Italy, France and into a country offering peace and opportunity. Many of the immigrants to Venezuela became naturalized citizens of the

country which is why it was not unusual to learn that a Venezuelan citizen might be part Italian, German, French or whatever. At that time, everyone was happy to be living in a safe environment with no threat of war which allowed people to relax and enjoy one another, their families, and their lives. Musiú's parents were from Germany and France and they, like many other individuals, were naturalized citizens of Venezuela.

"The tiny village of Puerto Ordaz, next to the jungle, was now a much busier community. The rainbow of colors that I had enjoyed when I first arrived in Venezuela was still in abundance. There were still many houses painted those beautiful soft pastel colors. The mighty Orinoco and Caroní Rivers still flowed tirelessly beside one another and separate from one another. The Venezuelan people were still as welcoming to me as they had always been when I was that young thirteen year old girl in Venezuela. My love of Venezuelan was unending.

"Once the house was completed, we were able to move in and settled down once again. Our house was in a new section of Puerto Ordaz known as Los Olivos. The house was a duplex with a wall between our house and the neighbors. The house was large enough for our family of five. I was able to plant bushes and other greenery while the girls had bicycles and were able to ride bicycles on the streets that were now paved. There were so many more streets and roads in Puerto Ordaz that I knew I could easily get lost in this new Puerto Ordaz that had grown so large in twenty years. As much as Puerto Ordaz has grown, in 1972, the people of Puerto Ordaz still did not have any television service. Movies were available on tapes that the mining company provided for employees through the company library. In addition, the company gave families the BetaMax machine needed to watch those movies at home. However, everything was changing since the Orinoco Mining Company would soon be nationalized by Venezuela. OMC would no longer be an American company, it would be a company owned by the Venezuelan government and known as CVG Ferrominera Orinoco, Venezuela's state-controlled mining company.

Life continued in Puerto Ordaz for the family. Shortly after moving to Puerto Ordaz, Musiú made the five hour drive to Puerto La Cruz to bring Isa and Luisa, the monkey, to the family's new home in Puerto Ordaz. "Unfortunately, several days later, Luisa bit one of the young girls who came to play with Joelle, Mia, and Brittany. After Luisa had bitten the girls' friend, Lisa, we had to give the monkey away, which we did. Musiú found a farmer willing to take the monkey. The children had enjoyed our monkey. Unfortunately, I learned, years later, that smiling at a monkey is not a smart thing to do because smiling at a monkey and showing your teeth is viewed by the monkey as a sign of aggression toward the monkey. I wish I had known that earlier because the girls and their friends were always smiling at Luisa."

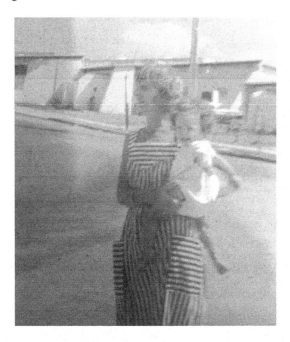

While in Puerto Ordaz, Terry gave birth to her fourth daughter, Derica, who was born at the end of the year in 1976.

Terry was sorry that when her babies were born her parents were never in the same country. When Joelle, Mia, and Brittany were born in Florida, Terry's parents were living in Puerto Ordaz. When Derica was

born in Puerto Ordaz, Terry's parents were retired and living in Florida. As expected, when Terry told her mother she was pregnant, her mother reminded her, once again, that she shouldn't be pregnant because she couldn't afford a new baby. Interesting how a statement made by a parent years ago is a statement that lives forever.

"When Isa would go to the bakery in the center of town, Bismark would often go with her. One day Isa and Bismark were separated from one another so Isa called Bismark. Isa was on the main floor and Bismark was on the second floor of the Civic Center. When Bismark, who was on the second floor, heard Isa calling him, he went over the railing and fell to the ground and amazingly, once again, Bismark broke nothing. Because of Bismark, many of our friends would come to our house, stand outside and call us to ask where Bismark was located. Those friends wouldn't come into the house until they knew where Bismark was and if it would be safe for them to enter the house and, yet, Bismark enjoyed roaming freely whenever he could."

"Taking the four girls to the club to swim was always an activity I enjoyed and it was fun for everyone. One time when Derica was only six months old, she was stretched out on her stomach happily watching the swimmers swim and the people walking around the pool. It was not unusual to see large iguanas walking around at the club. The iguanas were about three feet long. One day, as Derica was watching the iguanas, it was if the iguanas knew Derica was watching them so they decided to perform for her by moving side to side and back and forth. It was delightful for me to watch both the iguanas and my daughter as they watched one another. I never worried about the iguanas because it simply appeared they were having fun and they were not threatened by us and we were not threatened by them. Eventually, the iguanas dashed off into the jungle going their merry way."

"One year, on a summer trip to the United States, the girls, Isa and I, flew to Florida and rode with my parents in a large travel trailer to visit family and friends in Ohio and several other midwestern cities. While

traveling, Isa, for the first time, had American milk. She loved the American milk because it was thicker than Venezuelan milk. Isa continued to drink the milk until she had sores on her mouth from drinking too much. Two year old Derica had the opposite reaction to the milk. With her first sip, she spit the milk out and never drank the American milk again because the American milk was too thick for her. I never would have guessed either would have had those reactions to a glass of milk."

In addition to Bismark, while living in Puerto Ordaz, the family had other pets including fish in a large aquarium and two birds, a toucan and a macaw. It wasn't unusual for a friend, leaving Puerto Ordaz, to give the family another bird to keep in the the aviary. Terry didn't mind for she continued to love the colorful birds that flew freely in Venezuela or were housed in a cage on someone's patio chatting and squawking or trying to whistle along to the music it heard being played. One of Terry's favorite birds was a green winged macaw with a white beak, red body and green wings which she named Chico. Musiú came home one day with Chico. A man had given Musiú the macaw, Chico, because the man worked nights and needed to sleep during the day.

However, it was during the day that Chico was the chattiest and the nosiest. The man was happy to give Chico to Musiú. Among other skills, Chico could talk in three languages, German, Spanish, and English. Terry recalls fondly several of Chico's habits. "If someone happened to be talking, it would not be unusual for Chico to loudly yell, 'what? what?'. Frequently,

you could hear Chico calling 'Mom, Mom'. Chico could also imitate a baby's cry. There were times when I would be talking with friends and a friend would express concern that a baby was crying and no one was responding to the cries. I would quickly explain that it wasn't a baby crying, it was Chico imitating a baby crying. A joyful experience for me was the fact that the macaws I had liked to sit on my lap, roll over, and give me a hug. That was typical behavior you would often see when a Venezuelan family had a macaw, not unusual at all."

On Sunday afternoons in Venezuela, Terry made a treat that everyone loved. She would put an unopened can of Magnolia's sweetened condensed milk into a pan of boiling water for three hours. Once she took the can out of the boiling water, and let it cool, she would open the can and share a delicious tasting sweet treat with her family. In later years, when teaching, Terry would share that same treat with her students providing she could still find a can of the sweetened condensed milk with the right kind of lid, a lid that required a can opener because that type lid wouldn't explode while in the boiling water.

Another treat that the family enjoyed was a treat made by a family down the street. At that particular house, when the front window was open, you could buy bites of coconut on a stick which was always a tasty treat. The girls would take visiting grandparents to that house for a treat whenever they could.

On a weekly basis, Terry started making pizza for her family. It turned out that many of the girls' friends heard about having pizza at Terry's house and made certain they were around in time to have a slice of Terry's homemade pizza.

Lisa, one of the girls' good friends, was having a birthday and Terry had told Lisa she would take her to the Puerto Ordaz hospital to get her ears pierced. The ER department at the hospital would often do ear piercing for people. Terry and Lisa sat in the waiting room of the ER for several hours but decided to wait no longer because Terry needed to get home. Terry told Lisa they would go home and she would pierce Lisa's ears for her,

which she did. Terry put a potato behind Lisa' ears and with a sharp poke, Lisa's ear were pierced.

One of Terry's neighbors had an interesting experience. They had a dog door in their kitchen so the dog could walk in and out of the house whenever it felt like it. Everyone was surprised one day when a small black panther decided to make use of the dog door and walk into the family's house. A bit of creativity, which included opening all the doors in the house, allowed the panther to quickly leave and do no damage.

In 1962, the first year Terry taught in Puerto Ordaz, there were a number of holidays that were only enjoyed by the North American families; however, as the years passed, changes had been made and Halloween was now a fun holiday for all the students in The International School. Although the children had costumes and a parade at school, the costumes were not bought in any Venezuelan stores. The country of Venezuela did not celebrate Halloween. Terry recalls two children dressed as Raggedy Ann and Andy. Susie, another student dressed as the statue of Liberty. One year Terry's daughters dressed for Halloween as playing cards, Ace, King, Queen, and Joker. Since there were no stores selling Halloween costumes, all the costumes the children wore had been made by parents or by other women in the community, which was very impressive. Many American children would go "trick or treating" but only to the houses where they knew the families had children and were familiar with Halloween.

After living in Puerto Ordaz for nearly twenty years, Ray, was now an administrator with the mining company. He was currently responsible for the school that the mining company had built years ago. Ray was a friend and when talking to Terry he asked her if she would consider teaching again at the same school where she had taught her first year of teaching in Puerto Ordaz. The American School was now known as The International School. When The American School first opened, most students were from North America and the name of the school was appropriate; however, since there were more and more people working for more companies in Puerto Ordaz from different parts of the world, the school was now known as The

International School. English continued to be the primary language. Terry considered teaching again. She told Ray she would teach, in a heart beat, on one condition. The three older girls were now attending the Venezuelan school in San Félix which meant they had to cross the river everyday to get to school. Terry told Ray she would teach if her three older girls could attend The International School with her. Without hesitation, Ray agreed and Terry accepted the teaching position. For many years, Terry had been feeling that she had lost herself as she focused on Musiú, the girls, and, basically, the family. She no longer thought of herself as the capable educator that she had been years ago. Would she find herself, once again, knowing she still had the ability to teach? Could she teach and continue caring for everyone else? She would soon know.

The International School was the same size as the original American School; however, the Venezuelan school, in the middle of Puerto Ordaz, had grown larger and continued to grow. The Venezuelan school continued to grow as more and more Venezuelan families worked and lived in Puerto Ordaz and the American company kept building the additions needed to make the school larger.

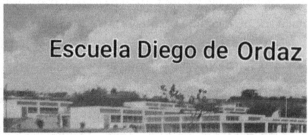

"When I returned to teaching in Puerto Ordaz, my students were from all over the world. There were more students from around the world than just from North America. I now had students from Norway, Iran, India, Wales, England as well as students from the United States."

Like everyone else, Terry continued to need her identification card for the country of Venezuela plus a second identification card indicating where she worked. Terry had a teaching job at The International School,

which was now owned by CVG FERROMINERA ORINOCO, and known as Escuela de Ferrominera.

One of the areas of interest to both teachers and students was to explain the meaning of the flag of the United States and the flag of Venezuela. The red, white, and blue flag of the United States has thirteen stripes for the original colonies and fifty stars for each state. The students learned that red represents hardiness and valor, white represents purity and innocence, blue represents perseverance and justice. The majority of students seemed to remember what the stars and stripes represented more than they remembered what the colors represented. The Venezuelan flag has three bands of color. The bands are yellow, blue and red with eight stars forming an arch in the middle of the flag. The stars represent the provinces of Venezuela. Yellow represents the rich soil of Venezuela, blue represents courage, red represents Venezuela's independence from Spain.

VENEZUELA AND UNITED STATES

Since Puerto Ordaz continued to grow with more students, many students could now take the bus to school from wherever they lived, whether in the A, B, or C area. Where her students lived was not important to Terry. What was important to her was that her students were willing to learn. Terry did not read reports from teachers who had taught a student, previously. It was a new school year and Terry felt each child should begin the year with a clean slate and a fresh start. Terry believed her thinking was beneficial for every child.

Terry enjoyed the freedom of being creative while teaching. She taught Physical Education in the mornings to students in all eight grades and swimming to all grades in the afternoon.

"Because I was the PE and swimming teacher, I could do a variety of activities with my students. Sometimes, just having the students on the ground stretched out on their beach towels looking at the clouds, talking about cloud formations was relaxing and encouraged creativity for my students. Students would have the opportunity to simply stop, relax, and enjoy what they could see."

One year, Terry decided to have a dance contest for the students that required all students to participate. It was apparent that the children enjoyed the music as well as dancing together. Terry did not judge the dance contest since her daughters were participating in it. As it turned out, each daughter and her partner won in their particular age group. Music and dancing was a natural part of Venezuela which everyone seemed to enjoy.

Another year Terry encouraged her students to start running. First a short run, then a run of one mile, next a three mile run, then a five mile run and finally, a ten mile run. "I encouraged my students to enjoy running and to remember they were not in a race but just running for themselves. Perhaps, because I'm not a competitive person, I preferred the running experience for the children be considered runs, not races. On the ten mile run, I stayed at the end of the run to make certain each child would be able to comfortably finish the ten mile run. However, by being at the end of the run, I didn't see the runners when they completed their run. As it turned out, two of my daughters were fast enough to be the first and second runners to complete the ten mile run. At the end of the students' ten mile run, my parents were visiting us in Puerto Ordaz and Dad had brought trophies for every student who finished the ten mile run, what a surprise and bonus for my students. Those two daughters who were the first two students to finish the ten mile run, would, years later, run a number of marathons in a variety of countries around the world."

Terry decided it would be a fun and challenging experience for her older students to explore the jungle as part of their PE classes. If a student didn't care to go to the jungle, that student was welcome to stay in the classroom at school; however, most of the student wanted to hike in the jungle. Terry loved the jungle and thought her students loved it more. Terry had no plans for what a student would see in the jungle. She felt they would see whatever the jungle wanted them to see that day. They would hike through the jungle, up the mountain and down into the valley. Terry took two classes to the jungle on two different days. Musiú agreed to go with Terry and lead the way, carrying his machete because you never knew what you might see, step on, or find in the jungle. Terry was at the end of the line of students. "We were prepared to crawl over fallen trees, branches or whatever was necessary to walk deeper into the jungle. We had no time frame which meant more freedom for everyone. Many of my students who had lived for many years in Puerto Ordaz were familiar with the jungle; however, new families, like the ones from India and Wales, were not yet familiar with the jungle, the animals, the birds, and even the variety of snakes. Also, there were several parents who preferred staying in Puerto Ordaz rather than exploring the jungle with their children and yet, the jungle was everywhere around us, behind our houses, behind the club, behind our school The jungle was more lush in the valley than on the mountain. No one was ever hurt on our jungle hikes and my students loved it. I never had to get permission from parents for our jungle hikes, we just did it. One of my students, Michael, was the younger brother of a student who had made a smilier jungle hike last year. To my surprise, when we reached the top of the mountain, Michael pulled a flag out of his backpack. On the flag was printed the words Mt. Croquer. Michael planted that flag into the ground on the top of the mountain. His mother had made the flag with my last name sewn on it, which was very thoughtful of her and a delightful surprise for my students and me."

"Upon returning home I realized that I had lost my favorite watch in the jungle. Ironically, the next day while walking walking into the jungle

with another group of students, I grabbed a bush to pull myself up the hill and there, on the bush was my watch, a pleasant surprise."

Since there were more and more Venezuelan workers in Puerto Ordaz, the Venezuelan school continued to grow larger. Spanish continued to be the primary language of the children and the staff at that school. The school turned out to be an unplanned gift to the families of Puerto Ordaz when the government nationalized the Orinoco Mining Company. Interestingly, The International School never grew as large as the Venezuelan school.

In addition to work and school, family outings were varied and enjoyed by everyone. One sport Terry had learned in Venezuela was a sport known as "Toros Coleados" or bull-tailing. It's a sport that involves one bull and several riders on horseback. There is a narrow dirt rectangular field, like a hundred yard corridor, with the bull at the end of the field waiting to be released. When the bull is released the riders begin the chase. The lead rider tries to grab the tail of the bull and flip the bull over, hopeful that the other riders can quickly stop and help immobilize the bull. The person to actually flip the bull over in the shortest time is declared the winner. Terry observed this sport several times when Musiú was involved in it and before they had children. After living in Puerto Ordaz, again, Musiú wanted Terry and the four girls to watch this event but on a hot summer day, it wasn't much fun for Terry. The girls would stand or sit on top of the car and Terry would be concerned that, as she had seen happen before, a bull could break loose from the field and run between the cars and attack the cars or the people watching the event. Musiú seemed happy that his wife and four daughters were watching him try to flip the bull. However, as was typical during that event many bottles of beer were enjoyed and, perhaps, a few too many bottles of beer were enjoyed by Musiú because after the bull-tailing event was over, Musiú joined the family and insisted on driving the family home. Terry, recognizing that Musiú was drunk, felt it would be safer if she would drive the family home; however, Musiú vehemently insisted he was the man in the family and, therefore, he would be

the one to make that decision telling Terry she should not argue. Musiú drove and the family made it home safely but Terry was not comfortable risking the lives of her daughters just so Musiú could feel like an important man. "I believe Musiú thought of the four girls and me as his trophies. He was the man and had to be the one telling me what to do. If I had driven home that day, Musiú would have suffered greatly because, in his mind, he had to be number one. Actually, Musiú was a likable person, commented Terry. He would easily meet friends, welcome them, entertain them but it was up to me to keep our friends."

At the end of the school year, Terry and the girls went to Florida to visit Terry's parents providing the grandparents time to enjoy their grand-daughters and providing time for the girls to enjoy their grandparents. It was a fun summer. However, shortly after Terry and the girls returned home to Puerto Ordaz and to prepare for the start of the new school year, Isa told Terry that another woman had been in her bed. Knowing that Musiú had been in bed with another woman meant that Terry's marriage was, basically, over. Many years earlier when Terry and Musuí were driving to Caracas together, a car passed them. In that car was Musuí's father and another woman who was not his wife. Terry knew it was not unusual in Venezuelan for a man to have an affair with another woman. It was also true that the man's wife would often stay married to her husband who had an affair. Terry had told Musiú that if he ever did that, she would leave him. Musiú understood, gently patted Terry's hand and promised her she would never have to worry because he would never do that to her. However, that was years ago and Musiú had broken his promise. Terry learned he had slept with another woman while she and the girls were in Florida.

No matter what Terry had learned about Musiú, she had a contract to teach and, therefore she planned to return to teaching as scheduled for the school year. Terry remembers, "I had to stay in Puerto Ordaz and com-plete the year of teaching; although, I think of that year as the year from hell, it was awful. Musiú and I were husband and wife in name only. He did what he wanted, went where he wanted and seemed to be free of the girls

and me. I was responsible for teaching, taking care of the family, the house, the animals and anything else that needed attention. It was not an easy year but I had no choice."

"I think I finally realized that Musiú was great and a much happier person before we had children. Again, in Venezuela, Musiú being the only son in his family received most, if not all, the attention from everyone, including family and friends. Whatever the son wanted or needed, he would get. I knew that with four children, I could not give Musiú my full and complete attention, which is what he expected. There were many times, before we had children, that I enjoyed being with Musiú, his family, and friends. Playing music and singing together with family and friends was always a special way to spend an evening. Musiú could play the cuatro which was delightful and I enjoyed listening to the peaceful sounds of the harp that he could also play. However, I could not give him the attention he desired. I think the tradition of being the only son in a family might make the son believe he is better than everyone else when that might not be accurate."

It was true that Musiú was no longer the primary source of Terry's attention since she had four daughters to care for and would have appreciated Musiú's help but Musiú focused on himself. Musiú had broken his promise to Terry and slept with another woman, a neighbor woman with four children; however, that woman was willing to give up her four children to live with Musiú and cater to his every need. Terry knew she would now have to leave Venezuela for herself and for the example she would be setting for her daughters. She wanted her daughters to understand the importance of being respected by a spouse and the importance of respecting yourself.

"During that year, before the girls and I left Venezuela, I probably should have explained more to the girls but I tried to keep our family life as comfortable and normal as I could for them. I was surprised, one day, when Brittany asked me what was wrong with Dad. I hesitated and then told her that her dad had a brain aneurysm which caused him to do some

unusual and strange things. Although, Musiú had no aneurysm, I thought that explanation might be acceptable at the time, detailed explanations could come later. I tried to keep our family life as calm and comfortable as possible for the girls with as much stability as I could manage."

Terry knew she would have to leave Venezuela but she also knew she had to maintain a cordial relationship with Musiú because he would have to sign the documents that would permit Terry and the girls to leave Venezuela. Terry couldn't risk the chance that Musiú might not sign the documents. "I needed to stay on good terms with Musiú so he would sign the necessary documents; although, he might have signed the documents even if we were not on good terms just to get rid of the girls and me. He never asked the girls or me to stay with him in Venezuela. However, I couldn't take the chance that he wouldn't sign the necessary documents for us to leave. I had committed to teaching until the end of the school year, which I would do, and then the girls and I would leave Venezuela. As I said many times, I could only describe that year as the year from hell. I had to think and prepare everything I needed to do to complete the school year, to permanently leave Venezuela, to provide a supportive positive environment for the girls, and to recognize that my marriage had ended."

Even when Terry's parents came to Puerto Ordaz for Christmas, Terry couldn't tell them about Musiú and her marriage. Musiú was still living with Terry and the girls but not really a part of the family. Were they just pretending to be a happy family at that time or did Terry's parents recognize that family life was difficult for Terry and the girls. Musiú went wherever he wanted, whenever he wanted which included partying with friends and golfing on the golf course which the mining company had built in the early sixties. Being part of the family wasn't a priority for him. On Christmas Eve, Terry had to search for him and his car because the trunk of the car was filled with Christmas presents for the girls.

Terry was comfortable teaching in Puerto Ordaz and knew it was her responsibility to finish the school year before leaving Musiú and Puerto Ordaz. She was happy she could take the three older girls to school with her

while Isa would be at home taking care of Derica, who was about two and a half years old. In the mornings, while Derica was still sleeping, the rest of the family went to work or to school knowing that Isa was there to take care of Derica. Isa had received a number of new experiences while working for Terry's family. She had a room to herself, she was given the money necessary to take college courses in the evening, money necessary to take driving lessons, pass the test and qualify for a driver's license. Isa, also, had the opportunity to travel around the United States with Terry's family.

However, Isa left the family one distressing surprise when Terry and the girls returned home from school for lunch one day. Walking into the house, they were greeted by Derica who had Terry's nightgown wrapped around her arm, Bismark was there but there was no Isa. Terry asked Derica, "Where's Isa, are you home alone?" Derica said she didn't know where Isa was but she wasn't home alone because Bismark was home with her. Terry was thankful Bismark was at home with Derica because Terry knew Bismark would always protect her family. Derica was able to climb onto the counter and get cereal to eat. Derica also knew how to use the BetaMax, the small machine that would allow her to see a movie over and over, which she did. She watched "Wizard of Oz" many times that morning singing the songs that Judy Garland had sung in the movie. Knowing Derica had been home alone all morning was so upsetting to Terry that it was impossible for her to remember, even years later, what she and the girls had done about school that afternoon. Did they return to school, stay home, or take Derica to school with them? Terry just didn't know and still could not remember.

The following day, after Isa left, Terry had to consider how and if she could continue teaching with no one to care for Derica. "There was no way I could leave Derica home alone. I was so thankful that Bismark had been with her but I had to figure out what to do. I told Martha, a friend of mine, about my situation. Martha told her mother and her mother, Louise, without hesitation, said to just bring Derica to her house and she would take care of Derica while Terry was teaching. Louise was such a kind and

generous lady that I was delighted with her offer and happy to accept it. Louise lived across the street from the school which was convenient for me. My mornings did change a bit because now the older three girls had to get ready for school, as did I, but I, also, had to prepare and organize everything for Derica, who would be spending her day with Louise. I was so grateful for Louise's help and Derica was thrilled to have the Raggedy Ann doll that Louise had made for her, Louise was such a kind person."

"Musiú did contact the police about Isa since we hadn't seen her for days. He also brought another young woman to the house to help with the girls. That young woman walked into our house and into Isa's bedroom where she proceeded to start kissing all the walls in the bedroom while wearing her bright red lipstick. I couldn't believe what she was doing. What was wrong with her? I never understood why she felt it would be okay to run around the room kissing the walls. I was so upset with her and, thankfully, Musiú told her to leave our house, immediately."

"A week or two later, Isa appeared, collected her belongs and left, never to explain why she left and never to be seen again. Apparently, the reason Isa left was because she now had a boyfriend. The whole experience was unforgettable and shocking."

As the year continued and life was becoming more complicated Musiú said to Terry, "What do you want?" At that time Terry was taking care of everything. Not certain how to respond to his question Terry said, "I want nothing". Musiú said, "At least I gave you four beautiful daughters". Terry thought that perhaps that was what this whole life with him was about, having the four girls. "Nothing surprised me", recalled Terry. "I held no grudge against Musiú because this is the life we agreed to have. Soul to soul, we had been together before and, apparently, it was Musiú's turn to be the bad guy, I thought."

As the weeks slowly passed along, Terry and the girls returned home after being away for the weekend, only to discover that Bismark was not there. After searching, no one could find Bismark. Terry knew that Musiú often did not take care of Bismark but where had Bismark

gone, she wondered. Terry was very sad that Bismark was gone and as the weeks passed she knew that Bismark might never return. That thought that she might not see Bismark again before leaving Venezuela made Terry sad since Bismark was such a treasure and companion, especially, to her. Weeks passed but still no Bismark.

Several weeks later, Musiú's mother came to visit and brought a new dog for the family. "I wasn't certain we needed another dog because but I missed Bismark and I was still hoping he would return. Nonetheless, the girls were happy to have a new puppy and named him Macho, our second dog to be named Macho. "Since I had to go to the Civic Center to do some food shopping, I invited Musiú's mother to join me, which she did. While I shopped for food, my mother-in-law was in another part of the store where she found several items she wanted to buy. Together, checking out, was embarrassing because my mother-in-law expected me to pay for her new items. I had no extra money with me and she had no money, at all. We left her items at the store and took the food home. It may have been typical for her to carry no money but I was certainly surprised that she expected me to have enough money to pay for everything because I rarely had enough money for anything."

As the months continued, Terry was busy preparing to leave Venezuela with the girls, she felt it was important to be careful. Selling things, packing everything that Terry and the girls would need in Florida was a necessity but it was also necessary to keep Musiú happy. "I think Musiú continued to struggle with our family because he really wasn't number one with us. The girls and I were like decorations for him, that's it, nothing more. I couldn't devote all my time, energy, and attention to him. I needed to get a way from him and Venezuela and, perhaps, recognize who I was and what I could do."

During the school year as Terry continued teaching, her neighbors were kind and offered to help her anyway they could. None of the neighbors spoke to Terry about Musiú's infidelity but Terry assumed they knew something was wrong because neighbors talked to one another and were

observant. Later, when Terry and the girls left Puerto Ordaz, the neighbors gave Terry a gift, a beautiful solid gold coin.

Life had been so comfortable and productive in Venezuela, especially in the fifties and sixties. It was the Venezuela Terry knew and loved. "The Venezuelan people, I knew, were hard working friendly people supporting and caring for their families; however, as the Venezuelan government changed so did the people as they had to learn to live with a government putting more demands on its people and expecting sacrifices from its people. Would the warm greetings and hugs continue for the people or had that changed with a different government? Where was the Venezuela Terry had loved so many years ago? Perhaps moving to Florida was right for so many reasons. Since the Venezuelan government now owned the school, there was no guarantee that even if Terry would stay and teach that she would have a home. Teachers were no longer, automatically, given a home for themselves and their families. The current house that Terry and family were living in was from the company Musiú worked for in Puerto Ordaz and they, certainly, would not give Terry a home to live in.

Terry knew that moving to Florida with her four girls would, most likely mean that the girls would be be in four different schools which could make it difficult for Terry to find a job. However, Terry also knew she would have to figure out a way to earn money, once again. With that thought in mind, Terry decided to sell as many of the household goods in Puerto Ordaz that she could. Having people, people she didn't know, coming to the house, looking at everything, going through closets and knowing that Terry was leaving was not comfortable for her but she did what she needed to do. Terry felt the hurt and disappointment of each of her daughters for they understood that they would be moving to Florida and not returning to Venezuela. Each of the four girls had different feelings about leaving their dad. There were various degrees of disappointment and anger as each daughter would have to, once again, adjust to a new community, new school, and new friends. Terry understood that if any of her girls felt angry, that anger would be directed to her which it was and, especially, by

Joelle the oldest daughter who was the closest to her father. Joelle spent the most amount of time with her dad watching and enjoying the many interesting things he did. However, there was also discomfort among several of the girls when Musiú would make demands on the girls, perhaps not all of which were appropriate for the young girls. A couple of the girls expressed their desire to never be alone in the car with Musiú. With some planning, Terry knew she would be able to pay for everyone to fly to Florida including herself, the girls, the new dog, and Chico, the macaw. No matter where she lived, Terry always enjoyed having animals around. She enjoyed the birds, especially the macaws, but returning to Florida wasn't a choice, it was a necessity and just thinking about what her mother would say worried Terry a great deal. Would her mother accept Terry and the girls gladly or would her mother remind Terry of everything Terry had done wrong. While preparing to leave, Terry had to hope for the best and move forward knowing she had nowhere else to go and no other place to call home. Thinking about how her mother would react to Terry and the girls living with her parents added to the many worries and concerns Terry had as she continued preparing to leave Venezuela.

"Before leaving Puerto Ordaz, I was driving near the Civic Center when a young boy waved me down. He asked me if I was really leaving Puerto Ordaz. When I told him that, yes, I was leaving he said that made him sad because next year he would be in my class and would hike to the jungle just as his two older brothers had done. I told him I was sorry as I drove away with tears in my eyes. There was so much about Venezuela that I would miss, including my students and the jungle."

Terry, knowing that she and the girls would soon be leaving Puerto Ordaz, continued to wonder and worry about Bismark. "I just wanted to know where he was. I wanted to know that Bismark was safe. I knew he did not like to be enclosed, anywhere. When we had lived in Florida, Bismark crashed through a window right into the aviary. He then broke through the aviary screen which released all the birds into the air. Bismark always wanted to be free. I kept thinking about Bismark and talking to him, in my

head, saying that I know you want to be free but I need to know you are safe. I need to know you are safe. I thought about Bismark so many times, not certain I could leave Venezuela without knowing he was okay. One morning, just before leaving, I walked out the door and into the backyard. As I looked up, there was Bismark on the top of the hill above our house with a pack of wild dogs, perhaps twenty wild dogs. Bismark walked down to me while the other dogs just sat still, not walking with Bismark. With tears in my eyes, I could only pet Bismark and tell him how much I loved him. Bismark listened, allowed me to continue petting him until he turned and left. He returned to the pack of wild dogs but by being there, he had told me he would be okay and that I could go on with my life without him. I was so thankful to see Bismark one last time. That was incredibly important to me and I think Bismark knew that."

Although, Terry had spent many years in Venezuela, she had never seen many blue butterflies until she was preparing to leave Musiú and Venezuela. She knew her girls had caught several blue butterflies for a class project and Terry had seen blue butterflies flying around the backyard; however, on the day leaving for the airport, Terry stopped and thoughtfully looked at one blue butterfly in her yard. She wondered if the blue butterfly, as folklore indicated, would truly represent a new beginning for her with unlimited strength and happiness. Only years later would Terry know if the folklore would be true for her.

As Terry, the four girls (Joelle, Mia, Brittany, Derica), the dog (Macho) and the bird (Chico) filled the car, Musui drove everyone to the airport to permanently leave Puerto Ordaz, Venezuela. Terry made the departure from Puerto Ordaz typical of what she and the girls did many summers hoping that the Venezuelan officials wouldn't realize and prevent her from leaving the country. Once again, Terry had to fill out the exit documents. She indicated that the purpose for leaving the country was for summer vacation in Florida and, perhaps, to find a high school for Joelle since Joelle was old enough to be a freshman in high school. It was well known in Puerto Ordaz that there was no high school at Escuela de

Ferrominera; therefore, finding a high school for Joelle was acceptable to Musiú and to the government of Venezuela. Terry and the girls would now permanently leave Venezuela. If anyone questioned why Terry was selling the family household goods, bicycles, clothes, and other family items before leaving Puerto Ordaz if she planned to return, no one asked her. Did Musiú understand that Terry and the girls were leaving permanently? Terry thought he knew and didn't care. Terry recalls sadly that she had to leave Venezuela, the Venezuela she had grown to love, in order to leave the situation with Musiú, the situation she did not love.

Life would also continue for Musiú in Venezuela with the woman he had chosen to replace Terry. He could, once again, be number one in that woman's life, until the day he died.

Terry believed she and Musiú had each chosen the parents they wanted for the life they would have. She also believed she continued to have a great deal to learn about her current life. Her life would continue in Florida but would it be the life she wanted?

CHAPTER ELEVEN:

Florida...Anguish *to* Contentment

When Terry, the four girls, Macho, and Chico arrived in Miami, Derry and his wife, June, were there to meet them. However, because authorities were alert to bird flu or a similar bird disease, Chico had to be sent to Texas to be quarantined for thirty days. The officials had to make certain Chico was not carrying any bird disease. At the end of the thirty days, if Chico had no disease, he would be returned to Terry and the family.

After the drive of several hours from Miami, Terry, the girls and the dog arrived at her parents' home in Ft. Lauderdale, Florida. "My parents said nothing to me, no hugs, no support. I don't think my mother was overly happy about my family moving into the family house but I had nowhere else to go. I had no job and because of that I didn't want to be in a position where Child Protective Services could take my girls away from me. The house my parents had was large enough for all of us. It was the house on Godfrey Road that Musiú and I had built many years ago. We had sold the house to my parents before returning to Venezuela. The house was surrounded with a couple acres of trees, plants, and Dad's garden. As we all adjusted to one another, my girls loved working in the yard and in the garden with my dad. Frequently, Dad would pay the girls a quarter if they would help him put rocks in a pile or some other task that he would think

for them to do. My parents had added a swimming pool and a tennis court to the property."

As the family adjusted, Terry's mother continued to be the rule maker. Any food on the girls' dinner plates had to be eaten, no matter who put the food on their plates. Shoes had to be worn in the house because Terry's mother believed feet had oil on them and she didn't want oil on her carpets. Everyone learned, listened, and adjusted.

"In Puerto Ordaz, I had learned to eat papaya which I would slice open and enjoy every bit of that sweet fruit. As Dad had promised, when he retired he let papaya seeds dry out and then he had planted the seeds in the yard. He now had large papaya trees bearing lots of fruit. Dad ended up with lots of papaya for everyone in the family to eat or to give away or to sell to the local supermarket."

Meanwhile in Texas, Chico was not happy. He did not like spending his day in a cage so he managed to break the cage and walk out. Terry was notified of the damage Chico had caused. She had to pay for the damaged cage and then purchase another stronger bigger cage for Chico, which is where he had to stay, until he could returned to Florida. When Chico returned to Terry and the family he was, once again, the happy and chatty macaw that Terry loved.

"It seemed to me that my girls had more of a cultural shock moving from Venezuela back to Florida than they had when first moving to Venezuela. The girls had grown comfortable in Puerto Ordaz because they had friends and were familiar with the area. Returning to Florida meant changes in schools, language, routines, and trying to be comfortable with classmates they didn't know. However, returning to Florida wasn't a choice but a necessity. Musiú was no longer a part of my life or my daughters' lives. He had made his choice and I had to make choices based on what I thought would be best for my four girls."

"Finding a school for each of the girls was important. Joelle would be in high school, Mia in middle school, Brittany in elementary school, and Derica in preschool. I knew I had to get a job but finding a job would be

a challenge because, among other things, I had to take each daughter to a different school, everyday. How could I, as their mother, handle everything alone. I wanted to make life comfortable for each of them but was it even possible? I, certainly, didn't want the schools to call authorities and say that my girls were not being well cared for by their mother. I continued to worry about that."

Adapting to life in Florida continued to be a challenge for Terry and the girls. Frequently, Terry would get a phone call from one of the schools indicating that Terry needed to return to school to pick up one of the girls due to an illness, an accident, or even a deliberate act of disobedience. Some times an act of disobedience was due to someone the girls thought was a friend but who turned out to not be a friend but, rather, a trouble maker.

To Terry, it seemed reasonable to expect her girls to be be unhappy and even angry at her for permanently leaving Venezuela and Musiú and she was right. The girls, to various degrees, were angry with her for breaking up their family and leaving Venezuela. Joelle, the oldest, was probably the angriest and her anger lasted for a long time until, years later, she finally decided to let go of her anger and become the happy person she had hidden away. Joelle was like Musiú in that she liked and enjoyed anything unusual, interesting, and different. No one could blame her for that. Terry recalled the time Joelle told Terry that she thought she would be an only child and was angry about having all the younger sisters that she had not wanted. Based on her belief, Terry told Joelle that she had picked Terry to be her mother when she could have picked someone else. That meant Joelle had only herself to blame. Only Joelle knew if she really believed her mother's statement. As the years continued, Joelle and her sisters continued to support, care and love one another with great affection as only sisters can do.

Terry spent as much time as she could searching for a job. She learned about and attended a seminar that focused on decorating homes and condos. Perhaps, Terry thought, by attending the seminar, it might be one way she could learn a new skill and start having an income again. Terry signed up for the seminar. "Dad agreed to watch Chico for me while

I was gone for a couple days. However, when Dad was trying to feed Chico, Chico grabbed Dad's arm and wouldn't let go. Dad said he thought about wringing Chico's neck to get him off but since he knew I would be very unhappy if he did that, he didn't do it. Dad knew how much I loved Chico; however, after that incident, Dad would only feed Chico by just tossing some food in the air allowing Chico to fly over, grab the food and eat it. By just tossing the food, Dad could stay far away from Chico, my chatty independent macaw."

After completing the seminar, Terry thought she could find a job which allowed her to help decorate model homes, primarily, with various pieces of art. It was an interesting job but often required more hours than she wanted to be away from home. There was no doubt that Terry appreciated that she and her family were able to live with her parents, but it wasn't always easy. Terry continued working whenever and wherever she could. Her job was to help clients select colors for their home; basically, to help clients select paintings, frames, borders and mats for the art work a customer wanted. Home at that time was still with her parents. "I returned home one evening and was met at the door by both my parents, both appearing stern, rigid and angry. They, immediately, asked me where I had been and what had I been doing. They knew I was working on a job so I was very surprised by how angry they both seemed. After talking to them and explaining where I had been working, I learned they were upset because one of the girls had crawled out the bedroom window, trying to sneak away, and that had significantly upset my parents. Was my daughter really trying to escape, to run away? What was she thinking? Generally, the girls were cooperative and followed rules; however, mistakes were made and adhering to the many rules established by Mother was a challenge for the girls. There was another time when one of the girls had been charged for shoplifting, which was not good and disappointing to me. Realistically, my life continued to be filled with a variety of ups and downs and I valued the good days.

With her parents annoyed with her, Terry told them she would be out of their home as soon as she could. "Mother thought my girls should

continue taking singing and dancing lessons again and again, which was awful. Finally, I told her enough was enough, no more. I remembered similar experiences in Ohio when I was growing up. There were several times when Mother dressed Derry and me, alike, to look like twins. We would ride the bus downtown to the local radio station to model clothes. I didn't understand how you could model clothes at a radio station when the listeners couldn't see your clothes; however, I learned that a script was read over the radio, describing the clothes, and that was how we modeled clothes on the radio."

On the weekends Terry and the girls would drive to Palm Bay to visit with Terry's good friend, Carol and her family. Since Carol and Terry each had four children, the children enjoyed playing together. Among other activities, the play often included placing a plunger firmly in the middle of a card table with a sheet draped over the plunger and the card table to create a tent where several of the children could play and hide. There were card games, board games, and outside ball games. Spending the weekend away from her parents was good for everyone, including Terry's parents who may have needed some quiet time for themselves.

Terry knew her mother would be happier when Terry and the girls lived elsewhere. "As it turned out since Chico was, once again, happily squawking and chatting in his cage which sat on the patio one of the neighbors heard him. Chico was visible and could be heard by Louise. It was not unusual to hear Chico chatting in German, Spanish, or English. You could, frequently, hear him call 'Mom'. One morning, Louise, who could see Chico from her house, knocked on the door telling me that she loved that bird, meaning Chico. Her husband was a pilot and her business was raising exotic pairs of birds, primarily parrots and macaws. Louise explained to me that soon she and her husband would be moving north and they could not move the birds until they had built enough cages for the birds in their new home. She asked me if I would be willing to move into her house and take care of the birds until she and her husband were ready to move all the birds to their new home. Since moving to her house would include

my four girls, without hesitation, I said I would absolutely be willing to move and take care of the birds. Within a few days, the girls and I moved into her house and I received the directions regarding the necessary care for the nearly fifty pair of birds. The girls and I happily left my parents' house which I think pleased my parents since we had been living with them for over a year. My parents never came to visit us in the bird house; although, we were just around the corner from their house. I thought that was strange but I never questioned it."

Shortly before making the move to the bird house, Terry and the girls were upset to learn that the family dog, Macho, the English Setter, was sick with coon fever. Because of the disease Macho could hardly move and it appeared that his back legs were paralyzed. The vet was hopeful that Macho would recover but he was not optimistic. One day, Terry decided to set Macho outside on the grass for fresh air. After going back inside the house and looking out the kitchen window, keeping an eye on Macho, Terry noticed that a cat had walked right up to the dog. "It wasn't a familiar looking neighborhood cat but an independent feral cat. The cat had walked right up to Macho and touched his nose and walked away. Macho watched but didn't move. The next day, the same cat returned to the backyard and again approached Macho who was, once again, just stretched out on the grass. The cat touched Macho's nose again and then took a couple steps backwards. For the first time, Macho tried to take a step towards the cat which he was able to do but then collapsed back onto the ground. Every day, for several weeks, that same cat would visit Macho and each day the cat would step further backwards away from Macho which meant Macho had to take more steps forward to get close to the cat. This procedure continued until Macho returned to normal and the cat disappeared. An amazing job well done by a visiting cat."

There is no doubt that in addition to taking care of the birds, Terry had four daughters to care for but now the school bus was picking up the girls for school, which was comfortable except for the neighbor's peacock who enjoyed chasing Brittany as she walked and then ran to get on the

school bus. While living in the bird lady's house, the girls enjoyed walking around the corner to see grandparents, swimming in their swimming pool, and helping Grandpa with yard work. After taking care of the birds, in the bird lady's house, for nearly two years, Terry knew it would soon be time for her and the girls to move into their own house. One day, while Terry was driving, she gave thought to the kind of house she would need to buy. When Terry returned home, she sat down and drew a sketch of a house that would be appropriate for her and the girls. Terry would drive up and down various streets where she thought she and the girls could live. Unexpectedly, Terry saw a house, not far away from the bird house, on Cardinal Road. A house that had just been put on the market. Terry looked at the house and bought it. After Terry bought that house, she realized it was the mirror image of the house she had sketched several months earlier. Once again, Terry believed that every step of the way, in her life, things seem to happen the way they are meant to happen and, therefore, she sets no absolute goals. "I just figured everything would work out the way it was meant to work out." Terry and the girls soon moved and everyone was comfortable in the new house.

One day, a young girl, Raven, came to the house for her swimming lesson. Terry met Raven at the door and walked Raven through the house to the pool. When Raven saw Terry's dog drinking water out of the pool, she was surprised and a bit startled telling Terry, in a frantic voice that the dog was drinking out of the swimming pool. Terry quietly responded by saying, "Actually, Raven, you'll be swimming in the dog's water bowl." With that, Raven giggled and quickly jumped into the pool.

While Terry and the girls were living on Cardinal Road and with Terry being the bread winner, supporting her family was a significant challenge for Terry. Terry remembers her mother telling her about Aunt Marge. My mother was caring for my dad who was dying of brain cancer plus she was concerned for her sister who had Alzheimer's disease. "Mother didn't think she could care for both and thought she should put her sister in a nursing-home. I asked her how much that would cost. Mother said

it would cost somewhere around $5000 a month. Since I had very little income, I suggested that perhaps Aunt Marge could move into my house and I would take care of her and earn the money that would, otherwise, be spent for nursing-home care. Mother agreed and Aunt Marge moved into my house with the girls and me. I had always liked Aunt Marge. She was a fun and very nice person. I thought having her at my house would be better than putting her in a care facility. However, that did turn out to be more of an experience than I would have predicted. Aunt Marge would take the magnet off the refrigerator, the magnet that resembled a candy bar and try to eat it. She would also put Derica's clothes on which were always too small for Aunt Marge. I would end up having to cut the clothes off her. In the middle of the night, I would often wake up because Aunt Marge would be standing over my bed just staring at me. Eventually, I registered Aunt Marge with the local Police Department since she started wandering off on her own. One day, when I couldn't find her and with the police helping me, we found Aunt Marge a couple blocks away sitting on a stranger's patio drinking a beer. I learned it was important to lock all the doors in our house or Aunt Marge would just walk out the door and go anywhere. I continued to work as much as possible helping clients select appropriate art work for their homes. There was one unforgettable day when a client came to my house to pick up several pieces of art work she had requested. As my client and I were putting the items in her car, I turned around to see Aunt Marge walking out of the house, naked. She carried her black purse in front of her private area and that was it. I asked my client not to laugh and she didn't as I guided Aunt Marge back into the house. Although, there were a number of surprises due to Aunt Marge having Alzheimer's Disease, it was nice having her with us for several years."

"Several days later, at my parents house, I was sitting by the pool with my dad, who at that time, was outside resting on his hospital bed. His bed had been moved outside so he could enjoy the fresh air and the sound of the water flowing into the swimming pool. My dad had always enjoyed being near water, especially near the ocean. Sadly, Dad could no longer talk

to any of us. I was sitting in a chair by his bed doing nothing but just being there beside him, just sitting outside together. For some unknown reason, I suddenly stood up and walked to the edge of the pool. I had a feeling of blankness. I reached into the pool and picked up a piece of pipe and put it back where it belonged. How did I know what to do with that pipe? Only my dad would have known what to do with that piece of pipe. I knew Dad couldn't talk but, somehow, I believe he told me what to do with that piece of pipe. I looked at him and said, Thank you, Dad, I fixed the pipe. I love you, Dad. Those are the kind of unexpected happenings I felt someone was guiding me to do. I have always left everything up to God because He is smarter than I am. Dad was my spiritual leader who introduced me, as a young girl, to various writers who expressed their spiritual thoughts and beliefs in a positive way, whether by books, through seminars, or on the internet. I am a spiritual person but not a religious person. I do not belong to a church, attend church services regularly or participate in church activities but I am truly spiritual and thankful for every gift God has given me."

Several months after Terry's dad died, Terry took her mother and the girls shopping. While she was shopping Terry's mother bought a life size doll. The doll was wearing a straw hat and Terry's mother named her new doll, Pedro. When Terry asked her mother why she had bought the doll, her mother told Terry she would put Pedro in a chair in the living-room where people looking into the house from outside would see him. She continued saying that no one would want to break into her house if they saw Pedro sitting in the house with her. What could Terry say about that? She said nothing but was surprised as her mother laughed about buying Pedro. Hearing her mother laugh was fairly unusual and a pleasure to hear.

Terry knew she needed a permanent job with full pay and medical benefits for herself and her girls; therefore, she started the process of completing the paper work that would allow her to teach in Florida. After applying for and receiving the necessary credentials to teach in Florida, Terry interviewed and was soon offered a teaching job. It was 1985, Terry was excited because she would now be teaching at Coral Springs High

School. She was hired to teach Spanish and to be the assistant coach for the cheer leading squad. Life was moving forward and Terry was feeling that, perhaps, once again, she would be the Terry she had known when she graduated from college. At that time, she was an enthusiastic teacher eager to welcome and teach her students. Could she, once again, be more than a daughter, a mother, a single parent? Terry was anxious to find the Terry she had known so many years ago. Was it possible?

Teaching was exciting for Terry. With key in hand, Terry would be the first person to arrive at school very early in the mornings, giving herself time to prepare for classes, review students' work and enjoy the quiet time that she didn't have at home. The girls were busy, getting older and very capable of preparing for school or their day without Terry continually watching over them.

"When I was teaching Spanish to my high schools students, I shared a great deal of information regarding Latin American culture, including the various holidays, activities, and events that were unique to that part of the world. One such event always happened in November and was called 'The Day of the Dead'. Many Latin American families would spend a part of that day remembering a loved one who had died or visiting the cemetery where the loved one was buried in order to place flowers or to pick up any debris that might be near the grave. However, several teachers didn't think I should be providing that kind of information to my students. I decided that I needed my own classroom so I requested a portable classroom where I could teach without criticism from another teacher. I was happy when that happened."

"One day while teaching at Coral Springs High School, in my portable classroom that had two outside doors, which I always left open, something unusual and simple happened. A wasp flew into the classroom which, immediately caused the children to get excited. I put my hand up high and told my students to stop and make no noise because we didn't need confusion. With my hand in the air, the wasp came over and landed on the tip of my finger. I walked outside where the wasp quickly flew off my finger and

away. When I returned to the very quiet classroom I reminded my students not to mess with Mother Nature. Events and things like that seem to just happen to me and I go along with it. Watching the children being amazed that the wasp simply wanted to go outside made for a fun day and my students learned there was no need to kill that little wasp who just wanted to be himself and be outside where he belonged."

Several years later, while teaching at Coral Springs High School, Terry read a letter stating that a new high school would soon open and teachers were needed. Since Terry was one of the the last teachers hired at Coral Springs, she thought she would volunteer to teach at the new high school, which she did. It was 1990 and Terry was hired to teach at the new Douglas High School. She would be the Spanish teacher and the coach for the new cheerleading squad which included selecting uniforms, having student tryouts, spending long hours and a great deal of travel time to attend all the games that required the cheerleading squad. That also meant getting home late at night after attending one of the school's sporting events which she needed to do as she continued coaching the cheerleading squad. Terry's purpose was to earn extra dollars, which she needed. The extra income was helpful but Terry needed more income for her family; consequently, she tutored several students and taught a semester of night school. One night Terry realized she could hardly stay awake while driving home from night school; consequently, at the end of that semester, she quit teaching night classes. However, to have the necessary income for her family, Terry decided to sell the gold pieces that were gifts to her from her parents and her neighbors in Puerto Ordaz. "I soon learned that many of the treasured items that I had would have to be sold in order to help provide for my girls. One treasure, that I loved, was a beautiful gold name tag that Puerto Ordaz friends had made for our dog, Red Boy. Since the name tag was solid gold and so beautiful we never put it on Red Boy. Dad had it attached to my charm bracelet. Sadly, I had to sell it along with several other gold pieces and uncut diamonds that I had received as gifts."

The girls were helping to earn money as best they could with each working at various jobs in order to purchase their own clothes or save for college classes or books. Joelle started work at four in the morning at the donut shop. Mia worked nights at a local restaurant. Brittany, after earning her high school diploma accepted a job in Columbus, Ohio. Derica was with her husband since she was married during her senior year in high school. Joelle raised and sold the unique Highlander kittens to help pay her college expenses. As Joelle was preparing for college classes, she needed to buy text books but didn't have enough money for the books; however, she knew she would have the money as soon as the kittens were old enough to be sold. Joelle asked my mother for a loan until the kittens were sold and then she would pay her back. Mother replied by telling Joelle that if you don't have the money to purchase your books, you shouldn't go to college. Mother was, once again, unpredictable."

After living in Florida for many years, one of the girls had a dream that her father was dying. With her personal feeling that everything in life should be clear and understandable, Mia sent Musiú a ticket so he could visit the family in Florida, which he did. Although Terry and the girls had left Musiú, realistically, he was still father to the girls. Periodically, there would be contact with him, but only if the girls initiated such contact. Musiú never recognize the girls' birthdays, holidays, or special events and he never contributed one penny to help Terry support them. "Interestingly," recalled Terry, "when Musiú came to Florida to visit, only Mia, invited him for a meal or to stay at her house. None of the other girls did. Sadly, I did not know everything that had happened in Venezuela between Musiú and the girls. I often wondered how I could not know and why had the girls not told me everything or had they told me and I had not listened, what did I miss? Feelings toward Musiú varied with each daughter as well as their feelings of trust towards him. Derica, being the youngest and leaving Venezuela when she was just three years didn't really have a relationship at all with Musiú."

If it's true that no matter the age of an only son in a Venezuelan family and that son is suppose to be the focus of everyone's attention, even as an adult, could that affect the son's parenting skills or lack of such parenting skills? One had to wonder.

One year, Terry and several family members were planning to fly to Venezuela for several days. Terry was willing to join them because Venezuela was always special to her. Terry told Brittany who was having problems at school, before she would graduate, that she would need to stay with Musiú, in Puerto Ordaz, until she felt she could handle herself properly in high school and make better decisions. Terry bought Brittany a round trip ticket to allow Brittany to return to Florida when she felt she could make better decisions; however, Musiú had somehow managed to cash Brittany's ticket in and claim the money for himself. Consequently, when Brittany called Terry to tell her she was ready to return home Terry had to send her the money to buy another ticket thanks to Musiú's behavior of selling Brittany's original ticket and keeping the money for himself.

"When I taught Spanish to my classes in Florida, I told my students that I wanted each student to walk out of my class understanding the love I felt for Venezuela so that when you go to another country, you'll learn about the country and you'll learn the language faster there than you will ever learn in a classroom. I encouraged students to pay attention to what people are saying not how they're saying it."

When students walked into Terry's classroom they were greeted with a variety of items typical of Venezuela; such as, a variety toys, interesting news announcements, posters on the classroom walls including a full-length picture of a well known basketball player with his body parts marked in Spanish. Even the air seemed fresher in Terry's classroom thanks to the various air filters around the room and her ongoing love of colors and smells, which all reminded her of her love of Venezuela.

"I suppose, realistically, I often did the unusual and surprising activities for my students. In my classroom, I had many items for students to see, use, and share. Such items as the musical instruments typical of Venezuela,

the harp and the cuatro. While the cuatro was about the size of a small guitar or ukulele, the harp was a larger instrument that could not be held in one's arms. Another items was the hammock which, when I first moved to Venezuela was the bed used by many families. A hammock was often the matrimonial or wedding gift given to newlyweds. I had many toys typical to Venezuela; such as, the Perinola (a spinning top), yo-yos, marbles, and kites. I explained to my students that kites were not just for children in Venezuela. Many adults, mostly men, flew kites and would have fights with their kites. One man would try to guide his kite into another man's kite in order to cut the opponent's kite line."

Terry had found a stuffed blue and gold macaw which she put in the classroom. Her students soon discovered that when they would talk to the macaw, it would talk back. She also would show various familiar movies to her students; such as, Walt Disney movies. Terry would give here students a worksheet to complete as they watched a familiar Disney movie in Spanish.

"One of the favorite days with my students was when we had food day. There would be several times throughout the year when I would bring food to school that was typical of Venezuela. Even a coconut could be interesting to my students. I would first hammer three holes into the coconut, drain the juice and offer a small cup of the coconut juice to each student. Then I would hammer the coconut open to offer each child a sample of the fresh coconut. Among other fruits, coconuts grew in Venezuela plus avocados, very large avocados that were larger than any avocados in Florida. Sometimes I had to search to find typical Venezuela fruit like carambola, the star shape fruit. Tamarind, a sweet sour fruit or mamoncillos. The mamoncillos hung on a tree like grapes. You have to break the shell to eat it and you have to do it carefully because you could, easily, stain your clothes. You suck on the fruit that's around the seed and then spit the seed out. I, often, made the Venezuelan Tres Leches Cake, the three milk cake, which my students enjoyed along with arepas, those soft puffy rounds filled with tasty items like black beans, meat, or cheese. My favorite cheese was the

Guayanés cheese which was hard to buy in Florida but readily available in Puerto Ordaz. Dessert dishes, such as, Flan or the three milk cake were always the favorite of my students. I believe the students and I enjoyed food day because, often, a student would bring in a new dish of food that I was not familiar with, plus the recipe. I had many students from different Hispanic countries. Many students, who were no longer in my class, managed to find a reason to stop by on food day, which was great."

"I reminded my students that sometimes when a student, or anyone, makes a negative statement to you, you carry that negative statement with you into the classroom and it could cloud your positive thoughts. While I enjoyed all my classes, the last class of the day was special and I would wish every teacher could end the teaching day with such a positive group of students."

"I was surprised to return home from school one day to see Mother, Brittany, and a stranger sitting together at the dining-room table. I asked what they were doing. Mother handed me a document and said I needed to sign it because she was buying a car for Brittany. My mother had never bought a car for any of the other girls. The other girls had worked and earned enough money to buy their own car but Mother thought I wasn't treating Brittany correctly which I didn't understand. What was Mother thinking? There were times when she would do things to cause friction between my girls. However, trusting Mother, I signed the document and then learned that I, actually, was buying the car, not my mother. The document I signed was for a car loan. Of course, I should have read the document rather than just signing it. I didn't appreciate what Mother had done, especially when I needed to buy a car for all my school commitments and couldn't because I had an outstanding loan on Brittany's car.

After a number of years working and with her daughters older now and leading their own lives, Terry moved to her new home which was a newly built condo. Only the youngest daughter, Derica, was still living at home and able to move to the condo with Terry. Soon Derica, who was now married, would be graduating from high school and moving forward

with her own life. Terry was happy that Derica was with her but knew that would soon end. After running several errands, Terry and Derica stopped for lunch at a local restaurant. Terry had a cigarette and was going to light it when Derica suggested to her mother that she stop smoking. Derica reminded Terry that her health was more important than smoking. Listening to her daughter, Terry thought about it, put down the cigarette and never smoked another cigarette, ever.

Thinking about her daughters, Terry was asked, by a friend, how she raised such fascinating and accomplished daughters. Terry replied, "I just tried to stay out of their way because they are each so much smarter than I am. I allowed them to choose their own paths and make their own decisions. I never wanted to stifle their creativity, options, and possibilities.

While living in Florida, George, a friend of Terry's had sent her a ticket to visit him in California. Terry remembers that it was a lovely visit and she enjoyed driving up and down the Pacific Highway with him. "As we were in the kitchen of his house, preparing a meal, I turned around and looking at him I saw a priest collar on his neck. I said to him, I just saw a priest collar around your neck. He replied saying, 'that doesn't surprise me at all.' I hesitated but told him that I knew I had been a nun in my past life." George also knew he had a past life so he wasn't surprised by my comment. The following day, George took Terry to see a psychic who seemed to know a great deal about Terry including that she was a mother, a teacher, and had a past life. Terry confirmed her philosophy that she has never had a plan or goal in life but that she always accepts whatever happens to her, no matter what.

With the girls no longer living with Terry, the girls decided Terry might welcome a new bird to keep her company. The area was new and Terry's condo was the first to be built which meant Terry had no neighbors, yet. The girls gave Terry a macaw that she named Dulce, which means sweet in Spanish. Terry welcomed Dulce to her home and to her patio hoping he would soon chat like Chico had done. Like most macaws, Dulce yelled and squawked a lot and he was loud. Just as Terry had done with

Chico, Terry took Dulce to school with her which delighted her students. Dulce enjoyed sitting on his perch, in the classroom, listening and watching the students. At that time, the school was new and the staff was able to be a bit more creative before parents became involved establishing more rules for the teachers and students. In addition to walking around Terry's classroom or sitting on his perch, Dulce also sat on his perch or walked around Terry's patio squawking or chatting. While on the patio, Dulce would make loud sounds typical of a macaw. Sounds that could be heard, at least, a half mile away depending on how loud Dulce wanted to be at any given time. Realistically, Dulce's loud squawking and talking could be heard by those walking in the park across the street from Terry's condo. Those people would yell to Dulce or to Terry asking someone to please stop the yelling or screaming. Terry decided she had to give Dulce to someone who lived far away from people but she knew she would miss Dulce. Dulce, like most of her macaws liked to be held. When Terry would hold Dulce close to her chest, he would, open his wings to hug her. Mia knew just the man who could help her mother with Dulce. The man, Todd Warner, was an artist and often rescued animals by taking the animals to his ranch. He agreed to take Dulce and care for him. Todd stopped at Terry's house and Terry gave him Dulce, Dulce's food, toys, and cage. Eventually, Todd and all his animals, including Dulce, moved north to a new ranch; however, before he left he stopped to see Terry to give her a piece of artwork that he had drawn. It was a painting of Dulce.

Although Terry continued to enjoy teaching and her students plus the satisfaction of sharing knowledge and activities with her students, she was beginning to realize she was getting older and retirement was approaching. Was it possible that after all the years living in Ohio, Venezuela, and Florida that those years would now become memories for her to hold dear, treasure, and cherish for the rest of her life or was there more to do?

CHAPTER TWELVE:

Retirement *and* Personal Reflections

The room was bare, the halls were quiet, the students were gone. Terry walked out of her classroom and closed the door one last time. Her teaching career had ended. No more teaching Spanish to her students. No more sharing the joys of Venezuela with her students. Terry was now retired. Her personal freedom and had just begun.

"I spent a great deal of time thinking about Venezuela. There was such a good feeling among the Americans who moved and lived there. My love for the Venezuelan people began so many years ago when I was that young thirteen year old girl. My love for the Venezuela I knew continues to this day. The country was filled with freedom, freedom for everyone. There was beauty everywhere but most of all it was in the warm welcoming spirit of the Venezuelan people. Years have passed but my memories and love of Venezuela have remained forever. The treasured memories of Venezuela are with me everyday allowing me to remember and appreciate the wonderful country that it was. It was sad that I had to leave Venezuela but Venezuela never left my heart. I know the Venezuela of today is different from the Venezuela I knew those many years ago. I wish I could share the Venezuela that I knew and loved with the Venezuelan people of today."

"Every move I have had to make has been a good move even though it may not have seemed that way in the beginning but the moves were always

positive, providing me with more to learn and more to remember. Moving to and living in Venezuela made me aware of another country's culture and its people, whether that be in North America, Venezuela, Africa, or Ireland. Respect for other people and other countries has always been important to me."

"After living in Venezuela with friends from all over the world, friends with different backgrounds, friends who spoke different languages, friends whose skin colors were different from mine, I am dumbfounded by people today who judge others for very insignificant reasons; such as, skin color, religion, or life style. Perhaps those who judge and criticize have forgotten that each of us is a significant part of the human race and it is our responsibility to respect and care for one another."

"I think of life as the classroom and we are the students of life. We are learning all the time. There are always lessons and experiences to be learned in life that can be constructive and instructive if you are alert and willing to learn them. Even the negatives in life are important lessons needing to be learned. With each lifetime, I believe, we adjust and become better with the many lessons life has given us to learn. Children select their parents based on the lessons the child needs to learn in life. I am so thankful my daughters chose me as their mother. I think each is smarter than me, more creative, and more able to lead successful and happy lives. They continue to appreciate and value the various animals they each have with their families including dogs, cats, birds, chickens, goats, and llamas which is so meaningful to me."

"I sincerely thought about visiting Venezuela one more time; however, a good friend in Venezuela told me that her family had been car-jacked twice and I should not come. Another friend told me that it is not easy to permanently leave Venezuela and move to another country. Another family left everything in their house, so the authorities would not think they were leaving permanently but the family left and never returned to Venezuela. It appears that if you want to leave Venezuela, you must do it carefully and skillfully and, if necessary, by fooling the government officials

the best way you can. The Venezuela I knew in the fifties and sixties is no longer there. The government of Venezuela is so different now compared to the Venezuela I knew and loved. It was a time when the United States and Venezuela worked together supporting, helping, and caring for each other. The two countries that I have called home and have loved the most my entire life are the United States and Venezuela."

Beginning in 1963 several men who had lived in either Puerto Ordaz, Venezuela or Ciudad Piar, Venezuela and worked for Orinoco Mining Company decided it would be of great value to have a reunion to see friends who had lived in Venezuela, to share stores, to remember and to talk about what we liked about Venezuela and the freedom that the Venezuelan people had. Freedom to work, to educate their families and enjoy a comfortable life. We were so blessed because the life we had in Venezuela was comfortable for everyone. During 2020, Terry and Derry attended such a reunion in Florida. At the reunion, one of the ladies who had grown up in Puerto Ordaz remembered the blue butterfly which is a rare butterfly but a butterfly often seen in Venezuela. To her, the blue butterfly represented the great love she had for Venezuela; therefore, at age eighty, she had a small blue butterfly tattooed onto her ankle reminding her and others of the love she had for the Venezuela she knew many years ago. The people at the reunion felt blessed to have been a part of such a wonderful welcoming country with experiences that have lasted a life time. "We lived in a Venezuela that very few Venezuelans have ever lived in, certainly not the young Venezuelans, today."

The country of Venezuela is led by a dictator who, according to a report presented by BBC on February 5th, 2019, Russia, China, Cuba, and Turkey currently support the Venezuelan government of today.

"Will Venezuela and its people ever become the freedom loving Venezuela that we knew so many years ago, I can only hope. I would wish for the citizens of Venezuela that they could, once again, enjoy the same freedom we have in the United States."

While retired, Terry had the opportunity to visit Africa where not only did she see thousands of flamingoes but also had an interesting experience as the car approached an unfamiliar mountain. At that mountain, Terry insisted the driver stop the car. She stepped out of the car and walked to the mountain touching the side of it knowing this was where she had died, in a previous life. Africa, seemed familiar to Terry with the soil in Africa the same color as the soil in Venezuela. Several years before the trip to Africa, Terry had attended a family gathering were a woman was to teach about auroras and conduct transformational sessions. When asked, Terry volunteered to learn about her past life. "I was told to relax, which I did. I closed my eyes and when asked where I saw myself, I said I was in a tree. When asked to look down at my feet and explain what I could see. I saw my black feet in a pair of sandals. When asked if I saw anything else from my previous life, I said I saw a man walking into a stable. When asked if I recognized the man, I did. It was Musiú. We had been together in our previous lives."

A trip to Ireland was exciting but Terry did not feel the same connection to Ireland that she had felt in Africa. She had seen a yellow truck with the family name, Curran, on the truck and several Irish Setters riding in the truck. Just thinking of Red Boy, when seeing those Irish Setters, made Ireland very comfortable for Terry.

Sitting and reflecting on her life Terry commented, "much of what has happened in my life, I believe, is because I have left everything up to God. I have always believed that I am on this earth for a reason. I spent quite a bit of time at church because my dad was the basketball coach for the church team. I think unusual things happened that guided me into a certain direction and I just followed."

Terry continues to be thoughtful and caring about others as is evident by her early morning posts, on the internet, which she happily shares with friends. Those posts offer positive encouragement and hope to others. She also enjoys days where her focus is on meditation and learning with the belief that learning must never end for anyone. As Terry would tell

others, "you can only be what you can be with what you have and what you've been taught through your personal experiences."

Terry had a friend who was in the hospital due to a severe asthma attack. While still, in the hospital and recovering from that attack, Lisa called Terry to tell her what had happened. She told Terry that she had died on the examining table in the hospital and dying made her feel so wonderful because everything was beautiful and peaceful. Lisa said she didn't want to return to life but her grandfather appeared and told her it wasn't her time, yet. The minute he said that, Lisa knew she was back in the hospital. She told Terry that she didn't know why that happened. Terry told her she may never know or there might be a time when she would know. Several months later, Lisa called to tell Terry that the priest at her church was dying of cancer and he was very upset. Terry reminded Lisa that the priest was human and had not had Lisa's experience about dying which Lisa should share with him to relieve him of his fear and Lisa did.

"Lisa and I would often talk about past lives. The dreams she would have about concentration camps was often a topic. However, since she was raised Catholic she wasn't suppose to believe in reincarnation, but I did believe in it because I have experienced it. I knew I had been a nun in a past life."

"While sitting with a group of young women friends, years earlier, my friends were saying that having a baby was one of the most exciting things a woman could do, calling it an adventure and wondering what could be more exciting. I said dying was more exciting because I had experienced it and that's what came to my mind. My friends were silent and didn't know how to respond to my statement. That ended the group conversation."

In her home, thinking about a life well lived, Terry recalled the many highs and lows that she encountered in her life. She continues to feel blessed for the life she has lived and the life she still enjoys. Her family and her friends provide her with many days of joy and happiness. Perhaps, the blue butterfly did represent unlimited strength for her that led to happiness. The blue butterfly represents the Venezuela Terry knew and loved.

The Venezuela she knew as a child growing up in Puerto Ordaz and as an adult living there. The Venezuela that Terry loved and knew will live with her forever.

"I continue to be thankful for the life I have enjoyed. A life that has been filled with my personal spiritual blessings. May the blue butterfly, once again, bring joy, happiness, and peace to the people who live in Venezuela. May I, and my fellow citizens of the United States, continue to enjoy and respect the freedom we have, never taking it for granted. My final words are love, respect, and peace to all who live in the United States and in Venezuela."

Terry's Personal Photos

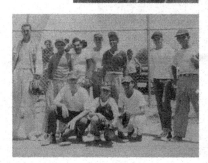

MAIN LINE

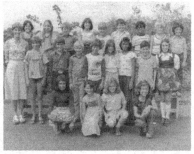

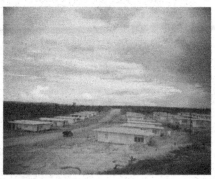

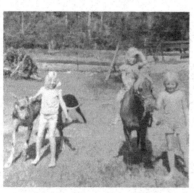
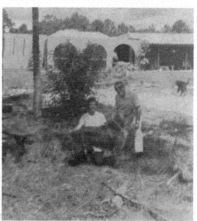
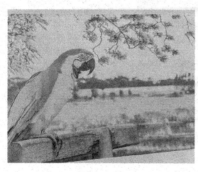